Two-Dimensional Man

Two-Dimensional Man
Paul Sahre

A Graphic Memoir

Abrams Press, New York

For Moe

Published in 2017 by Abrams Press, an imprint
of ABRAMS. All rights reserved. No portion
of this book may be reproduced, stored in a
retrieval system, or transmitted in any form
or by any means, mechanical, electronic, pho-
tocopying, recording, or otherwise, without
written permission from the publisher.

Library of Congress Control Number:
2016945921

ISBN: 978-1-4197-2415-2

Printed and bound in China
10 9 8 7 6 5 4 3 2 1

Abrams books are available at special discounts
when purchased in quantity for premiums and
promotions as well as fundraising or educa-
tional use. Special editions can also be created to
specification. For details, contact specialsales@
abramsbooks.com or the address below.

ABRAMS
The Art of Books

115 West 18th Street
New York, NY 10011
abramsbooks.com

Table of Contents

PART II
(Order)

I have used the title *A Designer and His Problems* for lectures I've given over the past twenty-five years—everywhere from Dayton, Ohio, to Cape Town, South Africa. It was going to be the title of *this* book until someone reminded me where I originally lifted it from: *The Graphic Artist and His Design Problems* (1973), by the late, great Josef Müller-Brockmann.

Even though I changed the title in time for publication, I would like to take this opportunity to formally apologize for any confusion I may have caused over the years. The problems I am referring to—typos, fuck-ups, and tales of woe—are in no way a reflection on Mr. Müller-Brockmann. Although I never had the opportunity to meet him, I have to believe he was above such things.

During a recent visit to my mom's house, I couldn't help but notice it.

It was a drawing I did years ago, probably as a teenager. Untitled and forgotten, I now refer to this work as *Demon Eating Human Flesh* (or *DEHF*). Apparently my mom found it in a box somewhere, put it in a frame, and hung it near the front door—where any visitor to the house is guaranteed to see it.

For years I've lived with the shame of seeing my early efforts on the walls of that house. In that regard, *DEHF* joins a rogues' gallery that includes *Handprint*, acrylic on wood (1970); *Dandelions*, crayon on newsprint (1974); *Einstein*, etching (1979); *Glue?!*, after a still from a Tony's Pizza commercial (1981); *Tyler, Family Cat #4*, gouache on illustration board (1982); *See No Evil: Three Cats Wearing Glasses*, graphite on paper (1982); *Indian Woman with Pox-Infested Blanket*, graphite on paper (1984). Dadaist John Heartfield decided at one point to destroy all of his early work—for "liberation," he said. But it was probably because of his mom.

It gets worse. Yes, *Demon Eating Human Flesh* is incredibly embarrassing. But that's not the problem, I'm used to embarrassing. The problem is that with its reemergence, this drawing is now exhibiting dark, even supernatural qualities. Just when I think it's gone, it reappears, straight out of a nineteenth-century W. W. Jacobs short story, instead of Wonder Bread America of the 1970s.

This is a cautionary tale, one that can serve as a warning to "all who make things." Once something is created—drawn, in this case—the maker, while exerting complete control over its creation, has virtually no control over what it ultimately means to others, nor, apparently, where it ends up.

I am often asked how I got into graphic design and I always answer that I drew a lot as a kid. *Everyone* draws as a kid, but most people stop at some point. I didn't. While other kids became interested in "normal" things pre-adolescents get interested in, I kept drawing, past the cute years, into my teens. For me, drawing was the activity that eventually led me to study design, and I'm glad things worked out the way they did, I just wish a visit to my mom wasn't so disturbing.

In these early efforts, I can look through the eyes of earlier versions of me. I'm reminded of place and motivation, yet most of what I see is totally unfamiliar, like I could never have been the person who drew these things in the first place.

Here is what happened, as best as I can remember.

I drew a picture.

I don't remember drawing it, but it does have my name on it, so I must have. Due to the subject matter, I drew it in the late '70s. I would have been fifteen years old at the time. This was my Frank Frazetta period (especially, but not limited to, Frazetta's work on Nazareth's *Expect No Mercy* and all of his Molly Hatchet album covers). I must have referenced some preexisting art, as I would never have drawn something like this from my imagination. *DEHF* was then forgotten. I moved on to Albrecht Dürer and highly detailed renderings of house pets.

The first time *DEHF* resurfaced was in 1986, on a circus train, in the possession of my brother Angus, or Kenny, as my mom still refers to him. He changed his name to Angus (after Angus Young of AC/DC) shortly before he dropped out of high school and joined the Ringling Bros. and Barnum & Bailey Circus. There weren't any "circus people" in our family, so this was upsetting to my parents, who were both college grads. I sort of saw it coming. He had been hanging around the local arena more and more over the previous year, partying with the roadies and some of the members of his favorite hair metal bands after the shows: Poison, Mötley Crüe, Twisted

Sister. A shy kid named Fred Coury who went to Sunday school with Angus had grown up to become the drummer for Cinderella. I vaguely remember Angus going to the show and then not seeing him again for a few days.

He did the same when the circus was in town. It was during one of these visits that his circus friends said, "Hey, why don't you come with us?" and off he went. He didn't give it any more thought than that. If he did, he would have realized that he was a few months from graduating from high school. I never figured out what his official title was, but he worked for years with camels and was later promoted to taking care of the elephants. By "taking care," I mean mostly cleaning up after them, much of which involved a shovel. He referred to them as his "girls."

He had brought the drawing on the road with him, and I saw it when the circus came to the Richfield Coliseum, thirty miles north of Kent, Ohio, where I was studying graphic design. It was hanging above his bunk on the circus train; it had acquired a dark blue matte, was unframed, and was wrapped in cellophane. I was sitting on the end of his bunk, concentrating on my breathing. This was my first experience dealing with the "circus smell" that permeated everything on that train, even the *beer* he handed me tasted like circus. Completely oblivious to the stench, my brother told me that *DEHF* was the best thing I'd ever done, or would *ever* do.

This experience—visiting my brother on the train, seeing the drawing, and trying to breathe through my mouth—repeated every time "the circus was in town," no matter what town I happened to be living in over the next eighteen years . . . which brings me back to the reason the drawing is currently in my mom's living room.

I learned about the accident via one of those middle-of-the-night phone calls. It was December 2004. My wife, Emily, handed me the phone, and, half asleep, I heard through my father's sobs that Kenny—Angus—was brain dead. He had been drinking and had fallen down the stairs of my parent's home. This was the house we grew up in, he had been up and down those stairs a thousand times. He died four days later. He was thirty-eight.

This is how *DEHF* found its way back to my mom. She decided to hang it on her wall and there is nothing I can do about it.

I have always felt a huge disconnect between my life as a creative person and where I am from; that despite my seemingly conventional upbringing—suburban, safe, *normal*—I have ended up pursuing an unconventional life. When I found design, I learned to think critically. I became self-aware. I lost my past in a way. I learned to perceive the world in a fundamentally different way than I had before design school. When this happened, I convinced myself that my background had nothing to do with me being a designer. I stopped drawing, thinking that drawing—especially the *way* I was doing it—was *un*creative. There was a disconnect. All of a sudden I wanted to deny my past. I was critical of all sorts of things that seemed totally fine before. The drawing appearing on my mom's wall is an articulation of this. My family seems to understand an awful drawing I did before I was shaving, yet doesn't understand anything I've ever designed, at least not in the same way.

My brother held on to the drawing. I was embarrassed.

My brother dies and my mother hangs it on her wall. I am horrified.

I was standing in the hallway thinking about all this when Emily came over and asked what was wrong. "This is a disaster. I am going to have to look at this damn thing every time I come back here."

"This isn't a disaster," she said. "This is how much your mother loves you."

PART I
(Chaos)

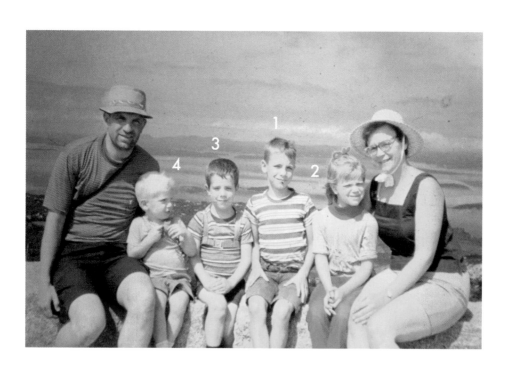

The Refrigerator

I was raised in a mind-numbing suburb in upstate New York, the third
of four, aka the middle child, aka *forgettable* (3). Unlike my siblings, I
wasn't born with a built-in "look at me" trait. I realized early on that if
I was going to get any attention, I was going to have to develop some-
thing. This isn't to say that I was neglected. There was yelling, consti-
pation, groundings, bed-wettings, hernias, bloody noses, stitches, and
masturbation, but there was also a lot of love. My parents were not shy
about showing affection for us and for each other. They were just out-
numbered; that, and the competition was *fierce*.

My father had been in the Air Force, and, as a consequence, we
did a number of things military style, despite the fact that we were all
so different from one another. Like my brothers, I had a crew cut until
my seventh birthday. My father would clear out a spot in the living room,
take out his electric razor, set it on the shortest setting, and one by one
we would be sheared, rubbing our stubbly heads as we left the chair. My
mom stuck with meals best prepared in bulk. Most of these meals were
cooked in a big pot and served with a ladle: beans and franks, tuna cas-
seroles, and goulash. We ate a lot of meatloaf.

Greg was the oldest (1). He had his own bedroom. He was
deaf and had a learning disability due to a case of German measles my
mom contracted when she was pregnant. To say he needed more
attention than the rest of us is an understatement. As a consequence, he
created, through no fault of his own, a domino effect that reverberates
through the family to this day. There are many examples I could give
to illustrate this, and the first that comes to mind is that my name is
Dwayne. Around the second grade, my parents decided that Greg would

never be able to pronounce Dwayne. He could pronounce my middle name, however, so Paul it was.

My sister, Sharon, was next (2). She was the only *girl*. This meant she also got special treatment, ostensibly in the form of a gender quarantine.

She rode in the front seat during family trips. When (not if) things escalated in the back seat, Dad would threaten to "pull over." If my brothers and I kept at it, the car would slow down. "WE'LL STOP! WE'LL STOP!" we yelled, but once such an event was set in motion there was no turning back. The car would stop, Dad would reach into the back seat, and my brothers and I hit the deck, trying, in vain, to avoid *the hand*. I always imagined what this would look like to passersby. From the outside, the car would be bouncing, windows steaming up, with muffled screams coming from the inside of the station wagon. My sister, who would watch this unfold from the front seat, just shook her head. She was sometimes strategically placed in the back seat as a way of separating us.

Sharon *never* got a crew cut.

Angus was the youngest (4), my roommate until I went to college. He liked to throw frogs into the busy street in front of our house in Johnson City and watch them get run over. Once you hear the sound of a fat toad exploding under a car tire going thirty-five miles per hour, you never forget it. Angus was spanked a lot.

As the youngest, Angus would have stood out for that reason alone, but he was also what my dad referred to as a "towhead," meaning he had blond, almost white, hair; this in a family with predominately dark hair. Strangers would frequently ask if he was albino. One of my dad's favorite quips involved Angus being "delivered" by the mailman.

As Angus moved on from frogs to spray-painting the neighbor's trees, my parents took him to see a child psychiatrist. He was diagnosed as hyperactive and put on medication. His behavior issues worsened, so that experiment didn't last long.

We were two years apart and I was his defacto protector, at least where the outside world was concerned. It was only at home that I would throw him under the bus, mainly so I didn't get in trouble for something he started.

Despite all of it, Angus was a very likeable kid, an extrovert. I was the opposite: shy, introverted. Angus always made friends before I did. If we were somewhere new, he would be playing with every kid on the playground and I would be off on my own. This held true for us as adults, too, only for Angus those playgrounds turned into bars.

In the middle of all this was me, making rumbling noises with my mouth as I pushed my big yellow Tonka truck around in the backyard. Scooping and dumping, scooping and dumping. I would never be the oldest or the youngest or a girl. Furthermore, I could never be better than my brothers at being learning disabled, deaf, or getting into trouble. This left only the refrigerator. Before I knew much, I knew that a finger painting, crayon scribble, or collage with glitter and feathers displayed on the refrigerator meant praise. We all had artwork on the fridge early on, but as we got older I continued to draw. I got better. The refrigerator became my Ferus Gallery.

Being a five-year-old in the late '60s was confusing and often terrifying. Protests. Strikes. Marches. Riots. Assassinations. War. I was insulated from all of it, except for the images that flickered in black-and-white on our Magnavox television set. Dad tuned in to the *CBS Evening News* every night. The program consisted of a flood of strange words spoken by a man seated in front of a screen. He didn't encourage me to watch the news, but he didn't *discourage* me either, even if he had to answer questions like "Who are the Viet Cong?" or "What is a body bag?" or "Why would someone shoot that man?" It took me a while, but I eventually learned to avoid the living room from 6:30 to 7 PM.

My father was an aerospace engineer, so I made an exception (as did the rest of the family) for anything related to the Apollo space missions. We watched it all like church. "Daddy, what is yaw?" Questions like this were certainly easier for him to handle.

The Sahre family drove. All six of us would cram into the car for vacations and visits to relatives. These trips were typically between two and three hours in duration (not counting our cross-country trip to Disneyland in the summer of 1974; that was an outlier). Most of the time, we would be driving north to Herkimer to visit Nana and Uncle Carl, or south to Lakehurst, New Jersey, to see Grandma and Grandpa Schoop. For years they operated a yarn shop out of their big house on Route 10, in Morris Plains, but they had since retired to an elderly community farther south.

Lakehurst was where the German zeppelin Hindenburg exploded in a fireball in 1937. We visited the naval station on more than one occasion, standing in the field where the disaster happened, touring the huge hangar. We frequently drove to air shows and aircraft museums anyway, so these trips to see the in-laws were two-for-ones as far as Dad was concerned.

Paul Schoop was a Swiss dairy farmer who immigrated to the United States in 1926. My mom would tell us stories of him skiing between farms making milk deliveries as a teenager, or of his forcing her to learn to play the accordion growing up. She also claimed he could yodel, but fortunately I never witnessed this. He left his homeland to look for work and to start a new life.

My mother always suggested that he had a case of wanderlust. I could never reconcile that last part with the person I knew. He didn't seem like a restless spirit. My grandfather was stern, reserved, and predictable, like his Swiss watch. He would sit in his La-Z-Boy recliner for hours in the same room with you, watching *The Lawrence Welk Show*, and never say a word. My grandfather was intimidating, especially when I was younger. His Germanic accent didn't help. Kid impressions aside, he was a gentle man—though there was that time in the Toys"R"Us parking lot when he climbed over two rows of car seats to whack Angus after he talked back (none of us thought he could move that fast). But mostly he tolerated us. Grandma Schoop was the affectionate one.

Now that I'm a father, I have a better appreciation for how disruptive our visits must have been. Theirs was a quiet house in a neighborhood of quiet houses. Not only did the Sahre family never fly, we never stayed in hotels, either. Our visits were more like invasions: We slept on cots, dug holes in the yard, and left toys strewn everywhere. We would leave, and then a few weeks later the process would start all over again. My grandparents must have spent all the time in between our visits rebuilding their defenses.

Grandpa Schoop had a distinctive *smell*—he wore Old Spice. I liked to play with the iconic cone-shaped bottle, with its etching of an old-time sailing vessel and script typeface, but only after locking the door. You never wanted to be caught playing with *anything* in the bathroom.

One day, I was running around in the yard and I ducked inside to take a piss when I noticed the head of one of our G.I. Joes sitting atop the bottle.

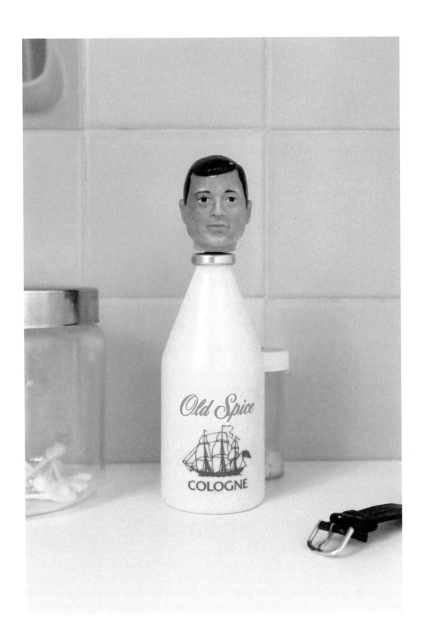

My first thought was one of my brothers had done this and that I should remove it before *our* heads started to roll. But when I brought them inside to see it, neither of them fessed up. They shrugged their shoulders, as confused as I was, and we all went back outside.

Although seemingly out of character, it was Grandpa Schoop who had reappropriated the head. He must have found it lying around in the aftermath of one of our visits and noticed that the neck diameter was the same as the cap on his cologne. I like to imagine his satisfaction when he placed it on top of the bottle and it fit so perfectly, as if the bottle was designed to be anthropomorphized. He transferred that G.I. Joe head from empty to full bottle until the day he died.

By combining two things that were designed for other purposes, he had created a design object, something Duchamp would have appreciated. It also demonstrated a playfulness and sense of humor that I didn't think he had. This new object clearly had meaning to him (it reminded him of us), but it also *communicated* something. Maybe it was a warning about what would happen if we left our toys lying around, or maybe it was a sign that we weren't such a nuisance after all, even if he never put that into words.

While the rest of us were walking to school down the block, Greg was flying (with Dad) to St. Mary's School for the Deaf in Buffalo. It was strange not having him around. And quiet. Because of Greg, everything in the house was at full volume, from our conversations to the TV. He had a hearing aid that helped him hear just enough to process some of the world around him. The earliest device had a molded earpiece connected by a curly wire to a silver box that was strapped to his chest. He was always adjusting it, trying to eliminate the acoustic feedback, and every time he did this, his hearing aid emitted a loud modulating whistle.

He had a very specific way of playing. He'd act out all the parts in an imaginary movie scene, with each character speaking loud enough for him to hear. He also liked to sing when he was alone in his room. By "sing" I mean a loud, guttural, off-key, chant-like chorus of repeated sounds with words thrown in every once in a while.

"Na, Na, Na Na . . . <indecipherable> Na, Na, Na Na . . . Na Na, Na Na, Na!"

<indecipherable>

echoed through the ductwork to all corners of the house. When I would bring a friend over to play for the first time, I'd warn them in advance. If I didn't, they might never come back. As with Angus, I defended my older brother outside of the house. This typically involved teasing, and twice the word "retard." Both times this ended with a bloody nose.

Greg seemed to always be in trouble. But his trouble was different from Angus's. Angus liked doing things with a purpose, like knocking over a glass of milk to see what would happen. Greg wasn't willful. He had a temper. If he didn't understand something (which happened a lot) things could escalate, often ending with my dad sitting on him until he cooled down. As he got older and bigger, he became more difficult for my father to subdue. These episodes increased in intensity and got more frightening, with stuff crashing off of shelves and whoever was in the house at the time helping out by grabbing a leg or an arm.

Angus and Greg were a potent combination, and it was left to Sharon and me to provide some sibling balance. We were both good, pretty much all the time. Seeing the mayhem and the consequences of bad behavior—spankings, groundings, threats of coal in the stocking—we, for the most part, avoided trouble . . . at least the obvious kind. Mom was petrified of the sound of the doorbell or the phone ringing, thinking it was the cops or a disgruntled neighbor again. As I watched Mom fret, it occurred to me that if I added any more trouble, she might very well be carried away in a straightjacket. I don't think I soaped my first window until I was in college.*

The late '60s was the golden era of American board games, and Greg loved board games. He treated everything he got for his birthday and Christmas like a priceless artifact, taking each thing out of his closet and letting my brother and I play with them, ONCE. He would hover over us while we played, carefully return the game pieces to their rightful place in the box as soon as we were done, then back into the closet it would go. He knew better. He saw how Angus and I treated our toys. We destroyed anything we came into contact with. Sharon was just as fastidious, only we didn't have that much interest in "Dawn's Fashion Show."

*My sister was able to loosen up by then as well. It was always surprising to see her drinking a beer or smoking a joint. During the summer months when we were both back from college, we would get home from the bars at the same time and sit in front of the TV and watch *Star Trek* together. WPIX televised reruns at the same time every night and I programmed the VCR to record them automatically.

Greg still has every game he's ever gotten in that closet of his, all of them mint—*Battling Tops, Stratego, Headache, Tip-It, Sorry!, Spirograph, Battleship, Hands Down*—along with everything else he's ever come in contact with: Wacky Packages, rubber bands, a bowling pin lamp, souvenir mugs, Disney pennants, his Marvin the Martian collection, puzzles, football helmet plaques, marbles, dice, Action Jackson dolls, and every Publishers Clearinghouse award letter he's ever received. Greg is a hoarder. His room in the basement resembled a hamster cage. A really fun hamster cage.

St. Mary's was the closest school for the deaf in the area, so Greg spent a few years with the nuns. While he was there, he learned to read lips and he underwent speech therapy. He learned sign language, but our family didn't, so when he returned home we communicated with Greg the way we always did—by speaking loudly. My parents were instructed NOT to teach the rest of us sign language. The accepted educational practice in

the '60s was the Oral Method. Back then, schools prepared deaf students for life in the hearing world, requiring them to study English, undergo speech training, and learn to lip-read. It was thought that someone who was hearing impaired had to adjust to society and not the other way around. In retrospect this was a terrible idea, especially for a child who had other issues, but at the time I didn't know any of this. It was just nice to have my big brother home.

The other thing my dad watched on TV was spor
racing, boxing, gymnastics, bowling, luge, and a
World of Sports with announcer Jim McKay's far
defeat," followed by that ski jumper bouncing do
one thing he didn't watch was professional baske
the channel saying, "Give each team 100 points a
the clock."

During commercial breaks, he pointed ou
nuances, depending on the sport. As a consequence
is in horse racing, I can keep score in baseball, and
between a football referee signaling "false start" and

His favorite sports were baseball and footb
too. When he was very young, his father would tak
at Ebbets Field and the Polo Grounds. The two of
Stadium on July 4, 1939, for Lou Gehrig Day. He w
at the time, so he had no memory of the game or, o
importance, the pregame ceremonies when Gehrig,
later be known as Lou Gehrig's disease, gave his fan
speech. All he remembered was a miniature comme
brought home from the game. I was skeptical—aftei
most iconic moments in sports history—but Nana c
that when they arrived home and she asked about th
exclaimed: "Mommy, the man cried!"

I remember one story from his playing days th
out for the University of Kansas football team. This w
athletics and he was in over his head. He wasn't recru

so he was trying to make the team as a "walk-on." On the day he and his teammates got their equipment, he was handed a pair of cleats with "John Hadl #21" written in permanent marker on the inside of the shoes. John Hadl, a former Jayhawk, had gone on to become an All-Pro quarterback for the NFL's San Diego Chargers. Dad would say, "I filled John Hadl's shoes at the University of Kansas."

He had to quit when the aches and pains of daily practice made it difficult to get out of bed in time for class. There was a point at which he was forced to choose between being on the practice squad or his studies in aeronautics. He chose wisely. He chose his studies.

After leaving school, he started his career on the West Coast at the Douglas Aircraft Company. Two years later, he moved his family east to take a job at Singer Link Flight Simulation in Kirkwood, New York. This was the company that invented the flight simulator. On weekends he was a football referee for the local Triple Cities Jets Semi-Pro league. He took me to the games, and I stood on the sidelines watching him run up and down the field blowing his whistle while trying to avoid getting run over by 225-pound linebackers. For a father of four in his late thirties who worked a desk job, he was remarkably fit.

In the summer of 1973, we moved from the old house on Riverside Drive to a new suburban housing development in the nearby town of Vestal. It was only a few miles away across the Susquehanna River, but it was as if we moved to the future. Everything was new and uniform. Hundreds of identical ranch-style houses, each covered with the identical metal siding, sat at the end of identical driveways with identical manicured lawns.

Inside, there was linoleum tile and wall-to-wall carpeting, an automatic dishwasher, sliding glass doors, and a number of other "modern conveniences" that the old house lacked. The biggest curiosity was the automatic garage door. The day my parents closed on the house, we stood in the driveway and watched it go up and down. (My dad had the remote behind his back and he convinced Angus that he was operating it whenever he yelled, "Abracadabra!")

Our new home was part of the Stair Tract development that stretched across and over a small valley in what was known as the Vestal Hills. Its eastern border was defined by the City of Binghamton and the west by Harper College. If the surrounding hills and the nearby reservation were any indication, this must have been a beautiful spot before the development happened. I suppose you could say the same thing about the whole Triple Cities.

I grew up in a worn-out corporate town in upstate New York. The Triple Cities are Binghamton (a city) and Johnson City and Endicott (technically villages), located in the middle of southern New York State, on the border of Pennsylvania.

I love my hometown, but it's not the kind of place people live in by choice. You work there, or you grow up there, or you go to school there. My dad worked there. It's a conservative area, even though its roots are progressive. It's an underdog town, and in that regard it's lovable. Its big industry used to be the manufacture of shoes. It was the home of welfare capitalism and George F. Johnson's Square Deal. Much of the infrastructure was built in the early twentieth century to provide quality of life for factory workers. There are a lot of merry-go-rounds.

It's the birthplace of IBM and the spiedie, a delicious meat sandwich that none of us can believe hasn't caught on elsewhere.

The best day by far of the Pee Wee football season was the day we got our uniforms. Up to that point we had been doing what the coaches called "calisthenics"—conditioning exercises that included, but were not limited to, jumping jacks, deep knee bends, push-ups, arm circles, and squat thrusts. We all agreed: Calisthenics sucked, but we understood, especially the veterans (and by "veteran" I meant anyone who had survived at least one previous football season), that calisthenics were a requirement if one wanted to see the field on game days. These exercises were done en masse, in formation, by a whole team of ten-year-olds. We also did a lot of running. The sounds of whistles echoed all around as a dozen or so teams in lines snaked up and down the hills of Arnold Park.

I'm sure all of this looked absolutely adorable to the parents, but to us it felt more like the first half of Stanley Kubrick's *Full Metal Jacket.* I've never served in the military, but when I saw that movie for the first time as an adult, I flashed back to Pee Wee football, complete with a coach yelling in my face, "Come on, Sahre, let's see some hustle out there!" Not so adorable were the kids who threw up during the early sessions.

Near the end of practice a truck backed onto one of the end zones. After it came to a stop, the back door rolled up to reveal a mountain of football equipment. Our team jostled for position at the open end of the truck, and each player in turn was sized up by the equipment manager with a single head-to-toe glance and tossed a pair of shoulder pads and padded football pants. Next you were issued your jersey and matching socks. All of the teams in the Vestal Youth Football League (VYFL) were mini versions of actual NFL teams. Our uniforms were exactly like the ones the pros wore, only smaller.

Finally there was the helmet. Years before the idea of branding became something universally understood and practiced, first by large corporations and now by one billion people on Facebook, the NFL had figured out that it was advantageous to put team logos on either side of each player's head. In a more innocent time, before merchandising reached the obscene levels we see today, the league was only just beginning to find ways of putting team logos on merchandise, from pennants to knit hats.

I would sneak into my dad's bedroom and play with his complete set of official NFL team lapel pins he kept in the top drawer of his dresser. These were flat metal pins in the shape of the profile of a football helmet. I'd stick them into the carpet in order of their current standings.

I didn't even open the copy of *The Joy of Sex* in his top drawer until I was in my teens. By then, football lapel pins had lost out to drawings of people

having intercourse. As I turned the pages, I tried to comprehend why that beautiful woman would want to do all of those things with *that* guy. This dude was horrible looking, and he had a beard. The only people with beards then were Charles Manson and Jerry Garcia. I also noted that the renderings were not much better than what I was producing. I wondered whether the artist was working from photographs or drawing from the bedroom.

But that was a few years off. Ten-year-old me was focused on football logos, especially when they differed from whatever was current; I would contemplate the change and debate which version was cooler. This year, Angus was a Redskin, so the team logo was on my radar. The helmet pin had a spear running diagonally up the side instead of the Indian-head logo that I was familiar with.*

My helmet was beautiful, classic gridiron. It was bright yellow with broad green and white stripes running up the middle. It had the familiar football-shaped *G* logo of Vince Lombardi's immortal Green Bay Packers on either side. I grabbed the two round edges by the earholes and spread the helmet wide so I could fit it over the top of my head. It was snug in there and everything sounded different. I felt encased in a tiny world all my own. I snapped the chinstrap to the opposite side of the helmet. *Pop!*

I was Ray Nitschke and I was ready to run into something.

■

Angus and I—covered in mud and grass stains, helmets off—were standing near the snack stand at the edge of the park. Mom and Dad were a few yards away, talking intently. Whatever was going on between them, it

*Our family identified as part–American Indian because my father's great-grandmother was said to be a member of the Shinnecock Indian Nation. The Washington Redskins logo stood out for this reason. The year before, he had been a Bengal and I felt sorry for him. While he was spared from unwittingly participating in the further discrimination of Native American peoples that season, at the time I found the Bengals helmet to be generic, uninspired.

didn't look like we were going to get an after-practice popsicle. We were ready to go home. We had no idea that our lives were about to change.

My father had always suspected his day would come. His father, a postman from White Plains, New York, died unexpectedly of heart disease—as did his father before him. Uncle Carl, my dad's younger brother, was only eight at the time. My dad was twelve.

Turns out, Dad was experiencing chest pains at the park. Mom thought they should call for an ambulance, but he was determined to drive us home. After dropping us off, he drove himself to Wilson Hospital.

My younger brother was eight when all this went down, so the fact that family history was repeating must have weighed on Dad.

He was young, he was fit, he didn't smoke, but there was something wrong with his heart nonetheless. They diagnosed him with genetic coronary artery disease. He had high blood pressure and high cholesterol. The immediate concern was the blockages in the main arteries near his heart. He would need double bypass surgery as soon as possible.

Now I was Bart Starr, dropping back into the pocket and getting blindsided by Dick Butkus charging in unblocked on a red dog.

I didn't know what "genetic" meant. I knew I didn't have a second grandfather, but I didn't know the specifics. I remember being scared even though my parents kept saying everything would be alright.

It was hideous. Centered in the middle of his chest, it started a few inches above his bellybutton and ended at the top of his ribcage. It was so straight that it looked like the surgeons used a T-square. The swollen incision bore a resemblance to the raised stitching on a baseball. The stitches themselves were black and they contrasted with the pale white skin of my father's recently shaved chest.

Once it looked like he wasn't going to die after all, his scar was the first thing I wanted to see. Actually, there were two scars. The other one was on Dad's left leg going up the inside of his calf. While impressive, I didn't focus on that one.

My brothers and I were scar aficionados. We would compare and retell stories that led to the few we had accumulated. Angus was the family leader. He had more than Uncle Carl, and Uncle Carl was a former ice hockey goaltender in the days before they wore goalie masks. Angus had a nice one on his forehead, and one on his stomach from the time he had the hernia. Greg may not have had any scars at that point, a fact that must have nagged.

I had an unsatisfying dime-size scar on my inner arm from the time I was being Spider-Man. Humming the theme song from the cartoon, I attached a rope to the swing set in our backyard, walked up the wooden flight of stairs that led to our back porch, then I tied the other end of the rope to one of the large hooks that lined the outside of the porch (these often had a laundry line tied to them so I knew they were sturdy). I tested the rope to make sure it was taut and secure, climbed over the edge— intending to descend the twenty-five feet back to earth by means of my makeshift web line—and as soon as I put my weight on the rope, it gave

way and I fell. Then I wasn't falling. I wasn't humming the theme song anymore either. I was screaming my head off, hanging from the hook by my left arm, impaled just above the elbow.

Good story, lame scar.

Even my sister had one, but she didn't like talking about it. Hers was from the stitches she required when her bathing suit got caught on the automatic garage door. She was lifted, screaming and flailing, to the apex of the track, then the door let go, sending her crashing onto the metal garbage cans below.

Dad's open heart surgery cured us of our scar fetish.

After he came home from the hospital, we adopted Dad's low-fat diet. Gone were the days of beans and franks and tuna casseroles. We ate a lot more bananas. Mrs. Dash appeared. Salt disappeared. No more meatloaf, no more fried chicken, no more ground beef, so goodbye to Mom's goulash (and good riddance). This was also the end for Dad's popcorn. Every Sunday night he'd pop enough to fill a large paper grocery bag. Dad would vigorously shake the bag while one of us carefully poured in four melted sticks of butter, followed by the salt. Then he'd close the bag and continue shaking until his arms got tired.

As time passed, his chest hair grew back and the scar receded a bit. It became lighter in color than the surrounding skin, but it was always there. In *All the Pretty Horses*, Cormac McCarthy writes, "Scars have the strange power to remind us that our past is real." Maybe it was because of where it was located, but every time I saw it, Dad's long vertical scar was a reminder that I had almost lost him.

My father wasn't sad. If anything he was the opposite: good-natured, excitable, a person who loved being a dad. But his near-miss made me think of what it must have been like for him to grow up without *his* father. He must have always had a scar in that location, only now it was visible.

Four Eyes

As my third-grade class picture indicates, I was a proto-hipster. But unlike today's class of cool kids, glasses were never really a choice for me. I am extremely nearsighted. Four-eyes comments aside, when I put on my first pair, I couldn't believe how much detail there was in the world.

There was complexity everywhere. Suddenly clouds had finite edges, I could read words on distant signs, and I could see that there were planes way, way up there. It was fall. Driving home from the optometrist, I kept telling my mom, "I can see the leaves in the trees!"

Schmaltz

My dad gave me my one and only nickname. He would come into the kitchen and say, "Hey Schmaltz!" I really liked it when he did that, especially since my brothers and sisters didn't have nicknames. I, however, was *Schmaltz*. At a certain point, he stopped calling me that, I guess when I got older. I always thought he made that word up just for me.

I was in a grocery store, as an adult, when I noticed a curious brick of gelatinous, putty-colored something or other. Wondering what this disgusting product was, I turned it over to look at the label. It was rendered chicken fat, or *schmaltz*.

Thanks, Dad.

I was a bed-wetter.

As I neared my eleventh birthday, I didn't have sleepovers like everyone else. Traveling was difficult. No summer camp. Not to mention that I lived in fear that Angus would rat me out to one of our friends.

Then there was the frustration and the guilt. My parents had been pretty understanding about the whole thing, but their nerves were beginning to fray. I caught my mom crying in front of the washing machine once. They finally decided to check to see if there was a medical reason for my bed-wetting. First, there was the doctor visit, where all I had to do was pull down my pants and cough. Then came an overnight stay at the hospital for tests. My most potent memories of this experience were the nausea, the terrible burning sensation in my groin, and the comically large packs of Wrigley's Spearmint gum being carried around on the hospital room TV overhead. "Carry the big fresh flavor!" But mostly I remember how weird it felt to be sleeping away from home, alone.

When the results of the tests came back negative (meaning there was nothing *physically* wrong), my parents turned to something new: a bed-wetting alarm. This device buzzed when the metal pad I slept on got wet. This woke me up.

Within a few weeks the problem was gone. Totally gone. I was free.

If you are a person with this experience in your past, you may have some lasting psychological issues—like, for example, an aversion to an iPhone in your pocket set on vibrate.

Larry Csonka vs. Kareem Abdul-Jabbar

I had two posters on my side of the room. On the left was the Zonk, the hard-nosed fullback of the Miami Dolphins. Larry Csonka was the prototypical football player of the era: tough, thick-necked, and smeared with eye black. On the right was Kareem Abdul-Jabbar, the 7'2" center for the Milwaukee Bucks. Though I was shorter than most people I played against in pickup games, I perfected my skyhook. The poster showed Kareem shooting over a helpless Wilt Chamberlain.

Kareem and the Zonk both hung there, vying for my attention.

Chuck Klosterman once wrote, "Former Dallas Cowboy quarterback Roger Staubach is my hero; this is because whoever is your hero when you're nine remains your hero forever." That is, unless your hero defects to the World Football League. Following the Dolphins sickening defeat to the Oakland Raiders in the infamous "Sea of Hands" playoff game (December 22, 1974), I left the TV with tears in my eyes, walked calmly to my bedroom, pulled the poster on the left off the wall, and ripped it into a million pieces. I didn't do this because *they* lost; I did it because *I* lost one of my heroes. It was announced before the game that Larry had signed a lucrative contract to play the following year in the newly formed WFL. He was leaving the team for money.

This left only the poster of Kareem. It stayed there for years. Kareem never disappointed me. When he forced his way out of Milwaukee (at almost the same time Zonk got the money he probably deserved), I switched teams and became a Lakers fan. He appeared in the movies *Airplane!* and Bruce Lee's *Game of Death.* When I was a kid, I didn't know he had changed his name from Lew Alcindor for religious reasons, I just thought his name was cool.

Since his playing days, Kareem has become a writer and is politically active as a Muslim American in the aftermath of 9/11. He was recently named Cultural Ambassador for the United States.

Larry Csonka hunts moose.

Not too long ago, after years of searching, I found the Csonka poster online. It's now in a flat file with my Kareem poster. I didn't buy it because my inner nine-year-old forgives him (he doesn't); rather, of the hundreds of posters I have collected (and designed) since, I have spent the most time staring at these two.

Hockey came to Binghamton in the early '70s. Like the rest of the town, my father had no previous experience with the sport other than watching the occasional NHL game on TV. No matter, we got season tickets, and Dad immediately volunteered in an official capacity as the team statistician.

The Dusters would play in the brand-new five-thousand-seat Broome County Veterans Memorial Arena. Interest quickly grew and, by mid-season, every Dusters home game was sold out. The sport was fast-paced and exciting, players chasing after a small black puck that bounced off the plexiglass that enclosed the playing surface. Unlike watching a game on television, violent collisions between players could be "felt" by the spectators in the stands, as could the punches that landed on every unshaven chin. Altercations between two or more players would escalate, both benches would empty, as all the players stormed onto the ice, each finding a "dance partner" on the opposing team. With upwards of forty players on the ice grabbing, punching, and gouging, there was little the referee and two linesmen could do, so these fights would sometimes go on for twenty minutes before order was restored. Fans would be on their feet cheering, beer and popcorn was thrown into the air, mingling with cigar smoke. I'd stand on my seat in a futile attempt to see who was getting the better of whom. My mom, unfazed, would sit there . . . crocheting. It was professional wrestling, only on ice and with real blood. Any number of colorful characters, almost all of whom were Canadian, played at the Arena. Dusters players (the good guys) included "Terrible" Ted McCaskill, the minor league tough guy with a thick mustache and a comb-over. Opposing players (the bad guys) were "Gypsy" Joe Hardy, who scored an unthinkable two hundred points in one season; the

Carlson brothers (Jeff, Jack, and Steve), who played on the same line together and all wore thick horn-rimmed glasses; and Bill Goldthorpe, the worst "goon" ever seen in professional hockey.

A booster club was organized, youth leagues started up, and I (and everyone I knew) started playing hockey. The Dusters players became local heroes and would visit schools and sign autographs and come to your house for dinner. The fact that the team had a losing record didn't matter, or maybe it made them all the more lovable. Hockey fever had gripped the Triple Cities to such a degree that by the end of the first season, Binghamton was calling itself "Hockey Town, USA."

▲

After the first season ended, my father volunteered to create the first Dusters Yearbook and began organizing the massive amount of press and statistics from the season. He was the team statistician, the one with all of the information, and more importantly, *he wanted to make this thing*. He had never done this before, so he recruited my mom, who had some background in art.

They did all of the layout and production themselves, setting the type with the IBM Selectric in the Dusters office at the Arena.

Armed with scissors, Scotch tape, and glue, they did the rest of the work at home on an improvised light table that my dad made out of our old Magnavox. He hollowed out the inside of the TV, replacing the picture tube with a table lamp. In a process that would later become my process, they labored in the den—what my dad called his home office—

Blazers beat Duster

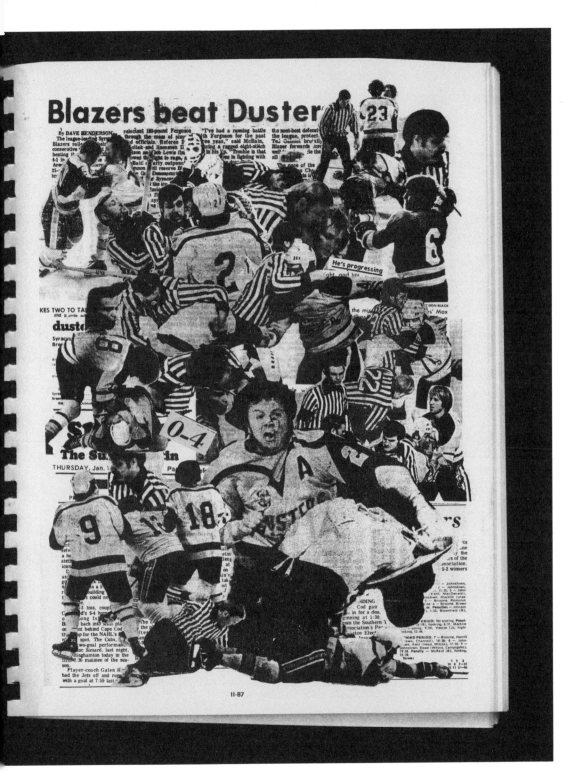

hunched over, endlessly cutting and pasting above a glowing box. When they finished, Dad sent off the stack of crude paste-ups ("mechanicals," I would later know them to be) to the printer. About two weeks later, the advance copies arrived at our front door. Dad tore open the box and the smell of fresh ink on paper greeted us. With a big smile, he handed us copies of the official *1974–75 Broome Dusters Yearbook*, compiled by Ken (and Elaine) Sahre.

The yearbook went on sale at the Arena in late November. While driving to New Jersey to my grandparents' house for Thanksgiving, my father stopped at a truck stop and used the pay phone to see how it was being received back home. He jogged back to the car and said, "It's selling like hot cakes!"

●

My father had gotten word that they were making a movie about all of this starring Paul Newman. A number of Dusters players were going to be extras in the film, including our best player, Rod Bloomfield, who was to be Newman's double. It was called *Slap Shot*.

New York City was a three-hour drive from my front door, but it might as well have been the moon. We never went near the place, even though my father grew up in White Plains and my mom in Morristown, New Jersey.

First contact with my future home was made during a sixth-grade class trip in 1975. As we neared the city, the view outside the bus became more and more bleak. Bombed-out buildings and abandoned cars along the side of the road signaled our approach. I stepped off the bus onto the cold gray concrete, and I imagined I was Neil Armstrong. "That's one small step for man . . ."

Our class broke up into small groups with parents serving as chaperones. My father led me, my best friend Dennis, and an odd kid (with retainer) named Jeff Sents into the unknown. We wandered around Manhattan for two days, climbing to the crown of the Statue of Liberty and visiting the United Nations while dodging mountains of garbage bags and homeless people sprawled out on the Bowery. My father told us not to look up because this would indicate that we were tourists (as if the camera and binoculars hanging from his neck weren't already giving us away). So Dennis, Jeff, and I turned our attention to the sidewalks, looking for interesting things blowing around with the rest of the trash. Jeff was collecting business card–size images of naked women with phone numbers printed on them, Dennis was looking for anything sports related, and I found a pamphlet called *Welcome to Fear City* that had a line drawing of the Grim Reaper on the cover. It was filled with recommendations for surviving our trip to NYC, including:

DON'T GET ON THE SUBWAY

and

STAY OFF THE STREETS AT NIGHT

When I showed this to my father he said, "Don't worry, that is only meant to scare people." *It's working*, I thought to myself.

That night I was lying on a cot in front of the door of our base (hotel room), staring at the row of chains and locks that was keeping whatever was outside from getting in. As I tried to fall sleep, I attempted to make sense of the dissonant sounds outside. "Dad," I asked, "Why would anyone live here?"

I walked in through the garage like I always did when going to Doug's house. His brother Danny was in there shooting baskets. (They installed a hoop *inside* the garage, instead of outside in the driveway like everyone else. It was a one-car garage, so you could only do layups or bank shots off the ceiling beams.)

"Where's Doug?" I asked and Danny informed me that he was grounded "forever." Their mother, Mrs. Skinner, wouldn't even let me say hello. When I asked what he had done, Danny pointed to the metal garbage can in the corner. It was filled with shards of black vinyl along with bits of torn album covers that had once served as protection.

■

Other than an old box of 45s and my parents' pathetic LP collection,* there wasn't much music available at home, so I spent a lot of time at friends' listening to records and studying the covers.

Doug had all kinds of illicit music that no one else our age knew existed (or would dare bring home even if we did). This was especially ironic because the Skinners were *strict* Baptists.

We would listen to Boston or Peter Frampton until his parents left the house, then we'd break into Doug's private stash, hidden under his bed. Each record was a 12" crack in our suburban veneer. We listened for

Victory at Sea, Volumes 1–3; Moog—*The Electric Eclectics of Dick Hyman*; Mike Post—*Railhead Overture*; Gordon Lightfoot—*Summertime Dream*; The Hollywood Bowl Symphony—*The Grand Canyon Suite*; Bing Crosby—*Songs of a Lifetime*; Arturo Toscanini—*The Nutcracker Suite*; *Nat King Cole Sings for Two in Love*; Eddie Fisher and Debbie Reynolds in *Bundle of Joy*; Tony Schwartz/ Dwight Weist—*The New York Taxi Driver*; *Glen Campbell's Greatest Hits*

swear words, spun records in reverse searching for hidden messages, and stared at album art.

By the looks of the garbage can and its contents, Mrs. Skinner had been under Doug's bed and this was divine retribution.

As I sifted through the pile of smashed vinyl, I could almost tell how upset Doug's mom was with a particular recording: the smaller the fragments, the more terrible the sin.

Black Sabbath—*We Sold Our Soul for Rock 'n' Roll*

Minimal, black cover. No imagery. Red typography (60 pt. uppercase Futura Extra-Bold Condensed). The Ss in the title are replaced with geometric lightning bolt shapes. The title is center-aligned and set on three lines occupying the top half of the album cover. The Ss create a symmetrical triangle pattern, the S of "Sabbath" is the apex, and the Ss from "Sold" and "Soul" form the base. The gatefold opens to reveal a stylized photograph of a woman lying in a pink-lined, mirrorball-edged coffin. She is heavily made up with black eyeliner and lipstick, hair pulled back in a tight bun. She is not dead. Her eyes are open, gazing outward but not at the viewer. She is wrapped in black shear and holding—or maybe impaled by—a glowing cross. It's hard to tell because the woman's left hand is obscuring the point of contact between abdomen and cross.

It's not surprising that Mrs. Skinner destroyed this album, but if you haven't experienced it, play record one (sides one and two) as loud as possible. While you are doing this, imagine that you are twelve years old.

AC/DC—*Dirty Deeds Done Dirt Cheap*

A group of people standing in a hotel parking lot. The signage and palm trees indicate this is probably Los Angeles. There is a grandma, a doctor, a man in a leisure suite, a biker, and a doberman. All the people (but not the dog) have a black censor bar placed over their eyes. The landscape photograph bleeds off the left and right sides of the cover. The top and bottom are gray and appear to be close-up images of asphalt. "AC/DC" is set in a typeface similar to Dom Casual. It is 115 pt., centered within the top bar and set in pink (outlined and with drop-shadow). The title of the album is set in a slab serif typeface (possibly Stymie) and is centered at the top edge of the lower gray bar. The type is printed in black ink on a white rectangle.

While it suggests censorship, the album art isn't really the problem—it's the music. The song titles alone would have led to this album's demise: "Dirty Deeds Done Dirt Cheap" (a song about for-hire murder), "Squealer" (a song about having sex with a virgin), "Big Balls" (a song about big balls), and "Love at First Feel" (a song about falling in love while having sex with an underage girl when her "mum and dad ain't home").

Queen—*News of the World*

This cover features a particularly disturbing painting of a huge metal robot holding the four members of Queen. The band is dead or unconscious and Freddie Mercury is bleeding from the abdomen. The robot has blood dripping from its left middle finger, indicating the source of Mercury's injury. The robot has a curious look on its face, as if it's trying to understand the appeal of these small, fragile beings who play this thing called rock music. The band name and title appear at the very top above the robot's head, centered and set all caps in Umbra. The title is a smaller point size than the band name and is letterspaced liberally so that it extends the entire width of the cover. The background is a bright green, nondescript environment. The image continues on the back cover gatefold, revealing more of the robot's torso and legs, as well as showing drummer Roger Taylor falling to his death. Directly below him is a crushed concrete and rebar structure of some kind—an arena, as it turns out, once you open the gatefold.

As far as I can tell, the problem in this case was solely the art. With songs like "We Are the Champions," "Spread Your Wings," and "We Will Rock You," nothing seems remotely objectionable. Even "All Dead, All Dead" is harmless. It's a song about the passing of a childhood cat.

The Jimi Hendrix Experience—*Electric Ladyland*

Color photograph of nineteen naked women, sitting/laying/lounging on a black cyc wall. All of the women are looking directly at the camera and three of the women are holding Jimi Hendrix LPs. The album title is set in 22 pt. Franklin Gothic Bold. The type is knocked out to white and is flush right-aligned in the lower-right corner of the cover.

Ditto. It was the album art. I don't think we even listened to this record.

Led Zeppelin—*Houses of the Holy*

Another gatefold, this one involving adolescent nudity. Eleven naked children climbing an ancient ruin—in reality, it is a photographic collage of just two children. The psychedelic image feels unreal. The figures toiling up the structure are pale, the rocks are green, and the sky is orange. A glow emanates from the top of the rock pyramid and seems to be the goal of the climbers. The image extends to the back cover.

 Inside the gatefold there is another image of the top of the structure the children on the front were climbing. The sky is now blue. Two pale figures (one standing, one not) seem to be engaged in a human sacrifice.

 There is no typography anywhere on the interior or the exterior of this album sleeve.

There was a rumor going around that the underage models on the cover photograph were Robert Plant's children, and that they had both died unexpectedly after the album was released—victims of the band's obsession with the occult. As this was the '70s, there was no Internet, so this could not be confirmed.

The Sex Pistols—*Never Mind the Bollocks, Here's the Sex Pistols*

The cover employs contrasting colors (fluorescent green and pink). The title appears to be letterpress typography, with subtle imperfections in alignment and spacing, alternating between a bold condensed gothic and condensed serif typefaces.

I consider this to be one of the greatest album covers ever, but at the time I didn't appreciate it. It just looked "British" to me, and not in a good way. The punk aesthetic was brand new so the only thing I could relate it to was a ransom note.

Kiss—*Alive!*

Full-bleed photograph of the band performing live: smoke bombs, stage lights, Kabuki-style makeup, and black-and-silver costumes, plus the KISS (Knights in Satan's Service?) logo in lights above the band. The only typography on the cover is the word ALIVE!, positioned in the extreme upper-right of the cover and set in 32 pt. Stencil Bold. It's an active

photograph, with the band and their instruments leading the eye around the composition. On the back cover the camera has been turned toward the audience. Two long-haired teens hold up a handmade KISS banner, a packed Cobo Hall in Detroit as the backdrop.

It wasn't just Mrs. Skinner—*all* parents were terrified of this band.

Devo—Q: *Are We Not Men? A: We Are Devo!*

Airbrush illustration of a tanned white male, wearing a leisure hat. He is superimposed on a large, golf ball motif. Handwritten in purple crayon in the upper left, at a 25-degree angle, is "Q: Are We Not Men?" Down the right-hand side, set in 240 pt. Helvetica Bold:

D
E
V
O

Each letterform is outlined in black and filled with a different color (D: red, E: green, V: yellow, O: blue). There is a curious stamp just above the brim of the man's hat that reads: ACTUAL SIZE

There was only one adjective used to describe DEVO: Weird. For us, this was a good thing; for Doug's mom, apparently not.

Rolling Stones—*Sticky Fingers*

A monochromatic, high-contrast photograph of a person in tight jeans. The image is cropped to emphasize the functioning zipper that is glued into the middle of the cover. The zipper is revealed via a die-cut that extends to the top of the belt. The bulge to the left of the zipper indicates that this person is male. The title and band name are randomly placed in the upper left of the image in red. The type is 36 pt. all caps and is set in an unidentifiable bold, serif typeface that has been distressed.

The back cover is a rear view of the male figure on the front cover. The interior is the same person, sans pants.

The follow-through of this Andy Warhol concept is admirable. Zipping and unzipping an album cover is pretty satisfying.

Aerosmith—*Live Bootleg*

The cover art appears to have been created with rubber stamps. All the typography and graphic elements are randomly placed. A light teal-colored, striped pattern runs diagonally across the entire cover and wraps around to the back cover. This pattern is translucent; it surprints a light yellow solid and a solid area of pink that runs at an angle along the bottom third of the cover. AEROSMITH LIVE is set in 86 pt. Gil Sans Bold Condensed and is contained in a 12 pt. rectangular rule with an inner 3 pt. rule defined by the length and height of the typographic grouping. The type and the frames are interrupted roughly in the middle of the T in AEROSMITH—as if an imperfection of the paper stock was the cause. The whole unit is shifted about 8 degrees clockwise. The band logo is in the lower-right third of the cover and is 5" wing tip to wing tip. It is slightly angled counterclockwise. The word BOOTLEG is set in 72 pt. Stymie below the logo and is repeated at a slightly different angle as if it were stamped twice.

At the time I wasn't sure why this album had been excommunicated. "Why Aerosmith?" I asked Danny, who was still dribbling.

He shrugged, as confused as I was. "My mom said it was because of the song 'Back in the Saddle.'"

What did Mrs. Skinner have against cowboys?

Adventure

It was the middle of the day, early July 1981. School was out. Instead of playing outside, I was in the den. The curtains were drawn, sunlight was sneaking in around the edges of the window frame, and I was staring at the glowing screen of our Tandy TRS-80 microcomputer.

THE COUNT

S START THE GAME
R RESTORE A SAVED GAME
C SHOW CREDITS
I INFO ABOUT PLAYING
Q QUIT

I type S

<--->
I'M LYING IN A LARGE BRASS BED
OBVIOUS EXITS: NONE
VISIBLE ITEMS: SHEETS, PILLOW
<--->
I SEE I WAS PUT TO BED. IT'S AFTERNOON & I OVERSLEPT!
I'VE A HUNCH I'VE BEEN ROBBED! MY NECK LOOKS BITTEN!
WHAT SHALL I DO? _

I type: FIND DOCTOR

I DON'T KNOW WHAT A "DOCTOR" IS.
WHAT SHALL I DO? _

I type: BAND AID

I DON'T KNOW WHAT A "BAND" IS.
WHAT SHALL I DO? _

I type: FORGET IT

I DON'T KNOW HOW TO "FORGET."
WHAT SHALL I DO? _

I type: GET UP

OK.

<--->
I'M IN A BEDROOM
OBVIOUS EXITS: NORTH
VISIBLE ITEMS: SHEETS, CLOSED WINDOW, BRASS BED
<--->

WHAT SHALL I DO? _

I type: OPEN WINDOW

OK.
WHAT SHALL I DO? _

I type: GO OUT WINDOW

I DON'T KNOW WHAT A "OUT" IS.
WHAT SHALL I DO? _

I type: GO WINDOW

I CAN'T DO THAT YET?
WHAT SHALL I DO? _

I type: HELP

TRY EXAMINING THINGS.
WHAT SHALL I DO? _

I type: EXAMINE BITES ON NECK

I AM CARRYING: TWO SMALL HOLES IN MY NECK.
WHAT SHALL I DO? _

I type: DOES IT LOOK INFECTED?

I DON'T KNOW HOW TO "DOES."
WHAT SHALL I DO? _

I type: EXAMINE WINDOW

I'M UP IN A CASTLE, IN THE DISTANCE I CAN SEE VOODOO
CASTLE. THERE'S STANDING ROOM OUTSIDE THE WINDOW.
WHAT SHALL I DO? _

I type: GO WINDOW

I CAN'T DO THAT YET?
WHAT SHALL I DO? _

I type: OPEN WINDOW

OK.

<--->
I'M IN A BEDROOM
OBVIOUS EXITS: NORTH
VISIBLE ITEMS: SHEETS, OPEN WINDOW, BRASS BED
<--->

WHAT SHALL I DO? _

I type: GO WINDOW

OK.
<--->
I'M ON A LEDGE OUTSIDE AN OPEN WINDOW
OBVIOUS EXITS: NONE
VISIBLE ITEMS: FLAG POLE IN WALL
<--->

WHAT SHALL I DO? _

I type: EXAMINE FLAG POLE

I SEE NOTHING SPECIAL.
WHAT SHALL I DO? _

I type: FLY AWAY

I DON'T KNOW WHAT "AWAY" IS.
WHAT SHALL I DO? _

I type: FLY TO VOODOO CASTLE

I DON'T KNOW WHAT A "TO" IS.
WHAT SHALL I DO? _

I type: FLY VOODOO CASTLE

I DON'T KNOW WHAT A "VOODOO" IS.
WHAT SHALL I DO? _

I type: YOU'RE THE ONE WHO MENTIONED VOODOO CASTLE

I DON'T KNOW HOW TO "YOU'RE."
WHAT SHALL I DO? _

I type: FLY CASTLE

I CAN'T DO THAT YET.
WHAT SHALL I DO? _

I type: YET?

I DON'T KNOW HOW TO "YET."
WHAT SHALL I DO? _

I type: FUCK SELF

I DON'T KNOW HOW TO "FUCK."
WHAT SHALL I DO? _

I type: JUMP

OK.
I FALL TO MY DEATH.

AS I FALL I NOTICE A DARK WINDOW UNDER THE BEDROOM
WINDOW LEDGE!

YOU HAVE LOST! THIS ADVENTURE IS OVER.
DO YOU WANT TO TRY THIS ADVENTURE AGAIN? _

I type: N

I turn off the computer and head outside.

Ms. Hayes rolled the 16mm projector into class and announced, "Today we are going to watch a film based on a short story by Shirley Jackson." As the lights went out, I shifted my weight a bit in the hard plastic seat/ desk combo. The countdown of the film leader ended abruptly with a *blip!* A deserted street and vacant lot now glowed on the screen. A lonely dog barked.

The title appeared—*The Lottery*—and the motorized *clack, clack, clack* of the projector dominated the room. Then came the warning:

THE FOLLOWING IS FICTION.

I looked over at my friend Anand who sat in the row next to me. He nodded and turned back to the screen, his face lighting up. Did he know what was coming?*

The lights came back on. Everyone was squinting. Everyone was freaked.

There was a discussion about themes. Ms. Hayes kept talking about tradition and rules and randomness. I raised my hand, frustrated. "It's not about any of that," I said. This was the first time I had raised my hand in English class all year. "I think it's about . . ."

The bell rang. We all got up and blindly headed to our next assigned group activity.

*All of the townspeople are gathering in the lot. Children are running around collecting rocks. A large black box is brought out and slips of paper are drawn from it. On one, we see a black spot. A woman named Tessy is holding it. She has won the lottery . . . and she doesn't seem happy about it. Close-ups of hands picking up rocks. Then the townspeople, including her own family, stone Tessy to death. The End.

My First Car

In the middle of my senior year at Vestal High School, I made my first major life decision: I bought my first car.

The only car I had ever driven up to this point—*the day* I turned sixteen—was a mustard-colored Ford Maverick. This was the family's second option, meaning this was the car my mom, my brother, my sister, and I drove. None of us were allowed to drive my dad's new Ford Taurus. My dad bought the Maverick, used, as a cheap second car. It spent the first ten years of its existence plowing through the winters in upstate New York. It was a beater. It was manufactured in 1968 and replaced my mom's "baby," a black Volkswagen Bug, after the rust overtook it. My parents bought the Bug when all of the kids were finally in grade school and she was able to resume her career, part-time, as an occupational therapist at Binghamton Psychiatric Center.

I was too young to drive the Bug, but I loved the way that car sounded, with its engine where the trunk should have been. I didn't know the Volkswagen was Hitler's idea, I just grew up thinking of our Bug as a minor celebrity. The origin of KdF-Wagen—or *Kraft durch Freude* (Strength through Joy)—had long since been replaced in the American consciousness by Herbie from *The Love Bug* movies. We thought of our Bug as a person.

My dad did most of the repairs on that car himself, in the driveway. I'd sit there looking at the illustrations in his *How to Keep Your Volkswagen Alive: A Manual of Step-By-Step Procedures for the Compleat Idiot* and hand tools to him like an assistant in surgery. "Wrench . . . Screwdriver . . . Chickenwire . . . Bubble gum."

The Maverick had no dark history or Hollywood charm. It was just a car, which is all it needed to be. The problem was that it was never available. With four of us driving, it was rarely in the driveway. I had a girlfriend at the time, so not having a car on demand was a problem. This was sufficient motivation for me to scrape together the money for a car.

I bought a used bright-yellow AMC Gremlin.

You aren't familiar with the AMC Gremlin? Along with its cousin the Pacer, the Gremlin was (and still is) relentlessly ridiculed. In fact, *Time* magazine called the Gremlin "cheap and incredibly deprived . . . awful to drive," adding that it "handled terribly due to its odd proportions." They conceded that the Gremlin's six-cylinder engine made it quicker than other subcompacts, but with the caveat that "that only meant you heard the jeers and laughter that much sooner." The Gremlin was also, rather unfortunately, named after a mythical, mischievous creature that sabotaged machinery. The AMC Corporation preferred its own tagline: "A pal to its friends and an ogre to its enemies." This clever bit of marketing did not influence my purchase.

The Gremlin was first introduced on April Fools' Day, 1970. Not a good omen if you are the type of person who believes in such things. Missing the joke, *Newsweek* magazine put it on the cover accompanied by the headline "Detroit Fights Back: The Gremlin, American Motors' New Sub-Compact." It was the first subcompact, smaller than a midsize car like a Dodge Dart but bigger than a compact like the VW Bug. It had a large (for its size) engine and a three-speed manual transmission (you read that correctly, a three-speed).

The story behind the design of the Gremlin goes that it was an on-the-fly retrofit of the AMC Hornet (a midsize car already in production), only with a shortened tail. The Gremlin was born out of an urgent design need, responding to pressure to be the first American car that could compete with any number of smaller compact foreign cars on the US market. The result was not perfect, but it was affordable, unique,

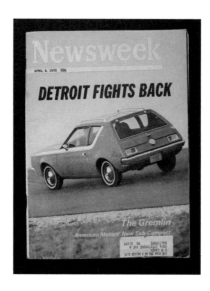

and succeeded in beating GM and Ford to retail by six months. At least partially due to this fact, the Gremlin was initially a success, becoming AMC's bestselling car at the time.

I, of course, was unaware of any of this. I bought that car for three reasons: I had enough money to buy it (I paid $400 for it in 1982), it had less than 100,000 miles on the odometer, and I liked the way it looked.

American Motors

The AMC logo was the first logo other than a sports team or a band that, with it's hidden "A," registered with me. At the time I wasn't able to appreciate the problem-solving that went into the Gremlin's design. I thought it looked like a futuristic squirt gun. It was quirky. Most importantly, after I handed over the money, it was *mine*. I think I may even have slept in it that first night.

This was my first big decision and it was predominately decided by aesthetics. I would have been happy with a Porsche 914—my car crush

during that period—but I also would have been happy playing right field for the New York Yankees instead of my high school team. The Gremlin was better than the Ford Pinto, the other car I was considering (that I could afford). Whatever its shortcomings, at least the Gremlin didn't explode when rear-ended.

What I didn't know was that by the time I owned one, the Gremlin had not only fallen out of favor, but was also well on its way to becoming an all-time automotive laughingstock. There were still Gremlins on the road, but every last one of them was beginning to rust. To remedy this, I set out to repair the body the only way I could afford: by doing it myself. So I got a how-to book and followed the instructions. I sanded. I cut out the rusted areas. I applied generous amounts of Bondo. I sanded again. I primed. I even repainted the whole car in my parents' garage (it didn't look showroom new, but it could almost pass). I installed a moderately priced but powerful cassette player in the thing, cranked up the Ramones, and drove and drove and drove. The feeling of independence that a seventeen-year-old experiences alone and behind the wheel cannot be underestimated. I learned to drive in that car.

I learned to "park" as well. Most of what constituted driving with my girlfriend was looking for good places to make out. I preferred somewhere private but not too private, having spent my entire newspaper delivery career reading headlines during the Son of Sam murders back in 1976–77.

I fixed something only when I absolutely had to, and when I did, I used the DIY approach. By the time I drove the Gremlin to the scrap yard six years later, I had developed dozens of ingenious workarounds when I couldn't afford a repair. Wire coat hangers held the muffler in place and duct tape held up the overhead dome light. The manual transmission came in handy during a number of dead battery and faulty starter situations. All I had to do was park on hills or on level ground with a few friends ready to push. If the car wouldn't start (which happened often), I would get the car rolling in neutral and pop the clutch. After

lurching a few times, it would start right up. Relying on this technique was challenging, but it was eminently more satisfying than starting up a car in the conventional way.

It seemed that no aspect of this car was without some issue. Take the gas cap for instance. No matter how many times I replaced it, it kept getting stolen. The Gremlin did have a terrific gas cap. It featured the trademark Gremlin character: Proud but mischievous, he (she? it?) stood, hands on hips, with pointy ears, pointy shoes, and bulging eyes. The problem was that the cap was out in the open, on the rear of the car, and was apparently cool enough to keep getting stolen. At least that's what I thought at the time. I must have replaced it four or five times, eventually opting for a more generic version, with a lock, to end the cycle.

▲

By the fall of 1988, I had finished my BFA, started my MFA in graphic design at Kent State, and put another 150,000 miles on the car. Aside from all of the mechanical problems, that meant it had over 250,000 miles on the odometer, far beyond what the engineers at AMC could have imagined. In the end, my Gremlin even outlived the company that made it (the American Motor Company was dissolved in 1987). By that time, the

brakes were shot and the rust had returned with a vengeance, creating holes in the floorboards so that driving through puddles meant wet feet, just like Mom's "baby" before it. It was time.

The day before I drove it to the junkyard—where it would be stripped for parts and unceremoniously salvaged for scrap by the cold hands of strangers—I threw a party for it, though it was more like a wake. I parked the car in front of my house on East College Street, invited all my friends, and filled the back hatch with ice and deposited a keg of Hamm's. The Gremlin had been demoted (or promoted, depending on how you look at it) to beer cooler. We shared stories, like getting stranded along Route 17 during a snowstorm or the time I lost my virginity at the V Drive-In Theater. This was its sendoff. I miss that car, no matter what *Time* magazine has to say about it. Not too long ago, I was in a Target and noticed that even Pixar was piling on. Grem, a character in the movie *Cars 2*, was cast as a villain. The Gremlin was not a villain.

It seems to me that critics apply criteria that doesn't take into account the context of the car and the decisions that went into its design. The same qualities that appealed to me appealed to hundreds of thousands of owners. The Gremlin was designed to satisfy a certain set of parameters within a specific time frame. It was not designed to be "timeless" or "high performance." Getting the car into production as fast as possible, and making it as affordable, fuel-efficient, and stylish as possible, were the most important parameters to be satisfied. It was quirky because of the situations involved in its design. Based on these criteria, the Gremlin should be on the *Best*-Designed Cars list. I take some solace in the fact that the Gremlin has begun to acquire a "cult-like following in today's collectible car market."* This makes total sense to anyone who drove one.

*According to Wikipedia anyway.

PART II
(Order)

"Kent State"

I drove the Gremlin out to Kent, Ohio, in the fall of 1984. I had been admitted to Kent State University that summer, and I was finally out of my parents' basement. I was a resident of my first college dorm, still in a bunk bed, only now instead of Angus, my roommate was a serious but friendly kid from Youngstown named Jim Stemple. Jim, like others attending Kent that fall, had a dad who worked for General Motors at the big plant in nearby Lordstown.

My decision to attend Kent State University was a function of my college checklist (in order of importance):

- A college with a good graphic design program.
- A college that would accept me.
- A college that was far enough away to prevent my parents from dropping in unexpectedly.
- A college that WAS NOT the University of Kansas (the alma mater of both of my parents and where my sister was currently enrolled).

Kent State University met all those criteria. DEVO went to Kent State, so did Jack Lambert, but I had heard of it for a different reason. To the outside world, "Kent State" is a terrible event in American history, not a place of higher learning. It's because of what happened there on May 4, 1970, when members of the Ohio National Guard fired on students during a protest of the Vietnam War. (At that time, I would have been tucked safely into first grade at Theodore Roosevelt School in Johnson City, New York.) To me, it seemed like a radical place to go to school.

Locals call it "May 4," as it would be difficult to work or go to school at a place reduced to "four dead in Ohio." I realized this only when friends back home started saying things like, "I hear your school has a good rifle team," when I told them where I was studying. I preferred, "Can't read, can't write, Kent State," only because it wasn't about kids getting shot.

When I arrived in the mid-1980s, the university was just beginning to figure out how to address May 4. There was an annual candlelight vigil in the Taylor Hall parking lot, where each of the students fell, but there was no permanent memorial.*

*There were a couple of unofficial memorials: what was left of *Partially Buried Woodshed,* an earthwork by artist Robert Smithson, and *Solar Totem #1,* a metal sculpture by Don Drumm that was pierced by one of the bullets fired by the Ohio National Guard. The artist insisted that the hole not be repaired.

Incoming freshmen were required to take an orientation class and this is when most of us learned about what happened that day, whether we wanted to or not. I was surprised to find that most of my new classmates didn't seem interested. Sitting in that lecture hall, my morbid curiosity about the event evaporated. I quickly learned that this school was anything but radical. Most Kent State students were from northeast Ohio and had decided to go there because it was close to home and because it was affordable. Many were the first in their families to go to college. They were not there to rebel. They were there to get a college degree and do the occasional beer bong. A few were there only to do beer bongs.

My first design class at Kent State was in the art building, just off the Commons area in the middle of campus. The class was called Visual Organization I, or Vis Org I. My teacher was a shaggy grad student named Bob Aufuldish. "This is the most important design class you will take here. It's the foundation for everything you are going to do as a designer. I don't care what is happening in your other classes, this class takes priority."

Then came the paperwork.

ART SUPPLY LIST

These supplies were mandatory:

> Rapidograph pens and ink
> Ruling pen
> T-square
> 24" metal ruler (cork backed)
> Haber rule
> Schaedler precision rule
> Hot press illustration board
> Gouache, black and white
> Paint mixing tray
> Brushes
> Pencil sharpener
> Assortment of drawing pencils

Art gum eraser

Blending stump

Paint mixing tray

Rubber cement

Rubber cement thinner

Rubber cement pick-up

Masking tape

White drafting tape

Dusting brush

Black match paper

Drawing pad (11" x 14")

Bristol pad (11" x 14")

Marker paper (11" x 14")

Tracing paper

X-Acto knife

X-Acto replacement blades

Scissors

Color-aid paper

Proportion wheel

Matte knife

Matte knife replacement blades

Triangle

Prismacolor markers

Fine-line black marker

Hard and soft lead pencils

Black Sharpie marker

Compass

I was totaling all of this up in my head, wondering how I could afford half of the stuff on this list, when we were handed the DIVISION OF DESIGN POLICY STATEMENT, which was basically a contract that went something like this:

CLASS ATTENDANCE

Class attendance is mandatory. Each unexcused absence will result in a lowering of your overall grade by one letter. Every three late arrivals to class will count as one unexcused absence.

PROJECT GRADES

Project grades are based on a variety of criteria, including:

1. Concept.
2. Development process.
3. Presentation and craftsmanship.
 Unacceptable craftsmanship will mean redoing the project and may affect the final grade.
4. Meeting project deadlines. No late work will be accepted.
5. Class participation in critiques.

FINAL GRADES

Final grades are based on a variety of criteria other than grades earned on individual projects, including:

1. Working habits or lack thereof.
2. Meeting deadlines.
3. Attendance, including late arrival or leaving early.
4. Working to potential.
5. Class participation in critiques.
6. Improvement over the term and reevaluation of total output in class in relation to program standards.

PLAGIARISM

Plagiarism is grounds for academic dismissal or an F grade for the project or the class, as determined by the seriousness of the situation.

We were required to agree to these terms and sign at the bottom.

_____	_____
Signed	Date

Although the professor (a graduate teaching assistant) was only a few years older than I was, I instinctively called him Mr. Aufuldish. He immediately corrected me: "It's Bob, man." He delivered this deadpan, in a manner I can only describe as coming from someone who knows to someone who knows absolutely nothing. It was a look I would see many times that semester.

It was during this introduction to the program that I first heard the words "Sophomore Entrance Exam." We were told that this exam wouldn't occur until the end of the year, so it was as abstract as the rest of this stuff, but it did come with a dire warning to work hard _or else_. This all seemed excessive, and I was beginning to form an unfavorable opinion of "Bob, man."

It wasn't until my next class, Color I—different teacher, but same policy contract and an equally onerous syllabus—that I began to suspect there was someone behind-the-scenes responsible for all of this.

After we got through the fine print, we were handed more paperwork.

CLASS GLOSSARY

This included an endless list of terms, each with a corresponding definition. We were expected to know (and use) this new nomenclature in class and all the classes that would follow. It was to be our new common language, one that we would use going forward to discuss our work during critiques.

The list continued for a dozen pages, it included terms such as:

Abstraction	Ground
Asymmetry	Harmony
Balance	Hue
Contrast	Brightness (Light Intensity)
Curvilinear	Saturation (Color Intensity)
Dominant	Line
Dynamic	Mass
Figure/Ground	Negative Space
Focal Point	Non-Objective
Form	Rhythm
Framal Reference	Unity
Gestalt	Value
Grid	and so on . . .

We were asked to turn to page fourteen of our packet, to the section titled:

PRINCIPLES OF
TWO-DIMENSIONAL DESIGN

We would begin at the beginning, with a fundamental definition of design:

Lack of design is *chaos*. Design is *order*.

●

During that first semester I was hopelessly lost, completely and utterly out of my comfort zone. This was not my drawing table back home. Yes, there was a plethora of rules and new terminology, each with its own precise definition, but the further in I got, the less tangible it became. I mean, I knew what chaos was, I grew up with that. But order? It was endless protocol, and at the same time it was abstract. No, wait, sorry, it was *nonobjective*, in a "stare at this white wall for two-and-a-half hours and tell me what you see" kind of way. I wasn't prepared for design school to be so regimented and yet so existential.

We started by moving black paper squares around. As promised, the class glossary was employed. Balance, grid, harmony, rhythm, contrast. There were constant admonitions to "consider the whole" and "activate the negative space." There was a preoccupation with something called "craft," meaning how well an assignment was constructed and presented. If something wasn't right, you had to redo it. Still not right? Redo it again. I heard, "You need to rework this" a lot. I learned to hate the word "rework."

95

But mostly there were the "crits," the endless discussions about the work. Our assignments were pinned to the white walls of the classroom (clear push-pins only), each pin leaving behind a small hole. Each hole in turn added to the thousands upon thousands already left behind, forming the chaotic universe of the crit wall, a byproduct of past struggles for *order*. If we hung our projects in a haphazard way, the professor would make us start over, this time making sure each project was at eye level six inches apart. The design critique was described as the logical conclusion to Gestalt psychologist Kurt Koffka's famous mantra: "The whole is other (greater) than the sum of its parts."

While I didn't exactly go into design school with an open mind, I was committed. I was living in Ohio now. I had come here to do *this*, whatever *this* was. Most of my fellow art students recoiled at the mention of anything sports related so I kept my background a secret even as I leaned on it to get by. All those years of practice had taught me that repetition and discomfort were essential if one wanted to get good at something. Whatever talent I thought I had seemed inadequate, but I knew how to be persistent. I would work as hard as I could, for as long as I could, even if I had no idea what I was doing or why.

This mindset, along with my drawing ability, got me through that first year. Reviewing a copy of my transcripts, I see that I barely squeaked a B out of Vis Org I, but I got an A in Design/Illustration Techniques, which was a drawing class. I also got a B in Color I and a C in a class called Great Books. I think my attention was elsewhere because the only "great book" I remember was Homer's *Odyssey*, and that was only because of Polyphemus—the giant cyclops who was eating Odysseus's men. Given the circumstance, poking out his one and only eye was totally justified, but as a graphic designer, I empathized with the cyclops.

As the spring semester drew to a close, more time and energy was spent preparing, worrying, and, especially, talking about the massive exam that awaited us. Stories passed through the hallways of the art building like Ghosts of Sophomore Entrance Exams Past. One involved, I kid you not, someone cutting off his own thumb with a #11 X-Acto knife and not being excused. He was bandaged up and only after he finished his project was he allowed to go to the emergency room. The doctors could do nothing. His design career now over, he joined the priesthood. The assumption was that most of these tales were apocryphal, but the closer the test got the more you were willing to believe . . . even if we all knew it was impossible to cut off a human thumb with a #11 X-Acto.

All two hundred freshmen gathered at 9 AM on that fateful Saturday in the lobby of the art building. We submitted our portfolios and were given our schedule for the day.

SCHEDULE

9 AM: Check-in and portfolio drop-off

9:30–11:30 AM: Written Exam, Rm 202

11:30–12:30 PM: Lunch

12:30–2 PM: Drawing Test, Rm 208

2–2:15 PM: Break

2:15–3:45 PM: Studio Skills Test, Rm 108

3:45–4:00 PM: Break

4:00–5:30 PM: Design Test, Rm 111

Everyone had to take the written exam in the auditorium during the morning session. After lunch we would be split up into smaller groups for the skills portion of the test. All of the faculty were there, as well as the graduate teaching assistants. I said hello to Kathy Warinner (my professor for Vis Org II), but I'm not sure she knew who I was.

I was as prepared as I could be, but I was still worried. I had reworked and reworked, and then reworked again, everything in the portfolio I had just handed over. I studied heavily for the written portion. I knew the glossary. But we had been told that there would be a copyfitting problem. This involved a typed manuscript, your Haber rule, counting characters, and a bunch of variables including typeface, point size, line length, leading, and basic math. A few people in class were good at this; I wasn't one of them. I was confident about the drawing portion. I felt I'd get by in the Studio Skills test (this would include an hour-long marker comp and another hour of some unspecified technical drawing). This turned out to be pretty difficult. It was a series of six rings that were to be rendered in ink, on hot press illustration board, each to be exactly 12 pts., with every ring touching. Everything we did that day had to be tissue flapped.

But it was the design test that I was most concerned about. I had fumbled around in my two-dimensional design classes all year despite having what turned out to be two very good teachers. Every crit was an adventure—I never knew if something I did was decent or shit. I still didn't get it. During the afternoon break I stared at a small poster Kathy had designed for the School of Art that was pinned to the bulletin board. I was cramming before my last test, trying to memorize the layout, thinking I might be able to replicate it.

Walking home to McDowell Hall afterward, I had no idea whether I passed or failed. I stopped momentarily at one of the four spray-painted peace symbols on the asphalt of the Taylor Hall parking lot. Another May 4 had come and gone. Candle wax surrounded me.

My relationship with alcohol was defined by the grandfather I never met. Edward Humphrey Sahre was an alcoholic. He died when he was thirty-nine years old and was expunged from the family history. I grew up not knowing what he looked like.

"Alcoholism runs in the family" is something I was reminded of so often that I didn't start experimenting with beer until I graduated from high school. When I did start drinking, I was behind. Competitive person that I am, I tried to keep up. This resulted in a period when I was known as "Lightweight Man." I threw up everywhere: bathrooms, front yards, off of top bunks, and in friends' cars. One time I threw up in my shirt on a subway train during a visit to New York City. (Why I decided to throw up *in* my shirt and not *outside* my shirt is a question I can't answer.) I was also introduced to hangovers at this time.

After a lot of practice, I built tolerance, and learned to know when to stop. There have been times in my life when I would have been considered a heavy drinker, but I have always been able to manage it.* Not only did I have my father's voice whispering in my ear (even when he wasn't there), I had a purpose: I had graphic design.

I smoked pot occasionally, but pot just made me sleepy. I mostly stayed away from the heavy drugs. I didn't like the idea of being totally out of control, but I don't remember that stuff being around much anyway. The kids at Kent State drank beer.

■

*The National Institute on Alcohol Abuse and Alcoholism (NIAAA) defines heavy drinking as more than four drinks per day or fourteen drinks per week.

It was the end of the school year and I had packed all of my belongings into the Gremlin. I didn't use boxes so I could pack in more stuff. When I was finished, the car was filled up to the ceiling. The only air space was the driver's seat. The interior of the car resembled a mold of a seated human figure holding a steering wheel. I couldn't believe I had gotten it all in there. The gearshift was barely operational, as it was underneath my coffee table. This was fine because most of the trip was highway driving. I couldn't see out the back so I would rely on the side mirror.

I went out and partied one last time—until about midnight—and was about to say goodbye and hit the road when I told one of my friends I had an all-night drive to Binghamton in front of me.

"How are you going to stay awake?" he asked.

"Coffee," I said.

"Forget that, take one of these," and he handed me two white pills.

"What is it?"

"Speed—it's like ten cups of coffee. It'll keep you awake." He said this in such a casual way that I didn't think twice about it; I put them into my shirt pocket. I drank coffee. I drank a *lot* of coffee. I was pretty sure I had never had that much caffeine in one sitting before, but I'd probably come close. My coffee drinking started earlier that semester as a way for me to stay awake during all-nighters working on projects.

I got on the road, driving northeast to the Pennsylvania border. Soon after I merged onto I-90 the monotony set in. As I stared at the small patch of illuminated highway in front of me, I got sleepy. I took one of

the white pills, washing it down with what was left in my McDonald's to-go coffee cup.

A few minutes later, I slowed as the highway narrowed to one lane. Then traffic came to a dead stop. There was a semi ahead of me, a semi behind me, a temporary cement wall to the left, and deep woods to my right. I was boxed in. I sat there, staring at the red lights that defined the rectangle of the trailer in front of me. It was 2 AM.

My hands began to tingle . . . then my nose, then my entire face. I was sweating. Then I remembered that pill. This *did not* feel like any coffee I had ever had. I panicked, realizing I was heading into uncharted territory, trapped in the womb of my overpacked car. Alone.

Now there were waves of goose bumps and rushes of adrenaline. My head felt like a balloon. I had this overwhelming desire to move, but I couldn't. I kept bumping my elbow on the corner of the coffee table. I squirmed. Then I noticed that the rectangle of glowing red lights in front of me had become an infinity mirror. I felt like I was going into convulsions, I couldn't take it anymore, so I did the only thing I could do: I got out of the car.

I gasped for breath, the way you would after being held down underwater for an extended period. I did twenty-five push-ups and ran around the car for a while. My panic went away and I was starting to feel pretty *good*. Now to see what the holdup was . . .

In front of the truck in front of me were more trucks. *Truckers had radios,* I thought, *maybe one of them would know why we were stopped?* I walked over to the vehicle in front of me, but there was no one in the driver's seat. "Hello!" I shouted. No answer. Same with the truck behind. Was I even there? What the fuck was going on? We had been there so long that everyone had turned off their engines. As my black Chuck Taylor high tops scraped the asphalt, I noticed how completely silent it was. I wandered around out there aimlessly calling, "Hellooo, hellllllloooooooooo!" I took a piss and walked back to the car without making human contact.

I was trapped in a *Twilight Zone* episode. I wondered when fellow Binghamton native Rod Serling would appear to explain what was happening to me. As I sat in the Gremlin, I listened to REM's *Reckoning*, grinded my teeth, and performed a kind of involuntary pop-and-lock in my seat until the truck in front of me suddenly started moving again.

The clock read 4 AM. I had been there for two hours. I exited at the next rest area, got out of the car, and ran around in circles again. Once I felt quasi-normal, I grabbed a cup of coffee and got back on the highway. I tossed that second pill out the window.

At the start of the next school year, my fellow survivors and I were intro-
duced to Room 107. This was the "stat room" and was off-limits during
my freshman year. I watched people come and go through the black
cylindrical doorway—always escorted by someone holding a flat orange
box with "AGFA" printed on the top. This doorway was directly across the
hall from "the Cage," a chain-link area where hundreds of these orange
boxes were stored. It had the feeling of a secret society, and now, having
passed the sophomore entrance exam, I was about to become a member.

The initiation consisted of myself and everyone else in my Graphic
Design I class entering the black doorway, one at a time, single file. We
found ourselves standing in a large, dimly lit room. In the middle of the
room was a waist-high track bolted to the cement floor, on top of the track
was a copy stand with big light panels on either side, and mounted to
the wall at the end of the track was an oversize camera lens and bellows.
We were about to learn how to operate the stat machine, a stationary
camera that we were told was used to shoot "camera-ready artwork for
reproduction," whatever that meant. This was by far the biggest camera I
had ever seen. It was so big it took up two rooms.

 "This is where you place your artwork." The lab tech demonstrated
by lifting the heavy glass lid and positioning a white sheet of paper with
an ampersand on it in the middle of the copy stand. She then closed the
lid and swiveled it into a vertical position facing the camera. Someone in
our class let out an involuntary *Ooohh.*

We were led down an even darker hallway to an inner room. This room was completely dark but for the red glow of the photo safelights. The walls were black and it took a few minutes for my eyes to adjust. There was a large tray of strange-smelling chemicals labeled "FIX" and a long tabletop machine the lab tech called "the processor." She directed our attention to a control panel with various gauges and knobs and a hinged metal door. This hatch was directly opposite the camera and bellows in the first room.

The tech explained how to operate the controls on the darkroom side of the camera, how to control the focus, and how to set the proportion for the stat. She opened the metal door, exposing the grid of the film board. Here is where the orange boxes came in. "Stats are photographic copies of an original artwork," she said. The high-contrast black-and-white film could produce either a positive or negative image. The receiver could be a paper "stat," to be used in a paste-up, or it could be film, for use in various printing methods such as silk screen. At the time, none of us knew what *any* of this meant, other than the fact that you could enlarge or reduce your image, from 5 percent up to 1,200 percent.

She held up a plastic disk called a proportion wheel and a floppy ruler called a precision rule and indicated that these would be important tools going forward.

Placing a negative on the film board, she flipped a switch that activated a vacuum, holding the film in place. The sucking sound was loud enough that I could no longer hear what the lab tech was saying. She raised the film board to an upright position parallel to, and facing, the copy stand in the other room. The shutter switch was flipped for a three-

second exposure. She reversed the process, lowering the film board, turning off the vacuum, and removing the negative. Taking a sheet of photographic paper from the second orange box, she sandwiched the exposed negative to this "receiver" and fed them carefully through the processor. They emerged from the other side wet and stuck together.

She indicated that the stat was now developing. Keeping her eye on the clock, she peeled negative and receiver apart and there was our "&," 859 percent larger than it was in the other room. This elicited an *Aaahhh*. She dropped the "&" into the tray labeled "FIX" and disposed of the negative. The fix bath prevented any further exposure to the receiver. The stat was then washed and dried. Our "&" was now ready to use in any way the designer saw fit.

If this all seems laborious, it was, but in 1985, stats were an essential tool for print production. Print was power. This was an important rite of passage to becoming a graphic designer, and we all knew it. Cutting and pasting was how a graphic designer made things, so access to the stat room meant you could resize elements for whatever you were designing. This was a few years before we had Xerox machines to reduce or enlarge, so the only other way to change the size of something was to do it by hand, or trace it on the Lucigraph.

In those first two years, we learned to use a host of tools of the trade: waxer, Haber rule, rapidograph pens, rubber cement pick-up, proportion wheel, color-aid paper, registration marks, T-square, triangle, X-Acto knife. Most, if not all, would become obsolete in the coming years due to the advent of desktop publishing, but I have always considered myself lucky to have had the experience of relying on these tools.

Operating the camera did take some getting used to, though, as each step involved feeling your way around in the darkness. You had to be careful when you put something down in there. Have you ever sat on a cup of coffee? I have.

You could easily lose things, too. One of the first times I shot a stat on my own, I misplaced my Schaedler precision rule. Months later, near the end of the semester, I was in the stat room. It was late and I was trying to finish up a project. I was running a stat through the processor when something came sliding out, sandwiched between the wet positive and negative I had put in. It was my lost precision rule!

I rinsed it off and named it Jonah.

I spent hundreds of hours in these darkrooms over the next few years. I never worked as a lab tech, but I eventually was able to use the stat machine anytime I wanted, day or night.

The Beatles had Hamburg, I had Room 107.

"The man from the dealership in Akron said that they were willing to pay $90 per hour." I was talking with Tonia, one of the secretaries from the School of Art office. *$90 per hour?!* This got my attention. "He asked if there was a student who we could send there this Saturday. Are you interested?" She had no more information about what I would be doing. $90 per hour seemed like drug dealer–type money, especially in 1985.

When I arrived at the car lot, I learned that they needed someone to replace the sign painter who was currently lettering car windows at the dealership. The $90 per hour was if I was as proficient as the person currently doing the job. He could paint nine to ten cars in an hour, at $10 per car. They also promised at least ten hours of work per month. One of the salesmen showed me some cars on the lot that were already lettered. I was upfront about my lack of experience, but told him I thought I could do it. "Give it a go!" he said.

This was a *lot* of money. I was coming off a series of brutal university jobs that paid minimum wage ($3.35 per hour, as I recall) and here was a promise of $90 per hour. Plus, this seemed super easy.

I had had the same thought the year before, when I discovered I could sell my platelets at an Akron blood bank. This started off in a similarly optimistic way, with the promise of helping my fellow man *and* easy money: $20 per donation, two donations per week, eight donations per month. All I had to do was lie there. The dream died at about the mid-point of my first visit as I lay on the gurney. Because donating platelets involves just one part of your blood, the process has several steps: Blood is collected, the platelets are extracted, and then your now platelet-less blood is pumped back into your arm—cold! Why I thought this was a good idea in the first place escapes me, as I have always been squeamish about needles. It wasn't quick either. It took hours. Making matters worse, David Lynch's *Dune* was playing on the TVs overhead (all throughout the clinic, basically inescapable). The pus-filled blisters of Baron Vladimir Harkonnen, floating, pulling the heart plug of that poor florist . . . these were the visuals for this experience. I never went back.

I headed to the art supply store and was introduced to the tools of the trade of the commercial sign painter. When I asked to see the sign paint, they brought me to a shelf filled with small yellow quarter-pint cans of 1-Shot lettering enamel. These looked nothing like the art supplies I was used to buying for school. For one thing, they looked industrial and

straight out of the 1940s. The logo, far from suggesting an artistic endeavor, consisted of a bull's-eye with a bold "1" in the center and an arrow with the word "SHOT" inside pointing directly at the "1" and the center of the bull's-eye. Reassuring. How could I miss, right? I also picked up a can of paint thinner for cleaning out my brushes (and a couple of rolls of masking tape, but I'm not sure why).

Being in my third year of art school, I knew brushes. But the one that the salesperson assured me was a sign-painting brush, I knew instinctively I could not operate. It was a Mack-brand outliner brush, and the bristles were made of squirrel hair. What the hell? Why squirrel? (Plus, the brush was $20!) The bristles were at least an inch long, soft, and didn't taper at the end like the brushes I knew. I thought that the sales guy must have made a mistake. I didn't buy this brush, instead relying on the ones I had from painting class. Go with what you know, I figured.

On the way back to the dealership, I was busy calculating how much money I was going to be able to make in a single afternoon. Yes, the cars the other guy had painted were well done, and he was clearly a professional, so he was going to be a lot faster than I would be. Still, I figured that at the very least I could do three or four cars per hour: In a single afternoon, I could make as much as a whole week at my old university job!

When I got back to the dealership, the salesman I had spoken with earlier wasn't around, but under the windshield wipers of the cars on the lot he had stuck sheets of paper, each with a short bit of copy and a sales price that I was to paint:

A REAL DEAL!
$2,500

LOOK!
(with eyeballs in the Os)

DRIVE ME HOME!
$3,900

LOADED, LOADED,
LOADED!

My plan was to employ a few tricks I had been able to pick up in art school. The windshields that had been painted by the other guy were the key. I would use tracing paper to trace the letters he had painted, do a graphite transfer technique to put an outline of the numbers and letters onto the windshield, and then I would paint.

The first problem I encountered was when I attempted the graphite transfer. After painstakingly tracing a few of the larger two-color numbers the other guy had painted, I used a soft lead pencil to apply graphite to the reverse. I then tried to retrace the number on the first car I was to paint. It didn't work. For those unfamiliar with this technique, it involves tracing whatever you want to transfer, then turning the tracing over and coating the underside of the paper with graphite (usually with a soft lead pencil). Next you retrace whatever you want to transfer while holding the paper steady in the exact position you want it. The pressure of the pencil leaves a faint graphite line behind. I had done this many times before—with a photograph that I was transferring from paper to wood, for instance—but in this case the graphite would not transfer to the glass because there was a coat of car wax on the windshield. I hadn't anticipated this, so I resorted to drawing the numbers onto the windshield using a grease pencil. This worked but was time consuming. Hours passed and the midday sun was beating down. By the time I was ready to start painting car number one, I had been there for three hours. That's when the real trouble started.

The 1-Shot lettering enamel had a thick consistency and, not having any idea that one had to thin it before applying, I started painting. The result was a globby mess. I went back and forth from my car to the cars the other guy had done to see what I was doing wrong. His letters were smooth and perfect. How was it possible that he got these results with the same paint? I was quickly developing an appreciation for lettering that read, "A Real Honey!"

I finished painting the first car and it was so bad that I immediately started scraping it off with a straightedge razor. This process took

twenty minutes. Four hours had passed and I hadn't finished a single car! It was about that time when David, the real sign painter, showed up. (In retrospect, I think the dealer must have seen me struggling and called him in to paint the remaining cars and to give "the new guy" a few pointers.) I introduced myself and told him I was an admirer of his work and that I sucked. I asked if he wouldn't mind if I followed him around and watched him paint. "Sure," he said. "You'll get the hang of it." I had a huge amount of newfound respect for this guy, and once I saw him in action, respect turned to worship. No tracing paper, no grease pencil; from car to car he did it freehand on the fly! Here was an *artist*. It turns out I was doing everything wrong.

David systematically knocked out all of the cars I couldn't. Two hours later, he had finished nineteen cars, all perfect. It was getting dark, I had been there the entire day, and all I had to show for it was a nasty sunburn. I was down $15: $20 for the two terribly lettered cars I painted, which went toward the $35 I'd spent on supplies. I was exhausted. Another "You'll get the hang of it" came, this time from the dealer, who was trying to reassure me. He could see I was defeated. I was surprised he wanted me back. "Not bad for the first go-round!" he said. "You can do this. I have a feeling about you."

I did get better. By watching this craftsman, and following him around in the months to come, I learned the proper way to hold the brush, as well as the correct consistency of the paint, how to load the brush, and at what angle to start each letter.

I painted windshields throughout undergrad and into grad school, lettering hundreds of them at dealerships all around northeast Ohio (and even a few showroom windows). It was hard work but it was oddly rewarding. I could almost see why someone like David would choose to be a sign painter instead of any number of other things he was obviously talented enough to be. For me, this was temporary; learning to sign paint was a means to an end. I earned enough to pay my living expenses and a

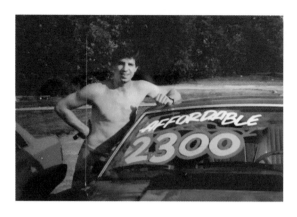

good chunk of my tuition. I viewed my side job as low, commercial. *I was selling used cars.* The reason I was doing it was so I could be in a position to *not* have to do this type of work in the future. David didn't have a college degree; he was painting cars to feed his family. I was never quite sure which of us was doing the "smart" thing. It took me years to make the same kind of money doing graphic design.

Sign painting also gave me a different perspective on what I was studying at school. I would leave campus after my History of the Italian Renaissance class and spend the rest of the day lettering car windshields. Every so often a random vehicle would drive by the dealership and yell, "Hey, Michelangelo!"

The Internship

By junior year, my foundation education was over and we were putting abstract ideas to use in more complex ways. We were introduced to concept. Form was still important, but now our work had to communicate. I stopped drawing. Whatever had compelled me to draw was now compelling me to design, and I was feeling less and less like the person I was when I came in as a freshman. After all of the years I had spent in classrooms, I finally "got" the idea of being a student. I was a sponge. If I wasn't upstairs outside Room 208 working on a project, I was camped out in the design library looking at the work of others. I now found that I had an opinion about what I was seeing. I tried to emulate the work I responded to the most, with varying degrees of success. My friends back at the dorm might not see me for days at a time. All-nighters happened with increasing frequency, and not because of deadlines. I just didn't want to stop working.

In the spring semester, I landed an internship at the best design firm in Cleveland. This would be my first real-world design studio experience. My new internship was to be *paid*, a big deal at a time when most of my friends were doing their internships for free. By paid, I mean barely above minimum wage. This was nothing like the *real money* I was getting lettering used-car windshields in Akron. But the thing was, I couldn't believe someone would actually pay me to do graphic design. I loved graphic design. From my experience, people got paid for doing things they didn't like doing.

My early resume was a reason I thought this: house painter, newspaper deliverer, dishwasher, *lawn mower*. I understood getting paid to mow lawns. There is no pro-bono lawn mowing. The reason: Lawn mowing is *work*. People who mow lawns expect to get paid. It's hot, it's loud, it's

messy, and at the end of the day you smell like gasoline. Worst of all, it's monotonous (this was pre-Walkman, there was no escape). Years later, I would live in New York apartments, surrounded by concrete. Whenever I hear someone going on about how much they love the smell of freshly cut grass, I cringe. The summers between 1975 and 1982 saw to that.

And so, in the spring of 1986, I made the forty-five-minute drive from Kent three days a week. In the process, I was introduced to the day-to-day realities of a well-respected and busy design practice.

As it turned out, *I* should have paid for my internship. No one said as much to me, but I was pretty worthless. I never did any designing while I was there. I remember being given a few rudimentary design assignments at the beginning, and after not being able to handle those, I was relegated to the darkroom, where I spent my days soaking up chemicals on the stat camera or making Image N Transfers (INTs) for "comprehensives," or comps, in-house. The Macintosh had not yet entered the lives of working graphic designers, so everything was still being done conventionally. There were no computers. Old school. This included the making of one-of-a-kind comps, dummies that simulated what a piece would look like once printed. Since comps were used to help convince a client to approve a design, making them was an everyday reality for a design studio. A lot of time and money were invested in making comps, but it was more production than design, so the full-time designers were not enthusiastic about doing them.

I was OK with it. I wasn't invested in the place; this was temporary. I was there to learn and to pitch in. I really just loved the creative environment and the camaraderie that existed between the designers. I also appreciated the chance to preview the new life I was going to have after I graduated. This was the type of place I could see myself working.

The biggest difference between a school assignment and the real thing was time. Having clients meant having real deadlines. While they bore similarities to the due dates I was accustomed to in school, the big difference was that if you were late with something in school, you got a bad grade;

if you flaked on the job, it might mean being told to pack up and get out. *Termination.* More troubling was the rapidity of these real-world deadlines. A project that I might have had three weeks to do at school was due in a day-and-a-half here. This created pressure and stress that rolled like waves through the studio whenever a deadline was looming. During these moments, it was better to be hiding in the darkroom doing color drawdowns.

On my last day, one of the senior designers, a Kent State grad, pulled me into the conference room. The partners were out at an offsite meeting and he wanted to show me something. On the conference table was a stack of design annuals, each carefully bookmarked with Post-it notes. "I make a point to do this with all of the interns who come through this place," he told me in an uncharacteristically formal manner. He proceeded to show me examples of some of the firm's best work. He showed me corresponding examples of other designers' work (designers who had certainly never worked here) and pointed out superficial (and, in some cases, not so superficial) similarities. He told me flat out that much of the work the firm was doing was, in reality, copied. Plagiarized. He and other designers in the studio had been shown these examples and told to "make it look like this."

So ended my internship.

As I drove home, I wondered what it would be like to have someone take notes on me this way. No one had yet accused me of stealing from all of the designers I had been introduced to in the design library back at Kent: Bob Gill, Robert Brownjohn, Wolfgang Weingart, April Greiman, Art Chantry, Rick Valicenti, Paula Scher, Charles Spencer Anderson, Rudy VanderLans, and countless others.

The composer Ned Rorem wrote, "All art is clever theft. The act of covering your traces is the act of creation." While incredibly cynical, this idea seemed to provide me (and my former employer) with an out.

I was worthless as an intern in Cleveland, but by my senior year, I was feeling like hot shit. I had won a scholarship. I was a member of Glyphix, the invitation-only work-study design studio. In class, I was winning my share of crits after years of getting destroyed and, related in my head but probably coincidental, I was no longer being totally ignored by females. I was *actually having sex* once in a while. But the thing I remember most about 1987 was that was the year I became a graphic designer. I may have *felt* like a graphic designer before this moment, but now, it was definitive: I had my first printed piece.

It was part of a book of recipes. A Cleveland-area typesetting company sent out a call for design submissions.[1] The book was wire-o bound and measured 9" x 4" (horizontal format). The binding was black metal. It had a blue cover stock, I'm guessing 80 lb.[2] The name of the book was set in a bold sans-serif typeface (maybe Gil Sans) and it was placed in a circle (like a dinner plate) and printed in silver ink. I can't recall the name of this publication or the company that sponsored it.[3] Each recipe was one page (front and back). The interior pages were printed in one color (black), full bleed, on a white-coated stock. Let's say 100 lb. text.[4] My entry was an attempt at graphic wit: Instead of sending in a recipe for something challenging or one-of-a-kind, I sent in instructions for making a Fluffernutter sandwich that I took right off the back of the label. (In retrospect, not so witty.)[5] The front was a collage consisting of a close-up of a kid's satisfied smile.[6] There were a series of rings that emanated from the smile and continued out to the edges of the composition. The Fluffernutter logo was enlarged and overprinted across the entire width of the page. It was located above the smile. A series of small graphic

icons ran horizontally across the composition, but I don't recall what they were. The back cover was a symmetrical split of fluff on the left and peanut butter on the right.[7] The instructions were set in a spiral shape that ended with a small icon of a Fluffernutter sandwich on a plate.[8]

It was exhilarating just holding this printed thing, knowing that there were thousands just like it out there . . . somewhere.[9]

Notes

1. These were companies—thousands of them in the United States alone by 1980—that provided typesetting services for designers, advertising agencies, and corporations. This was pre–desktop publishing, so typography was arranged according to a set of specifications that were applied to a manuscript that was prepared by the graphic designer and provided to the typesetter. These included typeface, size, leading, column width, and so on. Typesetters composed the copy and provided a set of camera-ready repro (called galleys) to the designer for paste-up and, eventually, printing. This industry was gutted with the arrival of the Macintosh.

2. Paper thickness is determined through a confusing and arcane method. In the United States, the basis weight is defined as the weight of five hundred sheets (aka a ream).

3. I'm not 100 percent about any of these details because I don't have a copy of my first printed piece. I lost it.

4. 100 lb. text weight paper is actually lighter than 80 lb. cover stock. Go figure.

5. I loved Fluffernutter sandwiches as a kid. I find it interesting that, despite going through my transformation at school, the first thing I did was to fall back on life before design.

6. The overall design aesthetic of this piece is, however, very much a byproduct of my design training.

7. I spread this out onto a piece of illustration board and then photographed it.

8. Insert sound of someone chewing.

9. This must have been how Gutenberg felt.

On the morning of May 4, 1970, j.Charles Walker was driving to work early, as he always did. But this was no typical Monday morning on the campus of Kent State University. Men in green army fatigues were at every corner, armed with M1 rifles. Military vehicles were everywhere, Jeeps and half-tracks painted the same drab green the soldiers were wearing. It was an overt show of force, and Charles could see that things were as bad as he had heard, mostly from updates from colleagues over the phone.

Then he saw the burned-out ROTC building.

On the previous Friday night, President Nixon had announced that US forces would attack, but not invade, Cambodia. To many, this signaled an escalation of the Vietnam War, which Nixon had promised to end. An angry crowd gathered downtown after the bars let out, started a fire in a trash can, broke windows, and chanted antiwar slogans. They were dispersed by police, but the Kent mayor had seen enough. He declared a state of emergency and requested assistance from the governor, James Rhodes, who mobilized the Ohio National Guard.

On Saturday, student anger focused on the ROTC building.

The Reserve Officers' Training Corps, or ROTC, building was located just off the Commons, a large open field in the middle of campus. A "victory bell" (used to celebrate football victories in less politically charged times) was on the other side of the clearing. Not surprisingly, the Commons had become a gathering area for protests during that period, facing as it did the old wooden structure only a few hundred feet away. The bell would ring and students would gather. The ROTC building had come to symbolize an unjust war on the other side of the world. Now,

some students had decided to eliminate it. It burned to the ground on Saturday night just as the National Guard was arriving. Flames illuminated the sky to the sound of an approaching army.

▲

Years before, as an undergraduate at the University of Cincinnati, Charles had realized that he wanted to teach. After earning his MFA at the University of Kansas he accepted a position at Kent State University as an instructor in graphic design. When he was hired, he was the first, and only, graphic designer on the full-time staff of a growing School of Art. Although the program was tiny and had no reputation to speak of, he took the Kent State job because it was close to family, and so he moved there with his boyfriend. He figured it would be temporary.

By 1970, he had changed his thinking. He had been named head of Graphic Design and instead of moving on to a more established program elsewhere, he saw the situation at Kent State as an opportunity. Although he was still formulating his vision for what it could become, he realized that here was a chance to build a program from the ground up.

When he got into school that Monday morning in early May, he sensed immediately that the university had no idea how to deal with what was happening. Things were clearly out of control. He immediately canceled all classes and advised his students to get off campus.

Charles, and most of his students, heard about the shootings on the radio later that day.

●

When I arrived in the mid-1980s, Charles was still there. He had not left "after a few years" as he originally planned, nor did he leave—as some faculty did—after Kent State became "Kent State." Instead, he threw everything into what eventually became one of the best graphic design programs in the state of Ohio. With the help of his faculty, including his lifelong

partner John Brett Buchanan, the matriculation had quadrupled since 1970. The program had six full- and part-time faculty and four graduate teaching assistants teaching in the undergraduate and graduate programs. He had written much of the foundation curriculum himself over the years—experimenting, responding, tweaking, and tinkering with methods and class offerings and always finding ways of leveraging the advantages and limitations of running a program at a large public institution that also happened to be in the middle of nowhere. He built a culture of design where there had been none before, exposing his students (mostly Ohio kids) to some of the best designers in the world during his summer design workshops on campus. He also created a Summer in Switzerland program, a Summer in England program, and a Summer in Italy program. The idea that Kent State had a good graphic design program reached at least as far as upstate New York, to whomever recommended the program to me.

Although he was no longer teaching undergraduates by the time I arrived, it didn't take me or my fellow students long to realize who was responsible for all of our pain and suffering. The credit—or the blame, depending on your point of view—went to j.Charles Walker (small j, period, no space). Charles believed, as did most modernists, in *order*; that a more organized world was a better world. Charles was a control freak, but he also believed in the original meaning of the principle "Form ever follows function," the one its author, architect Louis Sullivan, originally intended: Anything in design is OK, as long as it serves a function. He believed that, while form was important, it must be in service of content and intent. Once he had provided the rules, he encouraged his design students to find their own way, even to break those rules, as long as their departure served a purpose.

Some thrived in his system, others didn't. He alienated administrators and students alike. Love him or hate him, he had a vision. Charles was in control, behind-the-scenes. Over the years, I heard him referred to as GOD (not in a positive way), Daddy (this could be positive or negative

depending on how it was uttered), a hard-ass (I always took this as positive), the chief (sarcastic but not necessarily negative), a dictator, an ogre, a despot (all negative), and "the man behind the curtain."

During my senior year, Charles offered me a teaching assistantship. If I stayed, I could pursue an MFA at Kent and be paid to do it. I would teach, and relearn, all of the foundation classes I had struggled with a few years before. At the same time, I would have the freedom to explore my work on my own terms, outside of the context of class assignments. After much discussion with my dad, I decided to do it. Charles became my mentor.

The person I got to know as a grad student was different from the one I knew as an undergrad. He was just as tough and just as organized, but he was also warm, open-minded, quick to laugh, and passionate about design and his program. Mostly I saw him as a *graphic designer.* He led by example. He did this with his program. He did this with his work. He did this in his relationship with John and how he lived. He showed me that being a designer is not a job. It's who you are.

It was December 1988 and I was home from grad school during Christmas break. Angus was there as well. He was home for a few months while the circus was in winter quarters in Florida. He was bumming around for a while, hanging out with his friends and waiting to rejoin the circus in the spring.

Neither of us suspected it at the time, but his troublemaking, which had been escalating over the years, was about to reach its apex. What started out as crayon vandalism had, over time, progressed to his most recent entanglement. It involved a group of guys who were shoplifting (video-tapes if memory serves). Angus was at their apartment "hanging out" when the police arrived to bust them. He was detained for a time and released when it was determined that he wasn't involved. My father lectured him about choosing his friends more carefully, but in the end, Angus had dodged another close call. Angus made friends easily, too easily. Perhaps sensing that if he hung around, there could be more trouble in his future, he left for his life in the circus. That was a few years ago. He was an adult now, twenty-two years old. The circus seemed to straighten him out, or maybe he was just far enough away that nothing got back to my parents.

The two of us were downstairs in our old bedroom, at the far reaches of the basement. Mom had slowly been reclaiming territory in our absence and this included our old room. She had methodically removed our stuff while moving in stuff of her own. This had been happening slowly and by the time the sewing machine appeared, we knew this was no longer

our room. There were a few things left. Angus's vinyl records were still in there (probably too heavy for Mom to move) as well as my high school varsity ice hockey jacket and a few too-small sweaters. We were conducting our inspection when we were startled by a friend of Angus's named Tom Dale.* He was Angus's age but looked younger. He was slight and had a boyish face. They met back when Angus was working at his job as a dishwasher at the Roaring Fork restaurant in downtown Binghamton. My brother wasn't expecting him, and we both assumed our mom had let him in. Angus asked him what was up and he didn't answer. It was then that I noticed his face: It was flushed, he was glassy-eyed, and he had a peculiar eagerness in his expression that I immediately registered as odd. I think he was sweating. I assumed he was high. The two of them left and I resumed the inspection. It was weird, but it wasn't alarming, so I got back to the box of vinyl records. I wanted to see if anything of mine had snuck in there.

A week later I was back at school living in the Rugby House. This was my last residence at Kent. It was called the Rugby House because the previous occupants were rugby players and the team had used it as their de facto hangout before we took it over. It was located on East College Street, right next to the Alpha Epsilon Pi fraternity and a few blocks from the front of campus, and was surrounded by other houses that should have been condemned. I lived there along with three roommates I knew from that first year living on campus in McDowell Hall. There was Z, my best friend at Kent. His first name was Chris but everyone called him Z after the first letter of his unpronounceable last name. There was Chach; I never did know what his real name was. And then there was Oetting. This was his last name (someone tried calling him Track for a while but it didn't stick). Rich Oetting—an enormous, lovable guy—was a varsity shot-putter, recruited out of high school. (He was second all-time in the

*Not his real name.

Kent State record books for a throw of over fifty-seven feet.) He would have his track team buddies over all the time, so much so that I am surprised people didn't call it the "track" house. There was one guy—another hulking sweetheart, named Prisby or "Priz"—who was there so often I thought he moved in. We all worked at the bar down the street called the Robin Hood Inn. Z, Chach, and I alternated between tending bar and bouncing. The nice thing about bouncing at the Robin Hood was that nothing ever happened because of Oetting and Priz. No one was crazy enough to mess with those guys.

The Rugby House was basically a less endearing version of *Animal House*. There were parties constantly. Chach would invite half the bar to our place after closing time, and these parties would rage into the wee hours and involved all sorts of people none of us knew and the obligitory thrown onto the street out of a closed *window* *chair* all of this while I tried in vain to sleep with a pillow over my head upstairs. I was pretty much over it at that point. Once I was done with work at the Robin Hood, I wanted to go home. I had a serious girlfriend (who would later become my first wife) and I was even more serious about school. It occurs to me that this house and its inhabitants could fill a not-very-interesting book all by itself, but the only reason I got into it was to set up the place where I received an incredibly disturbing phone call about my younger brother.

Angus was in trouble again. It was my mom on the phone and this time it was serious. There had been a murder at a law office in the State Government Complex across from the Arena. The victim was a twenty-two-year-old woman. The police had a suspect in custody. It was Tom Dale, Angus's friend from the basement.

 That is what that look was.

 I knew it before any of the awful details emerged. He was burglarizing the office where his mother worked and was surprised by

a secretary who had come into the office on a Saturday. He raped and strangled the woman, who was eight months pregnant. Then he came over to see my brother.

While being questioned by police, Tom confessed to the murder and told police that my brother didn't know anything about it.

My brother was brought in for questioning and cooperated fully with the police in the days that followed. Although the police assured him he was not a suspect, he did have to provide a blood sample and an alibi. Angus always said he had no idea Tom could do something like that, and that's how he testified later that year at the trial. Whatever the police suspected, I knew he had nothing to do with it. Angus may have been a fuckup, but he would never knowingly be involved in something so heinous.

I wasn't called by the prosecutor, but my mother was. She took the stand to verify a few details of Angus's testimony. Where was I? I'm not proud of it, but I stayed in Kent during that whole awful time. This isn't to say it would have been impossible to get away, but I certainly wasn't going to tell Charles about this. As a teaching assistant I had classes and homework, plus I was teaching three design classes that semester. This was Angus's mess, not mine. There was nothing I could do anyway.

It is still inconceivable to me that a fresh-faced kid could have done something so horrible. He was convicted of first-degree murder and sentenced to life in prison. I've never seen that look on another person's face again, but if I ever do, *I'll know.*

■

Years later Tom sent Angus a letter from prison. My mom opened it before forwarding it to Angus, who was on a circus train somewhere. She remembers it as "an attempt to have some contact with the outside world." There were no answers in that letter. No apologies. No regrets. No remorse. In fact, it didn't contain anything about the murder. Nothing. Angus told my mother to destroy it.

A customs agent became alarmed as he looked through my bags. Other agents joined him and now they were pulling everything out. They were speaking in German. While I had no idea what they were saying, I could tell it wasn't good. Smith had already cleared customs and was standing on the other side of the partition, waiting for me. There was a burly female security guard named Gerda (according to her name badge) keeping an eye on him. The situation was getting tense.

This was 1989, so bringing a metal T-square and compass with you on a plane was probably OK. The matte knife and the one-hundred-count box of replacement blades that spilled out onto the table probably wasn't, but when the agent pulled the black hand waxer out, everyone hit the deck and I was seized by two security guards. One of them held it out at me in a *We've got you now* gesture.

"SCHNELL! WAS IST DAS?"

he demanded. I had watched enough episodes of *COMBAT!* starring Vic Morrow to realize that they thought this was some sort of weapon. I said, "Ohhh, it's only a waxer," playing it cool to defuse the situation. When this

didn't register, I did what every good American would do in this situation: I enunciated, repeating what I had just said, only louder.

"IT'S. A. WAXER."

Then louder and slower:

"A. W-A-X-E-R."

Gerda, still standing next to Smith, asked him, "For ze legs?"

So began our summer in Europe. Smith was a fellow grad student. We were at the Frankfurt airport making a connection—or, rather, almost *missing* a connection—to Zurich, where we were enrolled in the Kent in Switzerland program as part of our graduate studies. I was in my final year at Kent State, and I was only able to afford it because Grandpa Schoop financed my trip to his homeland.

Smith was pursuing his MFA during the summers. The rest of the year he was an associate professor at a small college in Nebraska called Kearney State. We had spent the previous two summers studying together in Kent, where we became friends.

The Ohio workshops we participated in were organized by Charles, but they were run (with panache) by John. They often hosted the visiting instructors at their house out on Twin Lakes, or "Fort Walker," as it was affectionately known. Designed by Charles, Fort Walker was an amazing place. It had an open floor plan, with interesting angles and details everywhere. The whole back of the house was glass, looking out over the lake. The design library was better than the one at school *and* it had a Warhol on the first floor. The only place I had seen a *Marilyn* was in a museum. Charles later told me that he had bought it in the late '60s for $250, then an astronomical sum, especially for someone living on a meager instructor's salary.

It was during one of these workshops that we were introduced to the Macintosh computer, an event that would alter our relationship to our chosen profession in ways we couldn't have foreseen.

There were receptions for the attendees—a few were from Kent like me, but students came from all over. There were drinks by the pool, wonderful food, and even better conversations and debates. We were able to study (and hang out) with design legends like FHK Henrion, Bruno

Monguzzi, Clement Mok, Lanny Sommese, Art Chantry, McRay Magleby, Mervyn Kurlansky, and Michael Cronan. I met Smith for the first time at one of these poolside receptions.

This year, we would be doing the same thing, only in Europe. Charles was there with us, overseeing the workshop. We would study with modernist graphic designers Ruedi Rüegg and Fritz Gottschalk, as well as architect Edgar Reinhard. Classes were held in a technical school in the small town of Rapperswil, just outside of Zurich. It was an amazing experience, plus we got to hear Ruedi and Fritz say "develop" about a million times in a three-week period, only when they said it, it came out "dev-lop."

There were a number of studio visits, too. One day we visited the home of functionalist architect Alfred Roth. He was in his eighties and still designing. He gave us a tour of his home, explaining that all of the color in a house should be on the walls. Everything else was in the neutral tones—whites, browns, grays, a lot of beige and black—except for the art. Of course, this is easier to pull off when the art on your walls is by friends like Le Corbusier and Mondrian.

Smith and I couldn't help being tourists. We were grinning for a snapshot in front of one of the Mondrians when Charles came over and spoiled it. "You know that painting is a replica, right?" It turns out that Roth had donated the originals to the Zurich art museum because there had been multiple attempts to steal them. We posed in front of the originals in the coming weeks at the Kunsthaus Zürich.

We visited a designer and publisher named Hans-Rudolf Lutz. He had figured out a way to control his means of manufacture: He had his own publishing company. He was a member of a band but didn't play an instrument. He was "Alle Visuals" (All Visuals). Vocals, guitar, bass, drums, graphic design.

We went to Karl Domenic Geissbühler's studio, where he showed us his poster work for the Zurich Opera. These were not only the most interesting posters I had ever seen but also the biggest. (The European A0 poster size is 84.1 x 118.9 cm, or 33.11 x 46.81 in.) This series of posters felt

so spontaneous and different from one another that it almost seemed like they were designed by different people, yet, at the same time, there was a consistency that made them feel like a body of work. This was because of his design process.

Geissbühler would go to rehearsals and spend whatever time there was (let's say two weeks) collecting images, typefaces, and anything visual that related to the performance in some way. Using the collected imagery, he would design the poster in a few hours the night before it was due to the printer. He didn't need approval from the client because he was finding the sponsors for the posters himself.

After I graduated and moved to Baltimore, I found a theater to design (and silk-screen) posters for. I employed Geissbühler's process.

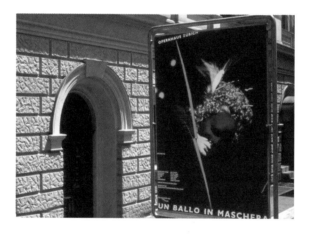

▲

After the workshop, Smith and I traveled around the continent. We soon learned that the smartest thing we did on that trip happened before we left for the airport: We bought a Eurail pass. I have no idea whether this is still a thing or not, but back then a Eurail pass allowed you to ride as much as you wanted anywhere in Europe. Thousands of other college kids with backpacks were doing the same. If we were lucky we got to stretch out in a sleeper car, if not, we would be sleeping in the aisles.

After my shakedown at the Frankfurt airport, Smith told me a joke that made me laugh so hard I couldn't breathe, so he repeated it dozens of times that summer. He told it while we were watching fishermen bash squid in Brindisi; he told it while we huddled in that dark, dilapidated youth hostel in Greece; and he told it while that poor vendor trudged up and down the beach yelling, "LEEMMOOONN IICCEEE!!" in the south of France.

Nazi Interrogator: Now old man, vill you sign ze paper?

Old Man: But what does the paper say?

Nazi Interrogator: Break a finger.

Old Man: Aaaah!!!

Nazi Interrogator: Now old man, vill you sign ze paper?

Old Man: But what does the paper say?

Nazi Interrogator: Cut off an ear.

Old Man: Aaaaaaaahhhhh!!!

Nazi Interrogator: Now old man, vill you sign ze paper?

Old Man: But what does the paper say?

Nazi Interrogator: Put out an eye.

Old Man: Aaaaaaaaaaawwwwwhhhhhhhh!!!

Nazi Interrogator: Now old man, vill you sign ze paper?

Old Man: But what does the paper say?

Nazi Interrogator: It sez you've not been mistreeted during your stay here.

We crisscrossed the continent, mostly getting on a train at night, and always looking for trips of at least six hours to see if we could get a night's sleep without paying for a hostel. We had very little money, we did a lot of walking, and we saw a lot of art. We were exposed to so much in such a short period of time that it felt like that *Star Trek: The Next Generation* episode wherein Picard is hit with the energy beam and lives an entire lifetime in the few moments he is unconscious.

I remember the epiphany well: I was drunk and I was looking for ice. I was on foot, cutting through the corner gas station, heading to a place on Water Street a mile or so away that sold ice when I stopped: In front of me was a Leer Model L40 Slant ice merchandiser (otherwise known as an ice machine). I hadn't noticed this one before, even though I bought gas there regularly. Happy that I didn't have to walk as far as I thought, and eager to get back to the party, I opened the aluminum door and reached into the cold and foggy interior, grabbing two bags of ice—one for each hand. But instead of paying for them and heading back, I just stood there, staring like a shit-faced Newton after getting beaned by the apple.

At that time, I was struggling with the written part of my master's thesis. I was trying to get out of it. I couldn't figure out what writing had to do with graphic design or changing the world. The graphic part of my thesis

was a series of advocacy posters that explored the overlap of semiotics and communication by applying, and combining, symbols for a specific effect—to pose an existential question about junk food, for example, or to parody the National Rifle Association.

I was exploring the multiplicity of meaning that can happen when a designer (me) considered all aspects of two-dimensional design as part of a code to be deciphered by the viewer (you).* I pleaded my case with Charles, who was having none of it. "I am a graphic designer, not a writer. Shouldn't the work speak for itself?" I quoted German artist Otto Dix: "Artists shouldn't try to improve or convert, they're far too insignificant for that. They must only bear witness."

As I stood in that parking lot, my hands getting cold, I realized that this ice machine was doing exactly what I was trying to get my work to do. Here was a sophisticated form of visual communication. Semiotics could be found anywhere—even at the corner gas station—not just in our *History of Graphic Design* textbook by Philip Meggs.

*If this is confusing, it's not you, it's me. My paper took years to finish and yet it was unintelligible, but I take solace in the fact that I still hold the record for most phallic symbols in a graduate thesis at Kent State University.

But, as I mentioned, I was drunk. In hindsight, I think I was just trying to avoid doing the sort of traditional research that I should have been doing, but I still think the ice machine holds up as an example of a surprisingly nuanced design object, even if it is ugly as hell. By any objective standard, its form is clunky and awkward, antiquated even. It looks like a big industrial freezer (which, of course, it is). Whoever designed it could make it any shape they wanted at this point. Yet it does not look like an Apple product. Even if you agree with me that beauty is not an important design consideration here, at the very least, it doesn't look efficient.

Continuing to play devil's advocate, the typography is unconsidered: a nondescript sans-serif typeface with a drop shadow and a cartoon accumulation of snow on top. Pure kitsch (which I liked, but I'm thinking Charles wouldn't). Note the inconsistent letterspacing.

There is no grid involved and it seems the type size and placement are byproducts of what would fit in each area. It almost seems like it wasn't designed at all. But it *has* been designed, not by Philippe Starck or Massimo Vignelli, obviously, but by someone. Engineers would be my guess. Outdated. This thing probably hasn't changed in the last fifty years.

Expanding on my drunk critique, I would now like to support the stance I took earlier: The ice machine is awesome!

After doing a little research I found out that the design hasn't changed since its introduction in 1952. This means that our relationship to this object is established. It's familiar. This also has to be proof that something about the design is working. That and "planned obsolescence" hasn't seemed to permeate the ice business.

The typography is red to grab your attention. It's a sans serif that might be Helvetica? (Cold, calculated, geometric; not a warm, organic

typeface like Garamond.) The addition of the snow reinforces the product's main attribute. The type adds an element of fun, and aren't most people buying ice for parties?

As stated before, it looks like a freezer (which it is), a place one typically would find ice. It's white (again, cold like snow).

Taken as a whole, the ice merchandiser's design is a reflection of its purpose, in a way that is appropriate and inevitable given how the product (in this case ice) is stored (kept frozen) and distributed (self-serve). Another way to put it is that it is a sign disguised as a billboard. It's there to sell you something (like a billboard) but it's serving a need (like a sign). I use *sign* here according to its broadest definition: "something indicating the presence or existence of something else."

So here it is, my drunk epiphany: You see this sign only when you need ice; otherwise it's invisible. You don't notice it until you actually need it, and then the thing you need is everywhere. There are ice merchandisers in front of every gas station, mini-mart, and grocery store that go unseen, until you are looking for ice. How the Leer looks and what it communicates is exactly what it is. It is appropriate and functional and familiar, and there is a beauty in that, even if it's ugly.

Most (but not all) commercial messages are screaming for attention, appealing to base impulses. Fashion ads in particular do this; the more retouching the better. You either *want* the person in the ad or *want to be* that person. It's an implied promise of either/or, and in both instances it makes us feel less than. We will never be the person in that ad because that person doesn't exist.

I realize that I am imbuing the ice machine with a kind of nobility that probably isn't there. After all, selling ice will never be fashionable or sexy. But hey, if they have convinced us to pay for water in bottles, maybe there is something admirable in the manufacturer's restraint. Either way, I can't help but think what things would be like if ice people ruled the world.

PART III
(Entropy)

Moving to a new city sight unseen is a weird experience. It was 1990. I didn't know anything about Baltimore, other than it was the home of the Orioles, my favorite baseball team growing up. I had married my college girlfriend after she gave me an ultimatum: "We get married or I'm leaving." Actually, Jody was too nice of a person to put it that way, but that was the gist. She was sure, I wasn't. We were living together and our lives were entangled. Remembering how much I missed her when I was studying in Europe, I reasoned that I would feel the same way if she left. So we got married in a small church in Peninsula, Ohio. On the way to the ceremony, my dad and I got stuck behind a funeral procession. I was late to my own wedding, but I stood up in front of everyone I knew and promised "Til death do us part." (My high school English teacher would call this "foreshadowing.")

We packed up everything we owned and drove to Baltimore. Our apartment turned out to be in a wooded complex that overlooked two highways north of the city. It was clean, and it looked safe, so we moved in.

 I set out on my first job search. I had finished grad school and studied with some of the best designers in the world. I had worked harder than I had ever worked before. I had the experience of teaching design for two years as a graduate student. I had found the thing that I wanted to do with my life. I felt like a graphic designer. I was confident the first job would take care of itself.

 I received a letter, before leaving Ohio, from the American Center for Design in Chicago informing me that I had gotten not one but two posters into the prestigious *100 Show*. This was the most respected

design competition at the time. While other annuals might select thousands of pieces of work for inclusion, the *100 Show* was supposed to represent the best one hundred pieces of graphic design in a given year. This was the holy grail of award shows and had been rumored (at school) to make entire careers. This letter represented empirical proof that the high opinion I had of myself was justified. Hell, if you did the math, I was responsible for 2 percent of the best work anyone was doing anywhere, and I was still in grad school. Two of the judges who had selected my work were none other than Paula Scher and April Greiman.

I had a letter from the *100 Show*—I would have preferred to have the actual *100 Show* catalog, but it had not arrived yet. I had a resume. I had my portfolio. My enormous portfolio. I decided it would be better to bring the actual posters than to photograph and mount them on black presentation board, so, as a result, my portfolio was 24" x 36".

My plan was to find out who was doing the best work in town, show them my letter and my humongous portfolio, and start working. I also planned on continuing to teach design as an adjunct at one of the design schools in town, but that could wait. True, I wasn't on my way to start my career in New York as I had planned, but I assumed Baltimore might be more manageable than New York anyway—remembering my sixth-grade class trip. Bawl-mer (as the locals pronounce it) did turn out to have a small but thriving design community, but when I began my job search, I wasn't aware of a single designer or design firm working in the city.

This was the early '90s, so the only way to find out who was doing what was to scour the design annuals (the world before the Internet is hard to imagine, even for those of us who were there). *PRINT* magazine's *Regional Design Annual* was the most useful for this purpose because it organized work by region, as opposed to other annuals like *Graphis*, the *100 Show*, and *Communication Arts* that selected the best work regardless of where it was created (which basically meant way more work from New York and Chicago, and almost none from cities like Baltimore).

I built a list of about a dozen firms and went about sending cover letter and resume, then following up with a phone call—replicating the process I used to successfully land my internship. It turned out that I had no problem getting in to see people, but each interview ended the same way: Whoever I was meeting with looked at my portfolio full of gallery catalogs, posters, and T-shirts, and said, "Honestly, you wouldn't be happy working here, you should contact Graffito."

Graffito was *the* design firm in Baltimore at the time. The problem was that I had already met with them. They responded to my portfolio, but they weren't hiring. As the rejections piled up, I realized that this was going to be harder than I thought. I had no idea what I was doing. I could talk about my work—more specifically I could go on and on about it—but I had no idea how the work of a designer fit into the world. The idea of getting paid as a graphic designer was foreign to me. When someone asked how much money I was looking for or what my hourly rate was (in case a freelance project came up), I had no idea how to answer. When was that *100 Show* catalog going to arrive?

I was nearing the end of my list and getting concerned. My wife was working—her fashion design position at Merry Go Round was the reason we were in Baltimore—but her new job would not cover all of our expenses, especially with student loans looming. We had no money in the bank.

In the middle of a particularly frustrating day of interviewing, I stopped by the post office to pick up a package after receiving one of those "while you were out" notices. After I handed the slip to the woman behind the counter, she went into the back for a minute and emerged with a small, book-size package. It was from the American Center for Design in Chicago. It was the *100 Show Annual*! I was saved. Seeing as I was heading to another interview in an hour, I ran back to the car and ripped open the package before the car door slammed. Staring back at me from the cover was an engraving of a human skull; there looked to be a digitized flame emanating from one of its empty eye sockets.

So far so good, I thought. The title at the top of the cover was set in what had to be 9 pt. Helvetica Bold. I quickly found my posters—one was on page eighty-four and the other was on page one hundred—and was immediately disappointed. Why were they reproduced so small? They bore little resemblance to the actual posters. The catalog was printed on uncoated paper so the images were dark. I briefly recovered after holding the book up to the sunlight on the dashboard. Maybe they aren't so dark after all?

Still in the driver's seat in the post office parking lot, I flipped to the back of the book, to the judges' statements. I am not sure what I was looking for. At that moment, I think I needed to hear some words of encouragement from the judges to help buffer all of the rejection I was dealing with.

I started with Paula Scher. Far from flattering, she accused all of the work selected of being derivative. When I read that, I flashed to the last day of my internship. I didn't know who Cheryl Heller was (yet), but she decried the excess of the work she saw and posed the question "What ever happened to communication?" April Greiman flat-out stated, "It used to be that getting one or two pieces into a show like this really meant something. This year we had to hold our noses to pick an additional forty pieces to bring the sixty we chose to the mandated one hundred." She concluded, "Is our profession an anachronism?"

I sat there for a few minutes, numb. Then I tossed the book into the back seat and drove to my next interview with renewed determination. Oh, I *would* show that book to whomever I was interviewing with. I just wouldn't let them read the damn thing.

My one and only job offer came from a company called Barton-Gillet that specialized in corporate communications and marketing for colleges and universities.

This would be my introduction to the world of gray cubicles, weekly staff meetings, and office politics. I was hired by an enthusiastic creative director named Bill Shinn, who could thankfully see past the fact that I had no "marketing" or "communications" in my portfolio. Bill was also the only person who didn't tell me, "You wouldn't be happy working here, you should contact Graffito," though he may have been thinking it.

The Barton-Gillet Company seemed huge to me at the time. They maybe had seventy-five employees? I worked in the art department, so they were at least big enough to have departments.

Barton-Gillet was located in an old office building on Gay Street right next door to a sex shop called the Big Top, which advertised "air-conditioned viewing booths." This was the gateway to Baltimore's famous "block," a seedy stretch of East Baltimore Street populated by strip clubs and porn shops. There were plenty of stories at the office about "the block" in its heyday, most of them from the '50s and '60s burlesque era. Blaze Starr was supposed to have started her career there. But that was a long time ago. This all sounded intriguing, but the block I came to know was not.

I would purposely walk a route to work that would take me down East Baltimore just so I could look at the signage, but that meant getting solicited by prostitutes and being invited in for the show by the bouncers out in front of clubs such as Chez Joey, the Jewel Box, or the Pussycat Club. (For the purposes of this book, I am a little sorry I never went into one of these establishments, but only a little.) The entrances all smelled like stale

beer and cleaning products. Plus, I'd never been in a strip club in my life. Part of me thought that if I went into one of those dark doorways, I might not make it out alive.

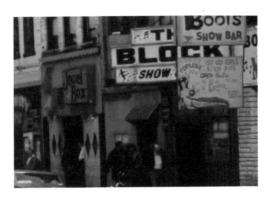

Such close proximity to the block meant that the front door of the office was kept locked because of drunks or whoever else decided to use the vestibule as a toilet. On my third day on the job I walked past a guy who was taking a shit in there.

All of this excitement and danger right outside the front door stood in stark contrast to what was happening inside. Barton-Gillet was a corporate office. It wasn't long before I started to think that they should leave the front door open. Someone shitting on the conference room table might liven things up a little.

*

I was a stranger in a strange land. One of the first indications of something remotely familiar was when one of the other designers started complaining bitterly about the typesetting on the galleys she was just handed. "Look at this rag, it's terrible!" Her name was Jennifer Phillips; she was clearly a stranger as well.

Jennifer filled in some of the blanks. The guys in the suits that came in every so often were called account executives. They were at the top of the company power structure. They brought in the projects. None

*This is an example of a terrible rag.

of them had any design background. Then came the writers. The writers were less intimidating than the account executives and worked more directly with the art department. Then there was the creative director, the senior designers, the junior designers (I was one of these), the support staff, accounting staff, receptionists, and so on, and then the paste-up artists. Seniority was also involved somehow in who could boss whom around.

I wish I had saved some of the interoffice memos from my Barton-Gillet days. One in particular was called "The Sales Bell." The account executives had installed a bell that was to be rung every time a new project came in. After more tone-deaf stuff meant to boost company morale, the memo ended with something like, "I'm sure we all look forward to hearing the bell happily ringing for years to come."

There was one account executive I called "The Black Hole." He would walk into the art department and instantly suck anything positive out of the room. This guy never smiled.

I was making a steady paycheck but this was not grad school. When I complained about it at home, Jody kept asking me not to quit. I don't mean to paint her as a controlling person. She wasn't. I was responsible for my decision-making. She was right, we needed both of our incomes, but I don't think I ever forgave her for that.

So I stayed and I tried to figure it out. No design decision was worth giving in on, no matter how trivial. Make the type bigger? "I can't, it would throw off the balance and make the composition less unified." (The design nomenclature I learned in school was worthless here, but I employed it anyway.) I didn't always win but I was persistent. I was a design mule and I'm sure I was terrible to work with. It helped that the creative director was on my side. That said, Bill's constant advice to me was, "You know, if you let some of this small stuff go, you'd make both of our lives a lot easier."

Taking his advice, I tried to look at the work I was doing in terms of a percentage. If I was doing good work 20 percent of the time at the beginning, I would push for 25 percent. Then 30 percent. If I felt like I got it there, I'd push for 40 percent. I didn't really know any better anyway. I knew I was unhappy, but I guess I thought that this is what you did: You got married and you got a job. It's not like there were too many choices. I kept channels of communication open with Graffito and a few other places in town and hoped something else might materialize. I was stuck in Baltimore and at Barton-Gillet.

Although it took me a while to appreciate it, there was an admirable design spirit in that art department at Barton-Gillet. Everyone cared. We stuck together. We made the best of the mediocre typesetting, lousy clients, and the powers-that-be. We listened to 99.1 HFS on the radio and debated about who killed Laura Palmer.*

I became friends with a paste-up artist there named Chris Panzer. Chris was a vegan who loved to freak out the people from human resources by eating a lunch consisting entirely of eight navel oranges. "But what about protein?" they would ask. This would allow him to start in on the benefits of a plant-based diet and how the human body is designed to eat fruit. "Did you know that fruits and vegetables have the same water content as the human body?" They would then go back to their meatball subs. Later that afternoon, they would be dragging and Chris would be buzzing around the art department. I wasn't eating meat anymore, so I experimented with some of his techniques. He turned me on to spelt bread and fasting and natural hygiene. He also loaned me a book called *Tissue Cleansing Through Bowel Management*, by Bernard Jensen, that I can't do justice to here.

Before he worked at Barton-Gillet, Chris had operated a silk-screen shop somewhere in southern Maryland. Once we started talking about silk screen, I convinced him to collaborate with me on theater posters. I would design the posters and he would print them. I would buy the beer and assist. I didn't have a theater yet, but since we were both prepared to do this pro bono I figured I could find one. This would be *my*

*I was absolutely convinced that "Bob" was either a graphic designer or a paste-up artist. Who else would leave cut-up letters under their victims' fingernails?

version of those posters I had seen by Karl Domenic Geissbühler. Like the Zurich Opera, my theater wouldn't be paying a design fee for the posters. I would be in control of the means of production, so I would do whatever I wanted with the design—a stark contrast to what was happening at the office. I wanted to design theater posters, even if I didn't have a particular interest in theater. It was important to me that I have a client. A purpose.

After some research I identified a handful of small theaters I would approach. First on my list was a nonprofit, seventy-five-seat black box called the Fells Point Corner Theatre. They were doing some challenging productions, and the 11" x 17" Xeroxed posters they were already doing sucked, although they did seem to be everywhere around town. I went to a show of theirs called *Burn This* and loved it. I reached out to the artistic director, an amazing person named Beverly Sokal. I think she was suspicious of me at first, curious about my motivation and perhaps wondering why what they were already doing wasn't just fine. When it came time to negotiate the size, Bev suggested 11" x 17" like they had already been doing. I told her that this size was more flyer than poster and suggested 18" x 24". We settled on 13.5" x 20": small enough to live where their posters already hung, big enough to have some effect.

So I started designing posters and, in the process, got involved in theater. I went to read-throughs and rehearsals, spoke with the directors, attended all of the productions. I would stay after work and design into the night. Chris and I would print these posters in his silk-screen studio at his Bolton Hill apartment. I approached these posters like I did my graduate thesis: by experimenting with my process and trying to capture some truth about each play. After the fourth or fifth poster I felt comfortable enough with the printing that I set up a make-shift silk-screen studio of my own in my basement. Everything (other than the squeegees) was homemade. Chris gave me his handmade spray sink. With no vacuum table, I improvised with a piece of glass with four

one-gallon paint cans holding the glass away from a fluorescent light fixture lying upside down under the glass. I created contact between screen and film with a blanket, a piece of foam core, and free weights. The spray sink itself drained into a five-gallon plastic bucket underneath. When the bucket filled, I would quickly swap in an empty one and dump the first in the laundry room sink on the other side of the room. My drying rack was a rope line with a series of clothespins.

At the time, silk screen was a dying commercial printing method and designers didn't print their own work. A designer traditionally hands off print-ready artwork with instruction for the person or people who print (that is, manufacture) the work. Printing my own work made me think about it differently. The process opened up to changes that could be made on the fly, between colors. Inevitably the work ended up much more graphic and direct due to the limitations of silk screen.

After Joseph Albers, I owe everything I know about color to the hundreds of hours I've spent mixing silk-screen inks. Randomness and mistakes could also be leveraged while printing. Silk screen, like the computer in those early days, was a way to rebel. Printing was a way to take control.

I usually tried to seek approval from the theater before I printed anything, even though this led to many frustrating discussions. They almost never liked a poster when they first saw it, often complaining about "readability" or asking why the actors weren't on the poster or where their logo was. I would nod and give assurances that I would try the things

154

they were requesting, but mostly I fixed typos. I addressed design issues only if I felt they made the work stronger (they sometimes did), but other than that, I would print what I wanted regardless of objections. A poster would sometimes change substantially after the client saw a comp, often during the printing process. I was printing these posters, I would do so only if I had control.

When I delivered the one hundred or so posters, I would get the inevitable "hrmmh" (that sound someone makes when they are disappointed), but they would always put the posters up around town anyway. The next poster I designed would be met with another "hrmmh," but now they asked why the latest poster wasn't as good as the last one, you know, the one they didn't like and couldn't read. It went on that way for five years.

I would drive around town to see how many of my posters I could spot around the city and to see how quickly people swiped them off the walls. I met illustrator David Plunkert this way. He saw one stuck to the side of a cigarette machine at the Admiral Fell Inn and sought me out. We eventually collaborated on a few of them. It was thrilling to see my design out in the world. I loved to imagine that I was taking over the city with my work. There was nothing on the visual landscape that was anything like these posters, even if they were sporadically tacked to bulletin boards and taped to telephone poles.

Working for the theater was a constant during my time in Baltimore. It was a creative outlet and it preserved my sanity. I didn't know it at the time, but this body of work would end up being my out.

▲

For six years I bounced around trying to find *the* job. I didn't realize that the reason I couldn't find it was that *the* job didn't exist. I submitted the Fells Point posters to design competitions and started to get some notice outside of Baltimore. It always struck me as sort of twisted that the fees

associated with entering design competitions cost exponentially more than the $100 or so it cost to produce them.

Designers whose work I knew from these design annuals, like James Victore and Stephen Doyle, called me out of the blue to tell me they appreciated the work I was doing. I started getting commissions from New York publishing houses to design book covers. No one was calling me about the work I was doing from nine to five.

Near the end of that last job in Baltimore, I had become director of a small design group that was part of an ad agency. After a particularly frustrating internal meeting, I huddled with my three designers in one of the outer offices. I was in a bad place. Jody and I had just separated, and I let five years of existential angst loose. "What are we doing here? Any one of us could get hit by a car tomorrow and here we are working on these shitty projects. We're wasting our lives."

None of us needed that much convincing, but still, no one resigned. No one was able to actually summon enough courage to be without the steady paycheck. This problem was solved for us a week later when we were all fired; the whole operation was dissolved by the managing partner. This asshole—who will remain nameless—was the worst art director I have ever known. But I have to admit, he got it right on this one.

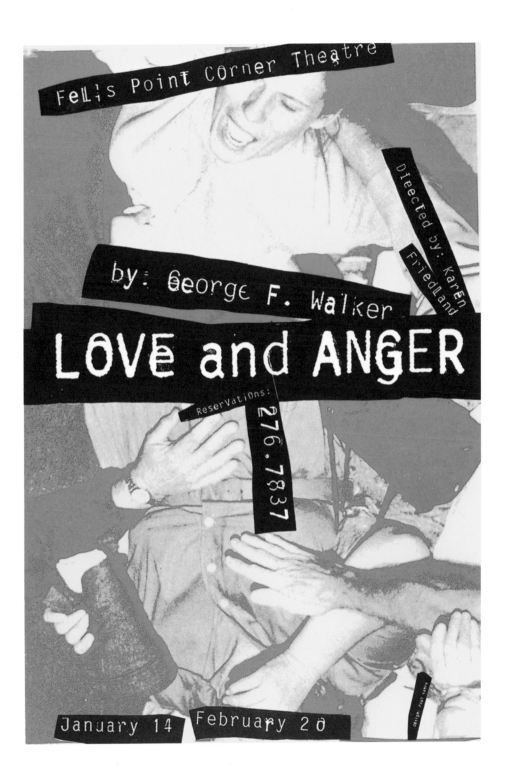

Fell's Point Corner Theatre

Directed by: Karen Friedland

by: George F. Walker

LOVE and ANGER

Reservations: 276·7837

January 14 February 20

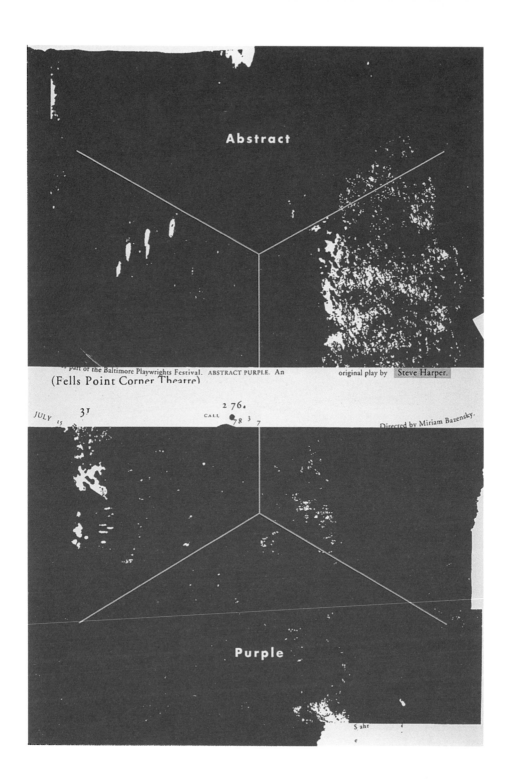

Abstract

part of the Baltimore Playwrights Festival. ABSTRACT PURPLE. An original play by Steve Harper.
(Fells Point Corner Theatre)

JULY 15 3¹ 2 76.
 CALL 78 3 7
 Directed by Miriam Bazensky.

Purple

A LIE OF THE MIND

BY SAM SHEPHARD

DIRECTED BY DENISE RATAJCZAK

BALTIMORE PREMIERE

276-7837

FELLS POINT

JANUARY 15 THRU FEBRUARY 21

CORNER THEATRE

159

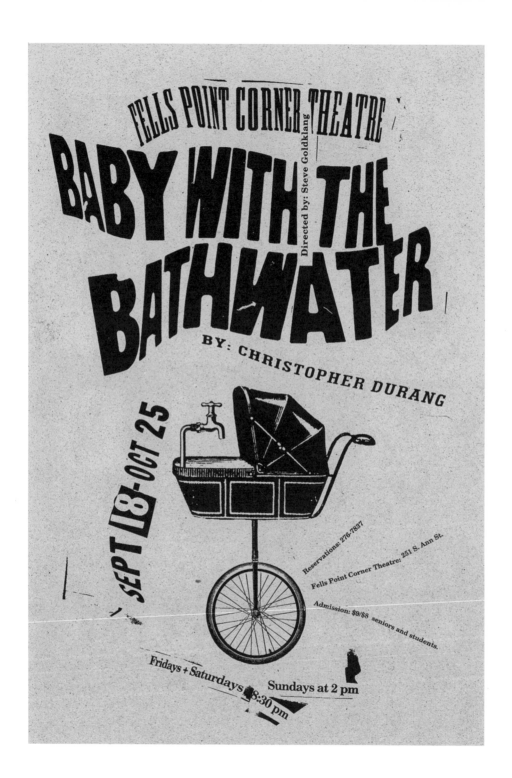

FELLS POINT CORNER THEATRE

Directed by: Steve Goldklang

BABY WITH THE BATHWATER

BY: CHRISTOPHER DURANG

SEPT 18-OCT 25

Reservations: 276-7837

Fells Point Corner Theatre: 251 S. Ann St.

Admission: $9/$8 seniors and students.

Fridays + Saturdays 8:30 pm

Sundays at 2 pm

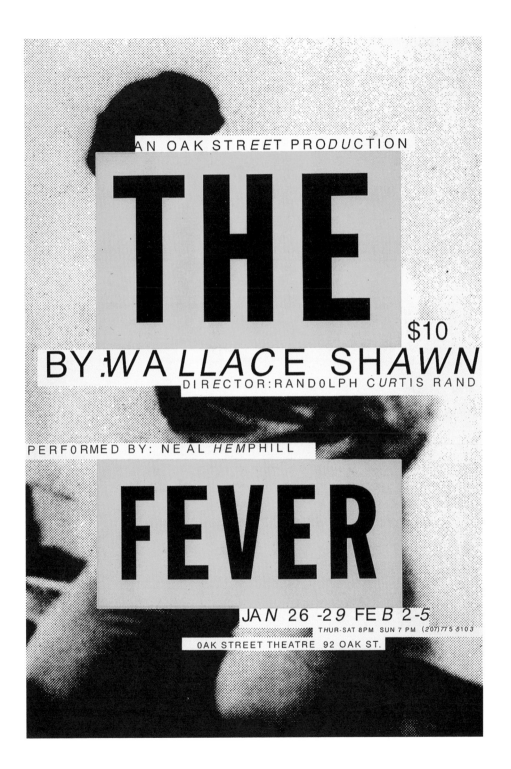

AN OAK STREET PRODUCTION

THE

$10

BY:WALLACE SHAWN

DIRECTOR:RANDOLPH CURTIS RAND

PERFORMED BY: NEAL HEMPHILL

FEVER

JAN 26 -29 FEB 2-5

THUR-SAT 8PM SUN 7 PM (207)775-5103

OAK STREET THEATRE 92 OAK ST.

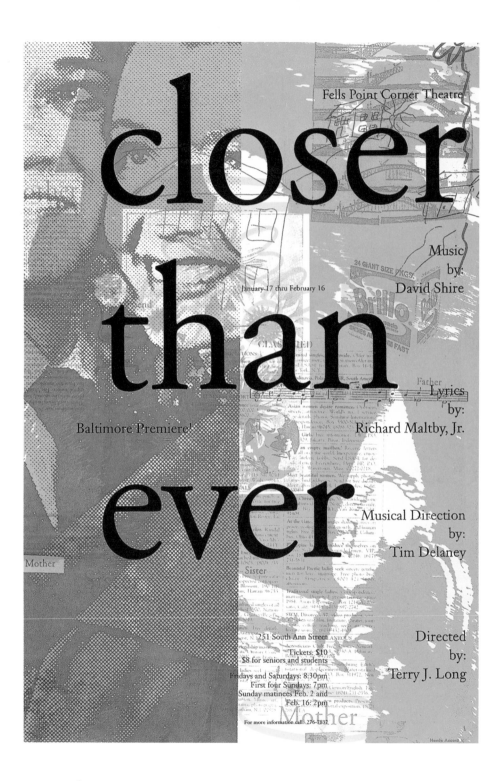

Fells Point Corner Theatre

closer

Music
by:
David Shire

January 17 thru February 16

than

Lyrics
by:

Baltimore Premiere!

Richard Maltby, Jr.

ever

Musical Direction
by:
Tim Delaney

251 South Ann Street
Tickets: $10
$8 for seniors and students
Fridays and Saturdays: 8:30pm
First four Sundays: 7pm
Sunday matinees Feb. 2 and
Feb. 16: 2pm
For more information call: 276-7837

Directed
by:
Terry J. Long

Edward Albee's

†INY
ALICE

Directed by Steve Goldklang

November 19 thru December 19

Info &
Reservations: 276-7837

Fells Point Corner theatre

Fells Point
276-7837

Corner Theatre

play by: **C P Taylor**

director: **Barry Feinstein**

Good

march **12** → april **18**

Baltimore
Premiere!

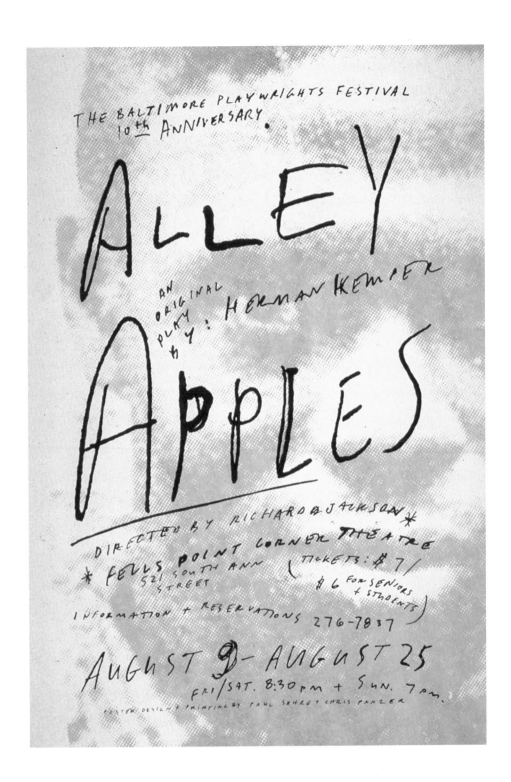

Baltimore Playwrights Festival

BY:

STEVE SCHUTZMAN

GHOSTS PLAY

ONE

This is not a home.

276-7837

Fells Point Corner Theatre

Sahr e

In 1994, two years before the end of my full-time employment, Angus had left the circus and was floundering. He couldn't find a job and was living with our parents again. My first instinct was to find a way to help him. Jody and I had bought a small row house in South Baltimore that needed work, and I decided to do it myself. I had no experience with home renovation to speak of, but I was excited by the challenge. I would hire out help occasionally, specifically plumbing and electrical, but I started the demolition myself. We were living a few blocks away in an apartment in Federal Hill by then and the plan was to move in as soon as the renovation was complete.

My idea was to have Angus move to Baltimore and help me with the construction. He didn't have any more experience than I did, but he was a strong guy with nothing better to do. He would have room and board and we would help him out with a little cash from time to time. Jody and Angus seemed to get along well, and the short-term plan was to get him out of our parents' hair. His dog, a black lab named Gracie, would come with him. There was no long-term plan.

The arrangement began well. He worked hard and spent a lot of time exploring the town—especially the bars. It was great having him around. Angus was an excitable person. If he was eating a burger, for instance, he would say, "This is the best burger I've ever eaten!" And he meant it. I loved that about him.

He had a few obsessive-compulsive ticks that became more pronounced as he got older. When we were kids he would turn the bedroom light on and off, sometimes a dozen times, before he got into bed. Now when we

were in a car he would cross himself a certain number of times super fast. Every once in a while he would squint using every muscle in his face—that's the only way I can describe it—over and over again while his upper lip tucked in exposing the top row of his teeth. *My shrink would love this stuff,* I thought.

We spent nights and weekends working together on the house and having a few beers while cranking up Frank Zappa on the boombox, both of us singing as loud as we could. But, slowly and imperceptibly, he began to slump. Empty liquor bottles accumulated in the kitchen. Progress on the house began to slow as he started missing days. Then he cut open his hand while he was slicing bread. This meant he couldn't work, but he would have more time to hang out at the bar. Now Jody was getting concerned.

A few days later we got the news that Grandpa Schoop had passed away. We were to leave at nine the next morning to drive to East Hanover for the funeral. But when 9 AM came, no Angus. We waited for a while, but without knowing how to get ahold of him, we decided to leave. As we were getting into the car, Angus staggered around the corner. He had been out all night. Seeing Angus like that, Jody decided to stay home. We were forty-five minutes late at that point and I was pissed. We argued for a few minutes. Incredibly, he was mad at us for leaving without him. He got in and the car filled with the smell of Jägermeister and regurgitated hot dogs. He was quiet for most of drive. By the time we made it to Restland Memorial Park, the place where Angus would later be buried, the service was over. *We missed our grandfather's funeral.* Another argument ensued and, in the middle of the cemetery, with the serene St. Giles Chapel as backdrop, I was rolling around on the ground trading punches with my brother. I think I heard someone scream.

Once we were all adults, I realized I felt fundamentally different about myself when I was around each of my siblings. This didn't happen that often because we all lived in different places, but when it did, I didn't like it.

When I was in the presence of my older brother, *I* was the older brother. I had all of the answers. He'd ask me to explain things to him that he didn't feel comfortable asking Mom about. One time, he was worried about his name being in an email. He wanted to know if this was identity theft, which he probably learned all about watching a commercial during an *Andy Griffith Show* rerun. I actually sat down with him and tried to explain the Internet, but I'm pretty sure I left him more confused than ever. Greg does not have a digital footprint. No email. Everything he does online, he does on my mom's computer. As a result, Mom's online identity has got to be pretty bizarre.

To my sister, I am the lefty artist. Sharon married a golf pro, votes Republican, and has two kids (who are now adults themselves). She lives a comfortable middle- to upper-middle-class existence in upstate New York. She's the "normal" one.

Angus saw me as a yuppie. Even though I'm not particularly comfortable with any of these personas, it's the yuppie thing that freaks me out the most. But after thinking about it, compared to Angus, I *am* a yuppie.

After the blowup at Restland, Angus moved in with his new girlfriend. He found a job driving tourists around the Inner Harbor in a horse and carriage. I could never stay mad at Angus for long, but my days as his pseudo-boss were over.

The renovation of our row home slowly lurched forward. Jody and I just about killed ourselves with the rented floor-sanding equipment, getting the incredibly noisy and messy job done in one long day. Our lease was up at the other place and so we moved into one room on the second floor. As we lived there we slowly claimed more rooms, eventually completing work on the whole second floor.

Additional stress was provided by our next-door neighbors. Jody and I had bought the house from an elderly couple who seemed in a hurry to sell (they also looked a little shellshocked). We got a good deal, and soon afterward we found out why. We had bought a row home next to neighbors from hell. The family of four we were now attached to were straight out of a white trash version of *Rosemary's Baby*, only add two drum kits, a beagle, and a junkyard covered in dog shit.

On top of the disorder of our unfinished house, the neighbors, and Angus, were two cats we'd had since our Ohio days, a silk-screen setup in the basement, and a new dog. Sid was a Boston terrier puppy we had gotten from a breeder in Nebraska. He flew into Baltimore-Washington International Airport and we picked him up at the airline office. When he peeked out of that crate and we made eye contact for the first time, that was that. He was my constant companion for the next sixteen years.

As this relationship was beginning, my marriage was coming apart. Things hadn't been good between us for a while, but I didn't realize how bad it had gotten until one night Jody, with tears streaming down her face, asked me to leave. This I did, staying with my friend Tasso for a few nights while Sid and I looked for an apartment.

I was looking for a temporary place to live that was cheap and close to the house. I didn't tell the real estate person this, but I was also hoping for an apartment big enough for me to silk screen in. Separation or no separation, I had posters to print.

I soon found a place at the corner of Light and Cross Streets, near the Inner Harbor. It was at street level, located behind a comic shop. It had two large rooms: a living room/bedroom and a kitchen. I envisioned the kitchen area as an improvement on the basement at home where I had been printing. It was run-down, smelled like cigars, and there was stuff in it. It was also ridiculously cheap. The real estate agent explained why: The previous tenant, an older gentleman named Bill, had passed away and his stuff was still in there. She neglected to tell me that he had died *in the apartment*, which I found out weeks later while talking to the guys in the comic shop. "Yeah, that guy Bill was great. But he stopped

coming around, then there was that smell." She offered me two months free rent to clear out the apartment myself. There didn't seem to be too much stuff in there, and my plan was to patch things up with Jody and keep this place as a print shop. So I agreed to a year lease. One weekend with a few friends helping and a coat of paint and I'd be ready to go.

That weekend, Dave and Tasso came over to help me load everything into a truck and haul it to the landfill. It was springtime but the apartment was filled with Christmas decorations, a plastic Santa Claus face on the wall. I'll never forget the sound Dave made when he discovered Bill's dentures in a cup under the kitchen sink, or how we wondered about all of that medical equipment in the closet. But the biggest mystery was in the kitchen cabinets. They were full of plastic multicolored margarine containers. Each container had been emptied and cleaned and had a white lid. They were neatly stacked, filling the cabinets. There were hundreds of them. I wondered out loud if Bill might have been a character in a John Waters film.

As a silk-screener, I am always scrounging for empty containers with lids to mix ink in, so this was the mother lode. But I was too weirded out to keep them. They were tossed with the rest. To this day I can't figure out an explanation for those margarine tubs.

Once I set up in Bill's old place, the first thing I printed was a big red rectangle over my marriage license. Dave later told me that he assumed I was punishing myself by taking this apartment. He was probably right.

A few months later, Jody moved to New York City. She took the cats and I kept Angus and the dog. Sid and I moved back into the half-finished house. Jody left me the car* and Angus took over the apartment on Cross Street. I had just been laid off and I was working out of a studio I set up on the first floor. I pursued more book-cover work, and within a few months I was making enough money to get by. The difference was that I was doing work that interested me on my own terms.

*A 1988 Mazda 323.

My marriage had fallen apart and I was driving around in my soon-to-be-ex-wife's car, but I had finally figured out how I should be working.

After Jody left, I realized the only thing keeping me in Baltimore was a half-finished house. It wasn't long after that that a to-do list appeared on the wall above my workstation. It read:

> 1. GET DIVORCED
> 2. FINISH HOUSE
> 3. SELL HOUSE
> 4. SELL CAR
> 5. MOVE TO NEW YORK

All work on the house had stopped since the separation. The ceilings were exposed joists and the walls were covered with graffiti from a long-ago party (pre-demolition), where each guest was handed a martini and a can of spray paint. The assumption was that the on-purpose vandalism would be covered over in the coming weeks with new drywall. (Of course, weeks turned to months, and months turned to years.) The lifeless eyes of spray-painted smiley faces seemed to follow me around the living room.

I considered putting the house on the market as is, but my real estate agent talked me out of it. I *could* sell it, but I would lose the tens of thousands of dollars I had already put into it—and that didn't include sweat equity. I had no choice. I had to finish what I started.

Added incentive to get out of there as soon as possible was provided by the ever-present next-door neighbors. The parents were never home, and since the drummers were already there, the "band" practiced there as well (they blew). So I recommitted myself. By day, I was designing book covers, and nights and weekends I hung drywall, laid tile, spread grout, and taped butt joints. I primed and I painted. I hired students and friends to help, mostly paying in beer and pizza. Sharon came down from Endicott with her husband, Mike, and their new baby (I was now an uncle) for weekend renovation camp.

I knew that once the house was finished, I was leaving. I started traveling to NYC to show my work around. I concentrated on publishing, putting a face to people I had already been working with over the phone. I also used this time to meet many of the designers I admired but didn't know because of my six-year detour in Baltimore.

During these trips I met with Woody Pirtle (Pentagram), Paula Scher (Pentagram), Chip Kidd (Knopf), Seymour Chwast (Pushpin), Stephen Doyle and Bill Drenttel (Drenttel Doyle Partners), Michael Ian Kaye (Farrar, Straus and Giroux), John Gall (Grove Press), Jane Kosstrin (Doublespace), among others. If you are wondering how I was able to get in to see these people, it was those damn theater posters. I didn't know anybody. It was my work that was opening doors.

My meeting with book cover designer Chip Kidd happened in the Random House copy room. I was apparently going on and on when he stopped me and said, "Can I give you a piece of advice? You've got to shorten this up, the people you are showing your work to have a life."

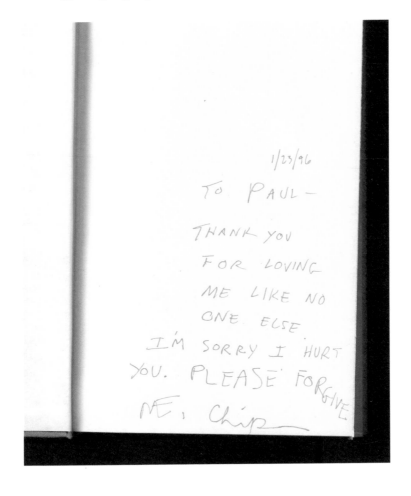

There were a few designers I couldn't get in to see. When I asked someone how I could get ahold of Dan Friedman, I was told he had died of AIDS in 1995.

I wanted to meet with Tibor Kalman of M&Co but he had closed down his NYC office and was in Italy working on *Colors* magazine. So I did the next best thing: I reached out to his protégé Emily Oberman, who had recently opened her own studio. I was familiar with most of her work from M&Co, including her design of the aforementioned *Colors*, but also for Talking Heads. I was particularly obsessed with an album cover she had designed for Jerry Harrison's *Casual Gods*.

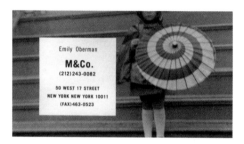

We met at Number 17, her studio. If this wasn't love at first sight, it was at least love at first meeting.

Not long after that, I convinced Emily and her partner to visit Baltimore to give a lecture to the AIGA Baltimore chapter. I made sure I was their chaperone. I showed them around town and took them out for steamed crabs. After dinner, I dropped them off at the train station. Other than some flirting, I did my best to keep it professional. It seemed creepy to try to get something going under the pretext of a design function, although that was exactly what I was doing.

I called that night to see that she got home OK and told her I couldn't stop thinking about her.

Christmas in New York

It was the end of 1996, and this meant the annual drive upstate for the holidays. My parents' house was the family gathering place since my sister's family lived in nearby Endicott, and it was a few hours south of my uncle, who lived in Utica. I was dating again. I had made a few trips up to the city to see Emily and she had come down to Baltimore once to see me. I didn't know if this was a long-distance relationship yet, but I hoped it might turn into one. I knew I loved this girl the moment she explained the presence of an ancient slice of lemon meringue pie in her refrigerator. It had been in there for years and was now a treasured family heirloom. Later on, it would move with us to Brooklyn. When it was accidentally tossed by an overzealous cleaning person, the whole family sat shiva.

Since I had to drive north from Baltimore anyway, I figured I'd stop in NYC and spend a day or two with Emily, then leave on Christmas Eve for Binghamton. It's a cliché, but New York really is romantic around the holidays.

Angus was still living in Baltimore at the time and didn't have a car or, apparently, enough money to get himself to Binghamton for the holidays by bus. I was expected to give him a lift. This would put a serious crimp in my plans as far as Emily was concerned. It also irritated me that my parents thought it was my responsibility to get his ass to Binghamton, as if I were his chauffeur. I gave in but told him that I was going up early in the morning on Christmas Eve and that he'd have to occupy himself all day if he wanted a ride. I didn't tell him I was going to keep him as far away from this new girl as possible. I was now careful where Angus was concerned—I knew my brother better than anyone, and I loved him, but too much Angus was never good for my love life. I'm not blaming

Angus for the failure of my first marriage, but I was really into this girl so I wasn't taking any chances.

When we arrived that morning it was cold but sunny. He didn't know the city that well, even if he had visited many times with the circus. I didn't know what he was going to do with the day other than buy a case of Halvah Bars and visit his favorite porn shop.

I dropped him off at the corner of Forty-Second Street and Broadway that morning and told him to meet me that night at the Nancy Whiskey Pub. This was a bar I had introduced him to on one of his earlier circus visits. It was all the way downtown below Canal Street, under the shadow of the World Trade Center, around the corner from Emily's design office. We agreed we'd meet at eight.

Emily and I did some last-minute shopping and spent the day walking around holding hands, making out in cabs, and whispering into the arches outside the Oyster Bar at Grand Central. When I said goodbye outside of her apartment it began to snow. I was running about an hour late. Angus wouldn't care; he was at a bar. I figured I'd have trouble prying him out of there was all.

When I arrived at the Nancy Whiskey, Angus was plastered. And belligerent. We left the bar and got into my car, heading up Sixth Avenue. He was jawing at me and I took a wrong turn, east onto Houston Street instead of continuing north as I should have (I didn't know the city that well either). It was then he said something that ended with "putting some

bitch ahead of his brother." That was it. I pulled over and told him to get out of the car.

He didn't budge. As we sat there, the snow started to fall harder. After a few minutes of silence, it was clear he wasn't going to get out voluntarily, so I pulled out and continued east on Houston. "If you want a ride, you'll sit there and shut the fuck up."

That's when I felt a sudden impact from my right. I was going about thirty miles per hour at the time, in a snowstorm, on Christmas Eve. We hadn't been in an accident. My brother had just punched me in the face. It wasn't a love tap. It felt like he had punched me as hard as he could. I pulled over and at the top of my lungs yelled, "GET OUT!" This time he did. I drove off.

I sped toward the Lincoln Tunnel, but as I drove, my internal big brother started in on me. Angus had no (or little) money. He had nowhere to stay. He didn't know downtown at all. He was drunk and I was leaving him stranded. Instead of going back to find him, I broke my own rule and headed back to Emily's. I don't know why I did it. When I got there she was in the lobby looking freaked out. "Your dad just called, what happened?" (I had given my mom Emily's number a few days ago, "just in case," and Angus must have used one of his last quarters to call our parents from a pay phone.)

The next thing I knew I was standing in Emily's apartment getting bawled out by my father. When I explained what happened, I got nowhere, just like old times. Angus was my responsibility. "I don't care what happened, GO OUT AND FIND HIM."

After driving around for a while, I found Angus on Lafayette Street, leaning against a pay phone. I pulled over, and, instead of getting in the passenger side, he opened the rear door and crawled into the back seat.

He was asleep in minutes.

O.O.P.S.

I had worked as a designer at three different jobs over a five-year period, but I had no idea how to get projects on my own. The account executives at Barton-Gillet used to do it with cheap suits, large expense accounts, and golf. But now that I was on my own, projects started to come to me. I was getting calls to design all kinds of things.

There were the book covers but I was also working for an agency again, but it was part-time, and was with Robert Wong. I had never met anyone who was more committed to doing interesting things than Robert was. The mid-1990s were sort of the Wild West of digital and interactive design, or "new media," as it was called then. Robert got me involved in all of it. It paid well and there were no rules. During this period, I worked on websites with him, making it up as we went along for huge companies, from Audi to Microsoft.

Another person who reached out to me was Nicholas Blechman. Nicholas was then the art director of the *New York Times* Op-Ed page. When he asked me if I had done any illustration and I told him I hadn't, his response was "Good!" He described the Op-Ed section as the heart of the newspaper, but visually it had always been the territory of political cartoonists. Nicholas was interested in getting graphic designers to respond visually to the editorials. The result of this way of art directing was that the page always presented the reader with something unexpected. The Op-Ed section was visually different every day because a graphic designer might do something graphic, typographic, or photographic, depending on the editorial. We had long philosophical discussions about the role of the illustrations on the page. The visual needed to draw attention and suggest the topic or point of view of the editorial, but it should also open up

a larger dialogue about the issues being raised by the opinions expressed. The art should have its own opinion.

Just like my theater posters, the work I was creating for the *Times* required a participant, a human on the other end. Interaction. It's interesting to see how that word has been co-opted lately by all things digital. Graphic designers have always been interested in interaction. It just hasn't always involved someone clicking on something.

My association with Nicholas started a whole new way of working, mostly because an Op-Ed illustration is such a finite design challenge. It exists in a different world than the one I was used to; it's news, it is ever changing. Once an illustration is assigned, I might have only an hour or two to do it, and that includes getting Nicholas's approval and then Nicholas getting an editor's approval. My friend, illustrator Christoph Niemann, whom I met through Nicholas, says that the severe restrictions involved in an Op-Ed illustration are liberating rather than restricting. He feels he can come up with sharper solutions because he doesn't have time to second-guess his ideas or entertain fancy printing possibilities. There is an editorial with a specific point of view. There is a specific size. It's limited to black and white. There is very little time, and the illustrator or designer has to bring his opinion along as well. I have done hundreds of these over the years.

Without any planning, and with virtually no interference from me, things seemed to be working themselves out on their own. The Office of Paul Sahre was open for business.

Emily pointed out that my acronym was O.O.P.S. and added, "It's perfect!" When she said that, I recalled something a former Kent State professor had told me years before. He said, "If you want proof that the graphic designer is needed, just take a walk down the street. Our visual world is a confusing, messy, and ugly place." When I first heard this, I embraced it as justification for committing to life as a graphic designer, but by this point in my career I had come to view it as impractical, subjective,

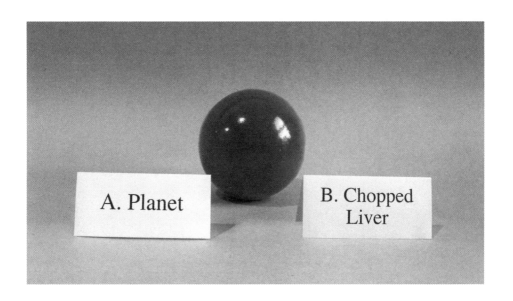

A. Planet

B. Chopped Liver

TNENIMMI SI KCATTA NA

and a bit elitist. Even if you accept the idea that the world is a mess, who, or what, is responsible? The lack of design? Everything around us, with the exception of nature, is already designed in some way.

While I will admit that my role as a designer involves ordering, clarifying, and sometimes even prettying things up, it's not my job to clean up the world. I couldn't even clean up my studio. I can't imagine a worse situation than one in which "designers" hold sway over every aspect of our visual world. Beauty and order and understanding often come from mistakes, spontaneity, and things unplanned.

O.O.P.S. it would be.

I checked off the last item on my list—MOVE TO NEW YORK—after a long and grueling day in the fall of 1997. Angus and I got up at 6 AM and started packing the U-Haul. By 10 PM, we arrived in Brooklyn in a torrential downpour. I barely had enough energy to drag my mattress up the four-story walk-up and collapse on it. Everything I still owned (after the divorce and the Baltimore fire sale) was parked outside. Angus left for Mugs Ale House across the street and Sid was asleep in the corner. I lay there and stared at the ceiling feeling more sad and alone than I have before or since.

I had just completed a two-year process of extricating myself from my former life and instead of feeling glad, I felt empty. I was lying on a bare mattress in a tiny apartment somewhere in Brooklyn. I was tired and hungry and soaking wet. What had I done? Had I thrown my life away? Then, like Marty Feldman in *Young Frankenstien,* I thought, *It could be worse.* As if on cue, the people in the apartment below me started having loud sex.

●

Walker Street is pretty dead after 10 PM. Factory lofts lined the dark and empty street. Being two blocks south of Canal, Soho Repertory Theatre (or Soho Rep.) is not technically in Soho, where all of the tourists are.

The window display my intern and I were working on was for a play called *Attempts on Her Life.* The display was a series of seventeen objects, each object representing an attempt. They were laid out on a painted powder-blue backdrop.

Attempt #1: Coil of Rope

Attempt #2: Kitchen Knife

Attempt #3: Pile of Cash (fake)

Attempt #4: Car Keys

Attempt #5: Ski Mask

Attempt #6: Answering Machine

Attempt #7: Mirror

Attempt #8: Television

Attempt #9: Sleeping Pills

Attempt #10: Laundry Detergent

Attempt #11: Empty Bottle of Scotch

Attempt #12: VHS Tape

Attempt #13: A Crowbar

Attempt #14: A Purse

Attempt #15: Pillow

Attempt #16: A Rubber Glove

Attempt #17: Table Lamp

■

Three girls, all in their late teens or early twenties, approached us as we worked. It was dark and no one was around but for the occasional passing cab. "Do you know which apartment is Ben Affleck's?" the tall one asked as she looked up.

"Ben Affleck lives around here?"

"Yeah, he has a loft on Walker Street, a block east of Benny's Burritos. At least according to *The Smoking Gun.*" All five of us were looking up now.

▲

When we first met, Artistic Director Daniel Aukin asked me for a logo. He had been working with Pentagram and he was unhappy. This was off-off-off Broadway. Like the Fells Point Corner Theatre, the productions

were challenging and the budgets were nonexistent. "They were doing the project pro-bono, but they gave me a chair! Can you believe that? A CHAIR?!" he said. It turns out that a chair as a visual metaphor for a theater was almost as bad as the comedy and tragedy masks. So, if you ever find yourself designing a logo for a theater, remember: NO CHAIRS.

While I found it surreal that I was being called on because Pentagram failed, I was also aware that I was now known as "that silk-screen theater poster designer." This was better than having no reputation, but I felt like I was more than that, so I consciously looked to do something completely different for my new theater.

They didn't need a logo, mainly because they couldn't afford to put a logo on anything. Posters were cost prohibitive in New York, so they didn't need those either. But they still needed an identity and an inexpensive way of expressing what was happening on the stage.

I designed them a sticker, a fluorescent yellow dot with SOHO REP. set in Helvetica Bold, all caps with instructions that they stick this sticker everywhere: on business cards, in cabs, and on the seats on the subway. I wandered around town trying to find Soho Rep. stickers. Spotting one was always satisfying, even if it was stuck to the side of an NYC garbage can.

●

A few hours later we saw the girls climbing up the fire escape across the street. They were determined.

Daniel emailed me one morning that the street-level window display had been broken into the night before. The large window in the front of the theater had been smashed and three items had been stolen: the fake pile of cash (Attempt #3), the pillow (Attempt #15), and the kitchen knife (Attempt #2).

The circus was back in town. Angus, returning for the first time since helping me move the year before, was staying with me for a few days in my tiny apartment on Bedford Avenue in Williamsburg. He had hung on in Baltimore for a while after I left, but he had broken up with his girlfriend, and without me to give him rides or the occasional meal, he had nothing to keep him in town, except his job driving a horse and carriage. Even though this involved animals, it just wasn't enough. When Angus left the circus, he lost his sense of purpose. It was difficult for him to describe his attraction to the circus life. He would say "I love animals" or "I like to travel," but I don't think it was only that. The circus had an audience; he walked the animals around the big top to the cheers of thousands of people, even if he was one of the guys shoveling shit. Every once in a while he would send me a picture of himself backstage with a celebrity. He was especially proud of the one he had taken with Alice Cooper.

An old vaudeville joke sums this up best: There was a man with the circus whose job it was to clean up the smelly piles of elephant dung. A passerby, who saw him hip-deep in the excrement, asked, "My good man, how can you put up with such demeaning conditions? Perhaps you should consider another line of work?" To which the circus worker replied, "What—and give up show business?"*

*As this book went to the printer, Ringling Bros. announced it was ceasing operations in May 2017. I would like to take a moment to address the concerns many had about the circus and animal cruelty. While I am generally a PETA supporter, I'd like to share Angus's take on it. He was puzzled by the protesters because he loved animals too, even if he was required to carry a bullhook (he told me he used it only in an absolute emergency). He saw himself as their protector, not their abuser.

▲

He returned to NYC, this time on foot. He walked through the Midtown Tunnel in the annual New York Elephant Walk, from Queens to Madison Square Garden. This was a traditional—mostly for show—way of announcing the circus's annual return to Manhattan.

He had a camcorder on this visit, his new toy, and he was obsessed with using it. He stuck it in my face a few times, but mainly he followed Sid around the apartment or took him out to McCarren Park to record him while he chased his Frisbee.

It was strange to see Angus with a little bit of money. Living on the circus train forced a degree of self-control that wasn't usually there. I guess there wasn't anything on the train to spend his money on.

When he had a day off, he would leave early in the morning and come back with three or four freshly recorded cassettes from his day. After one such day of filming, he came in and sat down on the couch. I was at my workstation deeply involved in a cover design for a book called *Stripper Lessons* by John O'Brien. The book is about a simple, socially inept man who is obsessed with a stripper. It struck me as I read the manuscript that my brother was an amalgamation of a number of the characters in this novel.

I didn't look up when he entered and may have grunted, "What's up?"

"Look at you, wasting your life," was his reply. I ignored him and kept working. I was on deadline and whatever Angus was talking about could wait. I had to get this cover out.

A few hours later, after the messenger left for the publisher with my cover, Angus sat me down in front of the TV. We were going to watch more of his NYC video documentation, which we did every night during his visit. His videos included the typical tourist stuff: a view from the top of the Empire State Building, shots of Rockefeller Center or Times Square . . . and footage of a woman in tight shorts walking down the street. Angus apparently followed her with his camera held low. "Get a load of that dick-breaker."

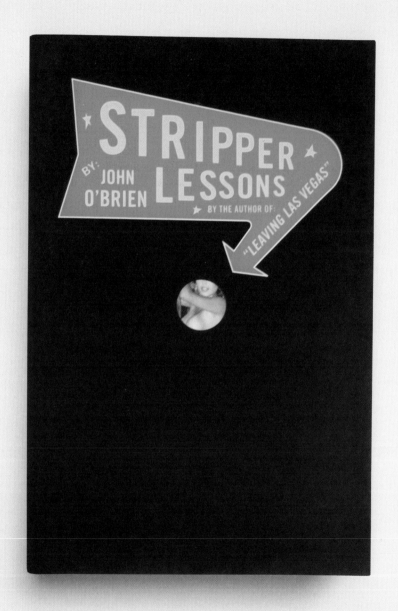

When he let this one fly I had just sipped some coffee, and it went down the wrong pipe. I coughed for a few minutes, spilling coffee everywhere. "Man, will you cut it out!" I said after I caught my breath.

Today's video started with a close-up of some pigeons. Then it followed a few people rollerblading and then some footage of himself with a homeless guy. There was a flicker in the video and then I was looking at me sitting at my computer. He had recorded me working.

Have you ever watched yourself working? Up to that moment I hadn't. Let me tell you, it's jarring. I didn't think of myself as a zombie staring blankly at a glowing computer screen. I was just sitting there. Then we came to the part in the video where my brother said, "Look at you, wasting your life." I now understood what he meant.

I don't know what I *thought* I was doing. I always felt like I was fighting, kicking, clawing. To me, working always felt like freedom. Like leaping over tall buildings. It didn't feel like what I was watching in Angus's video. The longer the video played, the more depressing it got. I had him turn it off.

Of course it's the mental things that happen when we design that keep us coming back to the screen. One illustration I did for Nicholas at the *Times* comes to mind. I found myself having to illustrate a four-billion-year-ago cosmic collision between the Andromeda and Milky Way galaxies. My idea was to anthropomorphize the galaxies. To make my idea work,

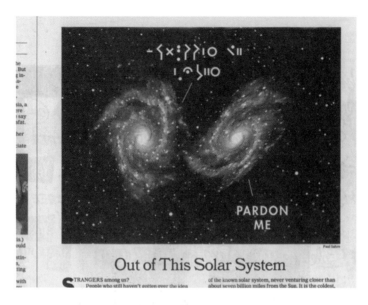

Out of This Solar System

I had to develop something that an alien galaxy might utter in response to getting bumped into by our galaxy, *and* that I could accomplish on a *Times* deadline, meaning in just a few hours. While I was working, someone in the office walked over to my desk and asked me what I was doing. "Inventing an alien language." End of conversation.

So while I spend most of my time designing digitally, I'm not always in front of a screen. There are so many ways of making a graphic mark. As a designer, I want to consider as many different means as I can. Why would you limit yourself to what the hardware and software can do? I started my career learning and employing the traditional tools of a graphic designer. Much of that work involved using my hands. I like using my hands, but of course I, like everyone else, am almost completely reliant on computers. When the power is out, it's hard to work. I remember that being a way to check in with yourself. It was a question graphic designers would ask themselves in the mid-1990s, when the transition to working digitally was underway. If you couldn't keep working in a power outage (meaning without the computers, printers, etc.), then you were somehow out of balance. That was considered a bad thing. Shows you how things have changed.

The subway ride from my office on Varick Street to the River Sound Studios in the East Nineties took about twenty minutes. When I arrived, I was led down a nondescript hallway, through a small office, and into the recording studio, where I was introduced to Walter Becker and Donald Fagen. I guessed that they were both in their mid-fifties, and my first impression was that they seemed like a pair of friendly, super-hip uncles. Still, I was nervous. I had never worked with rock stars before. This was my first meeting with Steely Dan. You know, Steely Dan. "Rikki Don't Lose That Number," "Peg," "Do It Again," "Reelin' in the Years"—*that* Steely Dan.

They played a number of songs from the album they were working on, and I remember thinking, "Look at me, hanging out with Steely Dan. Now this is why I wanted to be in New York."

I had by this time grown accustomed to getting work when the phone rang. So the day Steely Dan called (it was their manager, not Donald or Walter), I wasn't surprised, even though I hadn't done a lot of work for the music industry up to that point. I had designed a few CDs, but that certainly wasn't something I specialized in. The surprising part was that Steely Dan—a band from the '70s—still existed. The manager asked if I would be interested in designing their new CD, *Two Against Nature* (their first studio album in twenty years).

I found out later that afternoon why Steely Dan came calling. An art director at Warner Bros. had recommended me to the band. She had hired me earlier that year to work on a Tom Petty album called *Echo*. In that case I worked long distance, never meeting with the band. I ended up getting paid a kill fee after my initial work was rejected. In fact, if I remem-

ber correctly, not only was the work rejected, but it apparently pissed them off as well. I had ignored a request to work with a piece of art the band provided. It was a fax of something that was shitty to begin with, so I didn't use it—for their own good, I thought.

She indicated that Steely Dan wanted a designer they could work with in New York (Warner Bros. was in LA) and that she thought of me (I guess there were no hard feelings). What she *didn't* say was that Donald and Walter were perfectionists and could be "difficult to work with." They were infamous for torturing studio musicians. These were the kinds of things that I had read about them as I prepared for our meeting. Since I would describe myself as a perfectionist as well, it did occur to me that this could be trouble. But I didn't read anywhere that they tortured *graphic designers* and, I thought, at the very least, this could be interesting (not all design projects are).

Donald and Walter were neither difficult nor obsessive. The meeting was convivial and constructive. I felt comfortable with them. Here were two incredibly talented and focused artists who were making music, preferring the rather claustrophobic confines of a recording studio to playing in front of a live audience. It reminded me of how I worked as a designer and I felt some common ground.

We met four times. From the start they were interested in a purely photographic approach, so I introduced them to the work of my two favorite photographers, who also happen to be friends of mine: Michael Northrup and Jason Fulford. We looked through hundreds of images, and, with my help, they identified one—a black-and-white photograph of two shadows in an open field. At the third meeting they approved a cover. I then went away to design the rest of the CD packaging (back cover, booklet, disc, etc.). There was a question as to whether we should "colorize" the cover, but I figured I could talk them out of that later. Colorizing a black-and-white image seemed like a bad idea, and we could always have Michael reshoot in color. Everything was going well as far as I knew. That is, until the fourth meeting.

Something was different this time. From the start, this meeting had an entirely different tone from the previous three. I had spent the time between meetings designing the rest of the CD package. After I finished presenting, Walter and Donald immediately asked why I hadn't colorized the cover as they requested. Then they started to discuss the design as if I wasn't in the room, talking to each other and not to me. "We'll move this over there, make this bigger, replace this image, change this color," and so on. I explained, they ignored me. I tried again, they ignored me. I sat back and let them go. I was done.

As this continued, I was getting pissed. I started to do as Mom always instructed, "Count to ten, dear." My internal dialogue was something like, "Easy, easy, let them finish, get out of here without losing it." I didn't make it. I stood up and, as evenly as I could I said, "I don't work like this. I quit."

It was at that point that Donald jumped up and pointed a finger in my face and yelled,

"FUCK YOU!"

Then turning to Walter, I lost it.

"SEE WHAT I MEAN, YOU HAVENT SEEN ATTITUDE! "ATTITUDE?

ATTITUDE!" ATTITUDE!

 IF YOU THINK

 I WAS GOING TO DO ANY OF THAT,

"FUCK YOU!" YOU ARE OUT OF YOUR MIND!"

 "FUCK YOU!" *

*These may not be the exact words that were exchanged, but you get the gist.

197

"FUCK YOU!"

While exchanging FUCK YOUs at the top of our lungs, I gathered my impotent CD design and headed for the door. On my way out, I passed their stunned assistant, who had heard the whole thing from the other room, and I yelled,

"HOW CAN
YOU WORK FOR THOSE
ASSHOLES?!"

Heading back downtown on the subway, all I could think was, *What the hell just happened?*

▲

Sixteen years later, I still have no idea what happened. I mean, maybe in their minds I was somehow disobeying orders? But no order was given; I know because if there was an order, I would have disobeyed *immediately.* I wasn't ever going to colorize that image. I didn't show them an alternative, meaning I didn't initiate a photo shoot (this would have been a way of accommodating their request). In my defense, you don't spend money that doesn't yet exist to shoot something that isn't yet approved. And, if there is one thing I learned early on, it is that the designer's cliché holds true: "Never show a client something you aren't prepared to follow through with."

It does occur to me that, given their reputation, this sort of thing probably happened to them all the time (more likely involving a studio musician). Still, I wish I had handled it differently. Not because I said no—in my opinion, designers don't say no enough. It was the *way* I said no that I regret.

Part of a designer's responsibility is to manage a process and, in this case, management was the most important aspect of the project. In this, I

failed. A designer typically has clients, but at the same time a designer has to have a sense of ownership over whatever is being designed for it to be any good. Designing is not taking an order at a fast food take-out window. For that matter, design is not about making clients happy.

In my mind, doing what they told me to do would mean making something less than, but that wasn't the reason I quit on the spot. I quit because I was angry. I felt disrespected. But regardless of how I felt about Steely Dan in the moment, it was *their* CD. My contact at Warner Bros. deserved better for recommending me in the first place. If I had it to do over, I would have done everything the same, minus the part where I quit. I can see myself finishing the meeting with no incident, thanking them for the "input," and heading back to my office, where I would call Warner Bros. to inform *them* that I quit. This is how I should have handled it. If you are going to work with rock stars, you can't be surprised when they *act* like rock stars.

In the end, I was paid a kill fee and they hired some shitty design firm who gladly did every idiotic thing they wanted. I haven't worked for Warner Bros. again (and probably never will). Of course, CDs are obsolete now anyway, so all anyone will ever see is the cover, albeit the size of a postage stamp on iTunes or Amazon.

I should also mention that Steely Dan went on to win four Grammys for *Two Against Nature* (for the music, not the design).

As a sole practitioner I've come to accept that a crack opens in my head every three years. It seems biological, like the salmon run, or the Vulcan *pon farr,* only my three-year itch has nothing to do with sex. It's a reflex action in response to the cumulative affects of working for oneself. It's the longing to be taken care of: the steady paycheck.

After working for myself for a while, the novelty wore off and I had some clarity. I started to see my earlier working experiences in a different way. I always blamed *them*: the managing partner, the account executives, the clients, or the creative director. I came to realize that the problem wasn't them, it was *me*. I was ultimately responsible for whatever situation I was in. Even though it sometimes doesn't seem like it, we always have choices. And, like it or not, a lot of those choices involve money.

Money, meaning having more than I absolutely need, has never been that important to me. I have always viewed remuneration as the result of doing what I wanted creatively. But this way of thinking almost guarantees conflict if working at a job, or a lot of scraping and clawing where money and bills are concerned if you work for yourself, especially with New York City office rent and an employee or two. This inevitably leads to anxiety and stress. The pressure builds over time until you remember that you once had a "real" job. And at this job you didn't have to take out the trash or save your receipts or fix the computers or remember to pay Con Ed. *And* if you did absolutely nothing all week, you still got paid on Friday. The daily opening of the mailbox to see if that check came wears on you. You begin to forget why you work alone.

Over the years I have, for the most part, successfully navigated these dangerous periods. Discussions are had, possibilities are discussed,

and an interview or two may happen. Talks go nowhere, I don't accept the job (or it's not offered), and things don't happen for one reason or another. During this process, that check finally comes in, and then I remember how irritating Kyle from accounting was and that I despise groupthink. If all else fails I'll read Shirley Jackson's "The Lottery" over and over again until the urge subsides. I can then rededicate myself to staying independent for another three years.

●

In 2000, I deviated from my road map. I found myself at Doyle Partners, a graphic design firm founded by Stephen Doyle.

At almost the same time, *Emily and I broke up.* Even though we weren't married, it felt an awful lot like *my divorce. I had convinced myself* that I hadn't moved to New York for Emily, but I kind of did. *We were* living together and my life in New York was intertwined with *hers.*

I loved her, but *I was not getting married again.* She was sick of hearing that and was moving on, with a "friend," as it turns out, who we were sharing a summer rental with on Shelter Island.

Once I realized what was happening, I attempted a Hail Mary cock block in the form of a hastily conceived marriage proposal.

She said no.

I was wrecked. I was angry.

Everything in the city reminded me of her.

So instead of jumping off a bridge or joining the Navy, I chose full-time employment. I rationalized that I would keep my mind occupied, work with a designer I admired, and pay off my credit cards.

Stephen and I had talked about working together three years earlier. Despite numerous warnings of a potential *Odd Couple* situation from people who knew both of us well, I would join as an associate partner. We agreed to give it a year. I closed up my windowless office at Varick Street.

I would miss working alongside Brian Rea, my studio mate at the time, but regardless I moved into the Doyle offices on Broadway.

Early on, Stephen and I both made concessions to make it work (Stephen, as it turned out, more than me). Most of my stuff went to a storage unit, but I brought along my books, my Nike Hercules nose cone, and my dog, Sid. Working on Procter & Gamble was my biggest compromise, while Stephen's was having an animal in the office. The stuffed and mounted deer head in the lobby didn't count. In retrospect, it's sort of insane that either of us thought this would work.*

Sid knew. During his entire sixteen-year life, the only place he ever pooped indoors was right in the middle of Stephen's office.

*My time at Doyle Partners included arguments over pastel colors on Crest toothpaste packaging, power struggles that often centered on my attire, and a dispute over a 300 lb. container of cheese puffs. There may or may not have also been a meeting with *Talk* magazine's Tina Brown that may or may not have ended with her telling Stephen, "I never want to see that man again as long as I live." I resigned after eight months.

Life seems random, but damn if it's really just the same things happening over and over again, only with enough time in between for us not to notice.

But every once in a while there is a new wrinkle.

I was seeing this woman who was a Radiohead fan. So when I found out that Radiohead was playing *Saturday Night Live* that week I tried to get us tickets. "Fan" isn't quite right, but I'm not sure what you would call someone whose favorite thing is crying in bed while listening to "Black Star" on repeat.

I had been to *SNL* a few times with Emily, who had been designing the opening sequence for years (one year, she was even in it herself). But we weren't on speaking terms since the split, so I had to find another connection. I had been to *SNL* recently with my friend Leanne Shapton, who used to work for the show, so I was seeing if she could hook me up. It looked like it might be a possibility all the way up to that Saturday. In the end, Leanne couldn't get tickets for whatever reason. So what do I do? Well, obviously, I invite this girl to meet me and Angus (who was in town again) at the Nancy Whiskey Pub.

Repeat. We even sat at the same corner of the bar.

Angus was on his best behavior. We talked and drank and played shuffleboard. Time passed, more drinks were consumed. It was getting late and we were the only ones left in the bar. We were getting ready to leave when two guys walked in.

"OH . . . MY . . . GOD!"

she whispered. I said, "What?" She immediately motioned for me to keep it down. "It's Thom Yorke!" I wouldn't have recognized Thom Yorke if I

fell over him, which was sort of what was happening at that very moment. Angus, who was also oblivious, came over and said, "Who, those guys?" and off he went. She was mortified, but there was no place to hide. Angus was in control. He chatted with them for a few minutes at the shuffleboard table and motioned us to come over. We talked for a while, they were friendly, or at least as friendly as you can be when you are accosted while trying to unwind at an empty dive bar somewhere in Manhattan after performing on *SNL*. We left victorious—this was way better than going to the show—marveling at the sheer odds against something like that actually happening.

Instead of ending the night on a high note, I suggested getting something to eat. We went to Lucky Strike, a restaurant/bar that would still be open and was a few blocks away. It was during this dinner that Angus got belligerent and called this girl a bitch and the evening blew up like it was supposed to.

A few years after, I read a book by Bruce A. Smith called *The Path of Reason*.* Smith argues that coincidence is meaningless:

> The human mind tries to make sense of things. From the moment we are born, we start doing it. We have to figure out what all those blurs and funny noises are. We figure out the difference between real people and stuffed bears. We identify shapes and learn colors. We categorize. In our adult lives, we don't stop doing this. We continually look for order. It is no surprise that we should observe patterns around us. It is only a mistake when we assign meaning to these things when there is none.

While I might normally agree with the author here, he didn't know me or my brother.

The Path of Reason: A Philosophy of Nonbelief (Algora Publishing, 2008).

When O.O.P.S. resumed operations, there wasn't a plan other than keeping things small and the overhead low. My new office was on the third floor of a run-down four-story walk-up on Sixth Avenue and Fourteenth Street in Manhattan. The building was in a busy, nondescript seam between Chelsea and the West Village, belonging to neither. This was not an area you would expect to find a graphic design studio. It *was* an area you would expect to find a Dunkin' Donuts, which was on the first floor of the building.

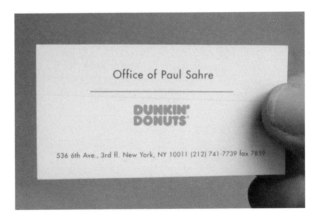

I found the space through fellow designer Hjalti Karlsson. His studio, karlssonwilker, was looking to vacate the third floor and move to the second (opting for a few more square feet and an existing bar area for a slightly higher rent) just as my experiment at Doyle Partners was ending. When I took over the space in 2000, I was paying $1,200 a month. (If you are wondering, by 2014, when I left the space, the rent was a little over $3,500. If you are reading this ten years from *now* and you work in Des Moines, this will probably still sound exorbitant.)

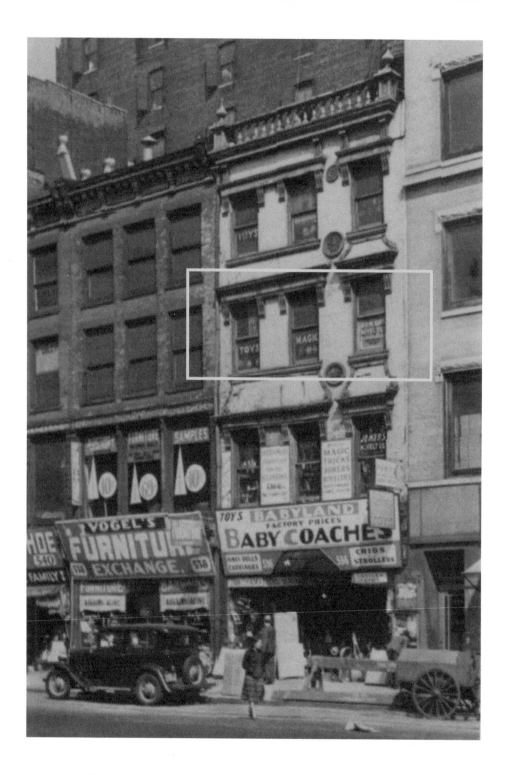

The building itself was built in the early 1900s. The interior was a jumble of crappy cosmetic and structural changes, mixed with original details like largely intact tin ceilings. At some point in the recent past, the place was a brothel. There was the occasional late-night ring at the buzzer, with an "old regular" at the door. No words were exchanged. They gave a knowing wink, we shook our heads, and they politely left.

We found a 1930s photograph of the building online. Incredibly, it *already* looked run-down. This building used to be the home of Babyland, which sold baby coaches and toys at factory prices.

The windows on the third floor read:

TOYS. MAGIC. JOKERS.

I installed a small neon sign with the studio acronym O.O.P.S. in one of the windows facing Sixth Avenue. It was on 24/7.

I was still trying to blot out the memory of those early office environments. Those spaces in Baltimore didn't inspire or coax a creative impulse, at least not for me. My studio today is a kind of alternate reality to those office spaces. My office has phones, file cabinets, desks, chairs, workstations, and a watercooler. It's just that I've concentrated on making my office a place where I would *want* to spend my time.

Above a portrait of George Washington hung a small banner I got
while on a press check in Seoul, South Korea. These banners were hang-
ing all around the print shop as a reminder for employees. It translated to
"You Are Alive." As in, you are not lazy, you have energy. Basically,
"Get back to work!"

White Sheetrock walls covered up who-knows-what in terms of original
construction. It turns out that pushpins work great in drywall, so if you
had visited the studio you would see hundreds of thousands of tiny holes
all over the walls, just like the crit walls back at Kent State. Where you
see holes, I see a book cover, or a *New York Times* illustration, or a theater
poster, or that doomed Spalding Gray project for the Criterion Collection.

I purchased most of my office furniture from a place called City-Surplus, a warehouse that used to exist in Baltimore. This was where all of the out-of-date public school equipment and furniture went up for sale to the public. The tables in the studio were old elementary school art tables— a million names scratched into them and a million pieces of gum stuck underneath. The word "fart" appeared seven times. It became a tradition for interns or freelancers to carve their names near their workspaces.

Jan from downstairs once questioned the legitimacy of a reference library in a contemporary design studio, pointing out that eventually all of the books I own will be available online. I highly doubt that books like *Easy Bazaar Crafts* (1981), *Transportation for the Elderly* (1979), and *Soda Cans, Old and New* (1972), would ever make it online. And even if they did, so what?

As far as technology is concerned, I may just be a graphic design pioneer. It happened when my twenty-two-year-old intern asked, "Why do you call the computers in the office 'machines'?" My first response was, "Isn't that what you call them?" He laughed, "No, I call them 'computers.'" Clearly I am the old guy in the room (I prefer pioneer).

I have been using computers—in various forms—since the mid-1970s when my dad bought his first home computer. When the Macintosh came out in 1984, designers referred to it as a "machine." This was an old/new term, employed because "computer" meant antiquated, black-and-white PC with cassette tape data drive.

I'm sticking with "machine."

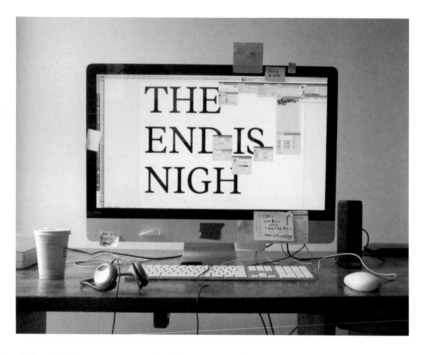

The office kitchen commanded just enough space for the ubiquitous office watercooler and a mini-fridge. The fridge was usually empty except for a few cans of beer and a couple packets of too-old ketchup. The office coffeemaker was located on the first floor (DD).

Two or three times a week, I ate at a luncheonette across the street called Village Yogurt. The name was misleading because they were known for their steamed vegetable dumplings. I ordered the Combination Fantasy with Kimchi. It didn't matter that the condiment containers were sticky or that there were C-level celebrity endorsements on the wall (including the signed portraits of Jan and Hjalti from the second floor).

I'd pour the small plastic container of tahini sauce over the brown rice and steamed vegetables, careful not to get any on the dumplings. I'd dip those in the soy sauce only. It was delicious. If the owner, Mr. Kim, served me, he'd make a comment about how kimchi is good for the intestines.

Mom, I made it: BFA (left), MFA (right).

The office was on one of the busiest corners of Manhattan. It was nice to just sit there at the window and observe the stream of people heading every which way. It was an ideal place to watch the Halloween parade.

■

Since the writing of this book, I moved the office. While much of what I have described exists in the new space, some does not. Location-specific stuff is no more. No more too-loud Eurotrash music coming from downstairs. No more Combination Fantasy at Village Yogurt. No more donuts.*

But no matter the location, putting the key in the door of my own studio each morning starts a day full of possibility. What do we have to design today? Over the years, working in that space, and in that way, allowed me to do the kind of work that I *wanted to do* rather than *had to do*—even if that meant just squeaking by financially at times. Any way you look at it, doing business in New York City is difficult and expensive. I am not complaining, mind you. Yes, my office is a dump, but it's *my* dump.

*I decided to describe the old space because, in some ways, I still feel like I'm there. It's kind of like the generally accepted relationship-breakup equation: Take the total time you were together and cut it in half. That is how long it will take you to recover. Using this math, I won't *really* have a new office until 2022.

The majority of us were spectators. Witnesses. Nonetheless, the events of that day—and the days, months, and years that followed—have created a bond with the city that is hard for me to describe. The city was shut down outside my new office window at Fourteenth Street. Everything stopped for a while. Missing persons flyers appeared on the streets. It was impossibly quiet, except for sirens and the sound of military aircraft circling. Then there was the smell. Fires burned at Ground Zero for months after the attacks. When carried by the wind, it would find you wherever you happened to be. Over the next few weeks, businesses reopened. The city restarted, out of necessity.

The reason I am going into any of this is that my life took a sharp turn then, in a way that had nothing to do with terrorism, or the deaths of thousands of innocent people.

I was on a deadline, so Sid and I got into the office early. It was a week after we closed up the summerhouse out in Montauk I had shared with Nicholas, Christoph, and Brian. I was tan and rested. This signaled the end of one of the best summers of my life.

I was doing some work for a Japanese cellular company. There was a deadline the next morning so it looked like it was going to be an all-nighter. I was sitting at my workstation when Ella from karlssonwilker came in. "Do you know what's happening out there?" I gave her a confused look and she pointed to the window. Sixth Avenue was filled with people looking south. I stuck my head out but all I could see was blue sky. No one was on my side of the street. "What's going on?" I headed out to see for myself. As soon as I crossed the street I saw that both towers of the

World Trade Center were on fire. Without thinking, I walked south, toward the towers.

I tried to piece together what I thought I was seeing, and what was going on around me. Both towers had smoke pouring out of them. The wind was coming from the west and I was a couple of miles north. It was absolutely clear where I was. There was no sound. There was no smoke, no smell, it was all headed east.

On the streets, people were freaking out, while others seemed to be going about their business. Some were standing and watching, and others were having breakfast like nothing was happening. There was very little traffic coming up Sixth Avenue. Cabs were pulled over with knots of people gathered around listening to 1010 WINS. I walked through all this, picking up little pieces of information, a word or two from a radio and parts of conversations:

"World War III."

"Two planes."

"Terrorism."

"Now we'll never get a cab!"

"Explosion at the White House."

"People jumping."

"Four more planes in the air."

I walked down as far as Christopher Street and stopped next to a tree to think. There were a lot of people walking up Sixth Avenue from downtown, away from the towers, while I was walking toward them. I didn't really know why I was doing that. I was still far enough away that the only thing I could make out was a lone circling helicopter.

Was I walking closer to get a better view? How many people are in those buildings? Only a few days before, I had watched a documentary about the Triangle Shirtwaist Factory fire. I had no interest in seeing people jumping out of a burning building. I knew that much. Should I keep heading south and see if I could help? Should I go back to the office, pick up Sid, and get the hell out of here?

As I stood there, unsure what to do next, the first tower collapsed. Not a sound from where I was, other than a collective groan from those watching on Christopher Street. I wasn't aware of how I reacted, but a woman standing next to me put her arm on my shoulder and asked if I was alright. When the smoke and dust started to clear, the outline of a single tower remained.

How many people just died?

It was only a matter of time before the second tower fell and I didn't need to stand there watching it. There was no hope. I turned around and headed back to my office. When I got there my assistant Cynthia and the intern were listening to the news reports on the radio. I told them they should go home. That's when the buzzer rang.

It was Emily.

We looked at each other for a few seconds. I gave her a hug. We hadn't seen or spoken to each other in over a year. She was completely out of my life at that point. She had never been to my new office. Now the sky was falling and here she was. Things were getting a little more chaotic outside but we went down to the street anyway. We walked up to Fifteenth Street, found a relatively quiet spot, sat down on a brick wall in front of a parking garage, and talked.

"How have you been?"
"Are you dating that guy anymore?"
"How are Moe and Arline?"
"My god, Delores isn't still alive is she?"
"Yes, Angus is back with the circus."
"What now?"

After Emily went home, I tried giving blood at an area hospital but they didn't need it, so I went back to the office, took Sid out for a quick walk, and got back to work. I still had a deadline in the morning.

Barricades and military personnel appeared at Fourteenth Street. I worked late into the night and slept on the army cot in the office. The city was deserted but for the occasional emergency vehicle or fire truck heading up Sixth Avenue, breaking the silence.

Not long after all that, we were dating again.
Then we moved in together.
Then we got married.
Then Emily gave birth to twin boys.

In 2004, friends of ours got married on September 11. They reasoned that they would reclaim that date on the calendar, at least for themselves and the people who loved them.

Emily and I think of 9/11 in a similar way, though our "anniversary" was not a choice. We don't celebrate it, but for us, 9/11 was the day we realized we needed each other.

LIMITATION AS OPPORTUNITY

I used to assign a CD redesign project in class. The brief involved each
student redesigning an existing album, taking into account two new
design limitations that would not have existed for the original designer:
no photography and one color only, *black*. These two new restrictions
were arbitrary; I could have easily told them that they all had to include
a unicorn (I did do this on another assignment). The point is, the two
new restrictions create a new situation for the designer. The design would
still need to visually reflect the music in some way, or, put another way,
would have to function as something to be *looked at* before (or during, or
after) being *listened to*. But now the designer would have to find a way
to do this without color or photography. On the face of it, severe limi-
tations raise the level of difficulty when designing, and some students
resented me a little. What they didn't get is that I was trying to make it
easier for them.

When I assigned this project to the class, they had already commit-
ted to a specific album they were to redesign. When I got to the part
about no color, there were a number of suppressed groans and one audible
"Fuck!" This student, Rus Yusupov,* let slip the expletive because he knew
redesigning his album with these new restrictions—Pink Floyd's *The
Dark Side of the Moon*—would be nearly impossible.

Why? Well, for one thing, this particular album cover is iconic. It
was designed by Hipgnosis and George Hardie in 1973. There is virtually

*Rus went on to cofound Vine.

no way to separate the album from the album art—ignoring or totally reimagining the existing cover with a redesign just didn't seem possible. And while this was testimony to how singular the original packaging was, this fact, combined with the new restrictions—especially the no-color restriction, because of the album's dispersive prism and resulting rainbow—certainly didn't seem to make things easier for poor Rus.

Nevertheless, he came back the following week and presented this:

The redesign was inspired. Armed with, rather than limited by, these new restrictions, he had found a way to do something both surprising and appropriate. This kind of result is why I like to throw trouble my students' way. Even an arbitrary situation is unique, one that will never come again. As designers we should not ignore or try to circumnavigate a particular parameter and instead allow limitations to become opportunities. An inflexible restriction like "no color," even when color seems essential, provides

an opportunity to react, and this is precisely what a graphic designer must do to get to work.

I would argue that the assignment's limitations helped this designer to a place he never would have reached had the brief been open-ended. In his response to the prompt, he found a way to address the two most important restrictions. By including the iconic triangle shape of the prism (a direct reference to the original cover) as a show-through, the designer produced a spectrum of light via the reflection off the disc itself, revealed in the case's interior. The result is a contemporary, fitting reinterpretation of the original iconic design. This solution is not forced but novel: a unique expression of the situation the designer faced. And, more importantly, it is attainable only through the filter of a set of given constraints.

A perfect example of the benefits of creatively embracing limitations. It amazes me how many graphic design students can emerge from four or five years of study and still not understand the core of the thing that they, as designers, do: make unique work from unique situations.

▲

I once handed my typography students a yellowed copy of *The Hockey News*, and required them to use this issue for all of the visual material for their design assignments that semester.

A few weeks before the start of the school year, during another visit upstate, I had found a box labeled "The Hockey News '73–'74" in my parents' attic. These were the newsprint publications that my father had used to compile the Dusters Yearbook thirty years previous. Some of the issues had holes where articles used to be. This box had not been saved on purpose; my father simply forgot it was up there or it would have been thrown out long ago. Even though these yellowed newspapers had no monetary value, I couldn't help but try to think of some way to repurpose them.

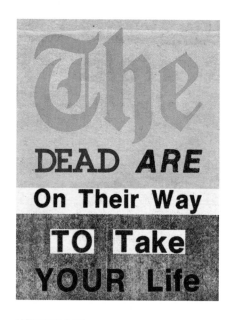

The
DEAD ARE
On Their Way
TO Take
YOUR Life

MAN ON
SKATES GETS
BLACK DISK
IN NET

HEY,
lets
SHOOT
THE
shit

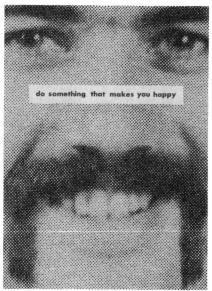

do something that makes you happy

A design brief like "Design a message for the future" (that had nothing to do with hockey), combined with the limitations of the existing typography and imagery, yielded interesting (and unexpected) results (especially with digital or interactive assignments)—another example of the benefits of creatively embracing limitations.

By the end of the semester each issue of *The Hockey News* resembled the cartoon bones of a fish.

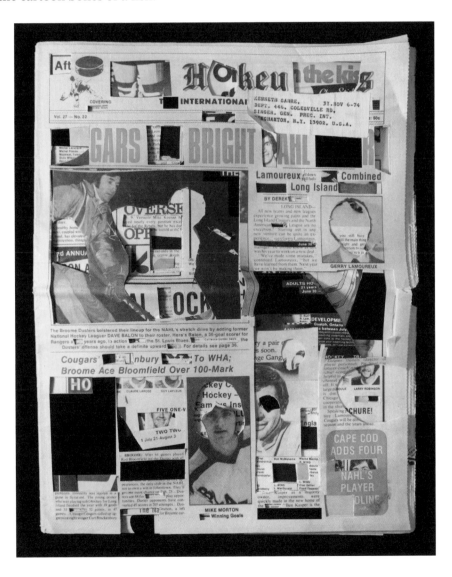

I am constantly telling my students, and need to remind myself from time to time, that it's good to be lost.

Students tend to try and visualize what something will be right away. This is the worst thing you can do as a designer. While knowing what something is going to be before you design it could remove some of the uncertainty and stress, it is antithetical to what design is. Design is a process of finding out. Plus, if you already knew what something was going to be, why bother doing it?

This was the premise for a senior project class I taught at the School of Visual Arts. The idea was to put the students through a process of finding out what they would be exploring with their work. It started with a simple reaction to a prompt that would lead them somewhere. This destination would, in turn, lead somewhere else, and so on. Eventually, each student would settle on a thesis topic to explore through a series of assignments. One of the most memorable was a project where they were asked to design a performance piece. Whatever they did, it had to be an exploration of their topic.

The performances were held at Soho Rep. The place was packed and it was hot. A student named Jeremy Diamond, whose topic was "What Is Difficult to Endure Is Empowering to Recall," was the last to take the stage.

He walked out with a bucket and proceeded to self-induce vomit, sticking his finger down his throat over and over. He threw up on stage for a few minutes, which felt way longer to everyone present. The smell of vomit

was now filling that small enclosed space. All eyes were glued on Jeremy. Where was this going?

He stopped, wiped his eyes. He reached into the vomit-filled bucket and fished around, taking out small objects. It took the audience a few moments to realize what he was doing. He was retrieving typography. He had actually *ingested type* and brought it onstage in his stomach. Now he was making a poster with the type. What is difficult to endure is empowering to recall, indeed.

SEND IN THE CLOWNS

Critiques continue to be the basis of design education. Students are given a brief and are asked to go away and design. They come back a week or two later and hang or project on the wall what they have designed. Discuss and repeat. I am often left to wonder if there is a better way.

While I consider myself unconventional as far as my teaching methods are concerned, I haven't found anything better. The problem is that crits can easily fall into familiar patterns, so I like to find ways of creating situations that are unfamiliar.

One time I assigned a project that required the students to design something cute, an oversize poster that would elicit a specific response from the viewer: *Awww!*

Seems pretty simple, right? Wrong, at least for a room full of graphic designers. After I explained the assignment I told everyone that they had a week to design this cute poster and that we would have a special surprise guest critic. They were expecting somebody like Stefan Sagmeister, but they got my mom, who had driven down from upstate and had dressed up for the occasion. I figure moms are cute experts, right? It was fascinating hearing her react to the students' work. She talked about pastel colors and teddy bears and rainbows. I did the same thing in another class, except with the prompt "make someone laugh." I rented a clown as our guest critic.

I like to teach by example, but at the same time it can be easy as a teacher to slip into an empirical mindset. No teacher has all the answers. Different and often conflicting opinions—even if they happen to come from my mom or a clown—can be invaluable.

Some of the students questioned the validity of what I did but had to admit they learned something. I know I did. In fact, I feel I have always approached my teaching in a selfish way. An assignment needs to be interesting to me first. As the teacher, I need to be engaged. If I am, I have a much better chance of engaging my students.

Centralia

> This was a world where no human could live, hotter than
> the planet Mercury, its atmosphere as poisonous as Saturn's.
> At the heart of the fire, temperatures easily exceeded 1,000
> degrees. Lethal clouds of carbon monoxide and other gases
> swirled through the rock chambers.*

Centralia, Pennsylvania, is a modern-day ghost town located seventy miles southwest of Scranton. It was abandoned in the 1980s due to an underground mine fire that started in 1962 and has been burning ever since. This town has literally been on fire for more than fifty years.

It would serve as a backdrop for a poster announcing an upcoming American Institute of Graphic Arts (AIGA)/NY event I had agreed to moderate. I would join photographer Jason Fulford, artist and author Leanne Shapton, and designer Peter Buchanan-Smith—along with the band Timber!—onstage at the Fashion Institute of Technology (FIT) in May 2003. Someone had the idea of creating a stage in the middle of the mine fire, and then replicate that stage for our presentation in New York.

This would end up being the strangest photo shoot I would ever be involved in.

The evening before the shoot, we drove to Jason's place in Scranton. He had carved out an amazing work/live situation in an old industrial building on the edge of the city. He hadn't been living there for a few months, so the heat was turned off and the furniture was covered with sheets.

*From David DeKok's *Unseen Danger: A Tragedy of People, Government, and the Centralia Mine Fire.*

That night, the seven of us—Jason, me, Leanne, Peter, Gus, Logan (from the band), and my dog, Sid—huddled together in the smallest room in the place. We slept en masse on mattresses on the floor to conserve heat. In the morning, before hitting the road, we all pitched in to create the crepe paper lettering that was to be used on set and we loaded the furniture.

This was before GPS. Centralia had been erased from our road map, so our small caravan got lost a few times trying to find it. There were no street signs either and we eventually had to stop at a gas station in nearby Numidia and ask for directions.

What was once a thriving community is now a couple of buildings. Houses were torn down or consumed by the mine fire over the years. Most roads leading into town were closed due to huge cracks in the asphalt caused by subsidence. In what was once the town center, all that remained was a decrepit public bench with CENTRALIA PA hand-painted along the back-rest, an assortment of mismatched lawn chairs, and a metal heart bolted to a tree that read

WE LOVE CENTRALIA*

The people are long gone, but the infrastructure is still there, the roads and fire hydrants now overgrown with weeds. Then there was the fire itself. Clouds of smoke billowed from the ground and the air reeked of a combination of sulfur and burning flesh. Hell on earth.

We shot on a frigid day in December. And yet, despite it being well below freezing, there was standing water due to the heat of the fire (see foreground of poster on pages 228–229). Other than the toxic fumes, one of the reasons the town was abandoned was the danger of the ground opening up beneath you. In 1981, a twelve-year-old named Todd Domboski fell into a steaming hole caused by the mine fire. He survived, barely, after his cousin pulled him out.

*Set in Hobo.

There we were (idiotically, in retrospect) right in the middle (or should I say, on top) of the most active area of the fire. Ignoring the toxic fumes, and the danger of a subsidence, photographer Gus Powell calmly documented us as we set up the stage exactly as it would appear months later in New York City (including roundtable, drum kit, amp, and crepe paper letters). Once Gus was sure he had gotten his shot, we packed up and left. No one got hurt (or got pneumonia), but this one has stayed with everyone involved.

●

When we reconvened on stage at FIT, Jason rented a smoke machine to replicate the mine fire. As we shared the experience of the shoot with the audience, smoke billowed all around.

It was early Sunday morning and we had the sidewalks of the Lower East Side to ourselves. I was still half asleep, coffee in one hand and Sid's leash in the other, trying not to spill as I was dragged to the East River Park by a twenty-five-pound dog. Sid was small, but he was solid muscle. During our daily walks he learned to leverage every ounce, keeping his center of gravity low—leaning, jerking, randomly changing direction, or slowly increasing pressure—to make me aware that he wanted to give something a sniff. If this failed and I insisted on skipping something interesting, he would resort to a sudden stop. Apparently, there were areas of the city worth marking even if it meant getting unintentionally dragged for a few feet.*

It was a push and pull that we both understood. He wore a shoulder harness because the standard around-the-neck dog collar seemed to be cutting off his air supply. Sid was a Boston terrier—or "American Gentleman" as the breed is sometimes called. This nickname refers to the Boston's distinctive black-and-white markings, which give the dog the appearance of wearing a tuxedo. This dignified visual interpretation was often at odds with reality, especially when Sid was digging for snacks in the cat box.

We were about halfway to the park when I looked up and found myself face-to-face with a book cover I had designed; it was wheat-pasted to a temporary wall surrounding a construction site.

*This happened every four or five feet of our twenty-minute walks.

In fact, there were about a dozen of these covers, poster size, on an area marked:

POST

NO

BILLS.

Now *I* was the one who stopped dead and, in the process, I crossed Sid up and his leash snapped taut, jerking him around. (Sid was just as perplexed at the things I stopped for.)

I'll occasionally see a book cover on the streets, which is to say propped up in a bookstore window and at actual size (6" x 9", give or take). Covers rarely become posters. Especially *this* cover. It was for a book called *Killing the Buddha: A Heretic's Bible.* An especially hard book to sum up, it was an unconventional collection of essays on religion. The title comes from ninth-century Zen Buddhist teacher Lin-Chi, who said: "Kill anything you happen on. Kill the Buddha if you happen to meet him." Anticipating my confusion, the publisher had also sent along this:

> After years on his cushion, a monk has what he believes
> is a breakthrough: a glimpse of nirvana, the *Buddhamind.*
> Reporting the experience to his master, however, he is
> informed that what has happened is nothing special, maybe
> even damaging to his pursuit. And then the master gives the
> student dismaying advice: *If you meet the Buddha*, he says,
> *kill him.* Why kill the Buddha? Because the Buddha you meet
> is not the true Buddha, but an expression of your longing. If
> this Buddha is not killed he will only stand in your way.

The cover design ended up being a literal visual translation of the title: part street sign, part religious pamphlet. When I initially had the idea,

I called Jason and asked him if he had any photographs of heaven. He sent me an image of a blue sky with sunlight peeking through clouds. To this I added a large red "X." The resulting image is the canceling out of the divine (or seemingly divine) and, we hoped, a canceling out of a particularly bad visual metaphor.

After much debate, I was able to convince the publisher that the cover would have more impact with no typography, just pure imagery.

The authors loved it, the marketing department not so much. To compensate for their concerns, the title and authors' names appeared on the spine as large as possible, with prominent sales copy and obligatory book blurbs appearing on the back cover.*

Given all of this, seeing this cover as a poster was a complete (and pleasant) surprise, even if I couldn't make any sense of it, assuming the publisher was responsible for the wild posting.

"Wild posting" is a form of advertising in NYC. It looks DIY, but is far from it. There is a company that controls the seemingly public street-level wall space in New York. It's always been a kind of quasi-monopoly maintained by a few shady media companies. And wild posting is not cheap. Advertisers pay hefty placement fees based on where the posters appear (per neighborhood). If you take matters into your own hands and paste posters without these organizations, you could get a summons (it's illegal) or your poster will be pasted over the next morning.

*Covers are an interesting design challenge because they need to do a number of things, simultaneously, that are at cross-purposes. On a purely functional level, a jacket is there to protect the book, but I also like to think of a book cover as a door. It's the beginning of the experience of reading. A book cover should be appropriate, it should feel right (in an unexpected way), and it should create an experience of its own. Then there's the packaging (selling) of a book. It is accepted as fact by the publishing industry that book blurbs sell books. Having spent years arguing with editors and art directors to forgo quotes on covers, I have accepted that resistance is futile, but that doesn't stop me from complaining. Of course this is all relative. I once had the misfortune of working on a James Patterson cover. When I called the author to see if there was a manuscript I could read before I started designing he replied, "You shouldn't need to eat a Big Mac to know how to sell it."

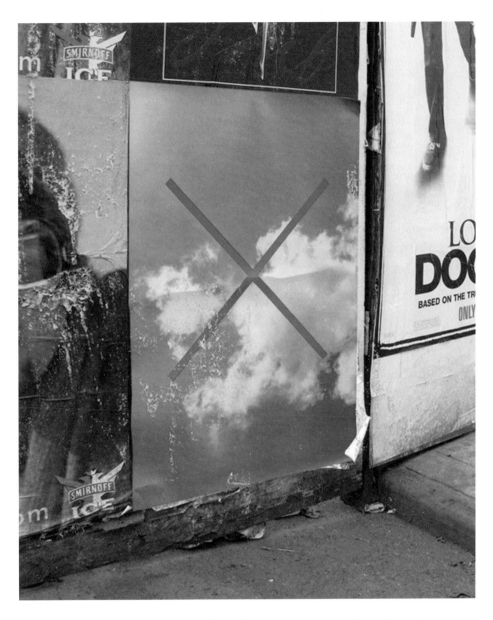

As Sid and I made our way back to the apartment on First Street I spotted more Buddha Xs. They didn't appear to be selling anything and they also seemed to be X-ing out whatever they were next to: posters featuring too-thin fashion models, Absolut Vodka ads, or the colorful Apple iPod silhouette dancers. The contrast was palpable.

A few years previous, Nicholas, Christoph, and I designed a poster for a lecture we were giving for the AIGA. It was 1999 and the lecture was happening at the same time as the Kosovo War and its resulting refugee crisis. Since we had to produce a poster to promote our event anyway, we used this as an opportunity to put a message on the streets of Manhattan to raise awareness of the humanitarian crisis. In addition to the poster being mailed to designers, we convinced the AIGA to pay to have them posted around the city.

The poster was direct, with the word MEANWHILE set in Helvetica Bold and superimposed over a photograph of a deserted Kosovar refugee camp. On the street, the message created a shared moment. It emphasized the urgency of the situation that was happening on the other side of the world at the very moment the viewer was looking at the poster. While designed to be open-ended when it appeared alongside commercial messages on the streets of NYC, the poster did have a caption and a phone number for the American Red Cross.

The Buddha X poster had no such call to action. Nothing indicated the poster was a book cover. No title. No author. No blurbs. Nothing but a red "X." I couldn't get over it. Why would the publisher decide on such an abstract form of advertising to promote a book?

Some things defy explanation. Some things can't, or shouldn't, be explained. It was a graphic design miracle.

☐ ZOMBIE
☐ SPACESHIP
☐ WASTELAND
A BOOK BY
PATTON OSWALT

Omon Ra

Victor Pelevin

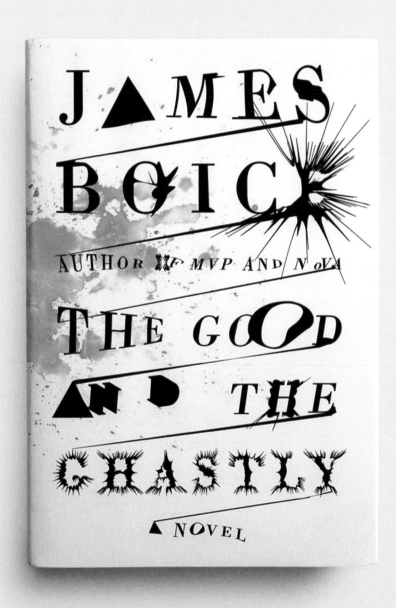

JAMES BOICE

AUTHOR OF MVP AND NOVA

THE GOOD AND THE GHASTLY

A NOVEL

242

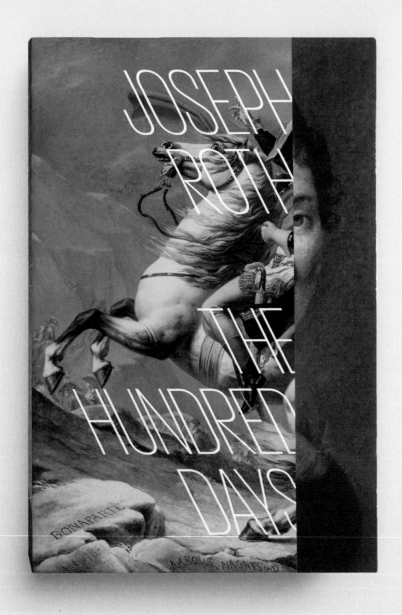

But What If We're Wrong?

Chuck Klosterman

There is a misconception that most graphic designers suffer from, myself included. It's the idea of the dream project. It goes something like this: If only I could work for my favorite soft drink, organization, band, etc . . . only then will I be truly happy. I think this idea persists because, for the most part, a graphic designer is consistently put in situations where she or he doesn't know anything about a new client. Even if there is some familiarity with what they do, there is still a period of research involved before we can start designing. So we are always designing for concerns we might not have any knowledge or affinity for. We tell ourselves that this is a good thing. "We are always learning." While this is true, we don't really believe that. Because I began my career working on projects that an account executive got just because he played golf with someone, I suffered from this delusion . . . until the first time I actually got a dream project.

■

I was in a cab heading uptown when I called Emily. "Yeah, it's my first meeting at Marvel Comics. I am now six years old, and if I don't grow up between Fourteenth Street and midtown this is going to be a bad meeting." I grew up and the meeting went just fine, if a little disappointing. I would be designing a concept book for Marvel called *Maximum FF*, the brainchild of author Walter Mosley. I met Walter, which was great, but the Marvel office was not what I had in my mind's eye. It looked like some of the stale corporate offices I started my career in, only here there were life-size cutouts of the Hulk and Spider-Man. The company

had been sold numerous times so there was nothing left: no Silver Age art, no old inking pens, no archives, no Steve Ditko.

Walter wanted to re-create the wonder he experienced as a boy when he first read *Fantastic Four* #1 in 1961. He envisioned a "maximized" hardcover book version of the comic. We were able to access scans of the original negatives. The original art is missing, which has led some to speculate that Stan Lee has it up in his attic. The story goes that he hid it from the lawyers when artist Jack Kirby won his lawsuit with Marvel and reclaimed much of his original art.

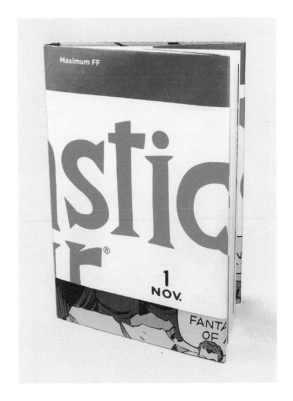

On the whole, I think we ended up with an interesting book. Walter and I worked together at my office on Sixth Avenue to iron out the details. The book jacket was a folded-down poster enlargement of the cover of the original comic. Working with the original scans gave me goose bumps more than once. All that was great.

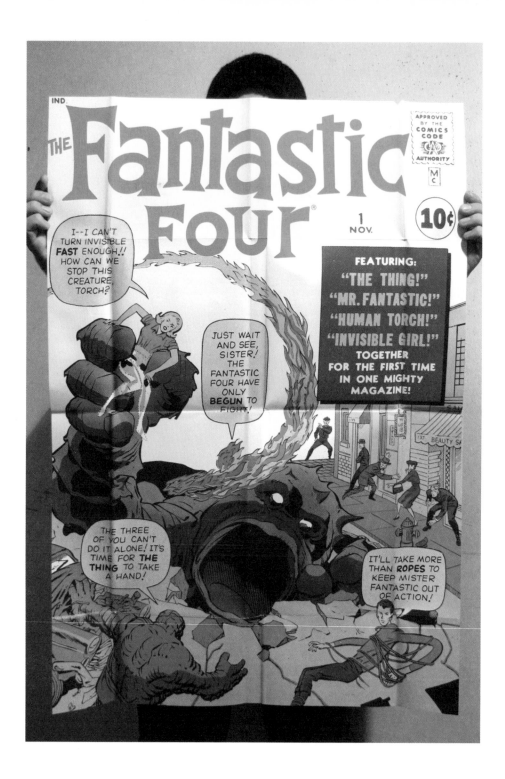

And the process of dealing with Marvel was *fine*, I guess, but the expectations were so high there was almost no way I wasn't going to be let down. There were production issues that stemmed from Marvel's inflexibility and cost-cutting. The most egregious of which was that the hardcover book was perfect-bound instead of stitchbound. This meant the pages were glued into the spine instead of sewn in, so after you pay your $50 and read the book a few times, the pages fall out.

Some fans liked it, most complained about every aspect of the design and production (some justified, some ridiculous). One comment was aimed at the jacket-cum-poster: "Sure, I'd love a poster of the cover of *FF* #1 . . . *if it wasn't folded.*"

I picked up drawing again in 2004 as a subtle form of protest of the Bush administration's policies, most notably the Iraq War. I drew members of the Bush administration for Nicholas Blechman's alternative-political magazine, *Nozone*. They looked like disturbing, unfinished fan art.

It was strange, I thought I had forgotten how to draw, yet I was drawing as if I had never stopped.

Ever since, drawing has been part of my image-making repertoire. The drawings aren't any better, and the subject matter hasn't changed much, but they don't end up on my mom's refrigerator.

MY FIRST POSTER

The poster announced the third in a series of design workshops at Kent State. It was 1987 and it was my first year of grad school. I was aping the modernist approach of my mentor, j.Charles Walker. I don't see much of "me" in this. I was struggling to put into practice some of the two-dimensional design theory I had been taught as an undergraduate.

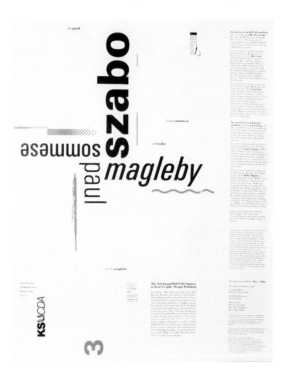

We were working on Macs at this point, but they were really only used for comping. The art that went to the printer was a conventional paste-up and Linotronic output. Enter the waxer.

Here I am a year later pushing away from my modernist base camp while clearly aware of *Emigre,* a highly influencial design magazine in the late 1980s. This year it was workshops in "Computer Design."

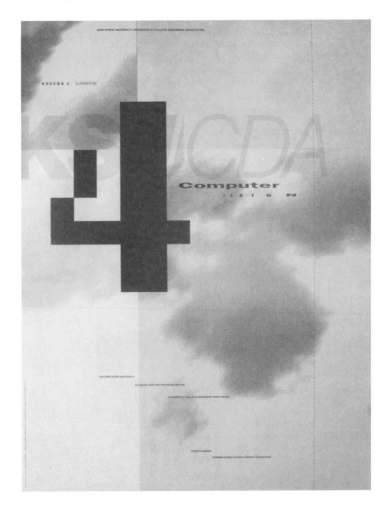

The credit reads:

DESIGN BY PAUL SAHRE USING THE QUARK EXPRESS AND DIGITAL
DARKROOM PROGRAMS ON THE APPLE MACINTOSH II*

*With its twenty-megabyte hard drive.

A young designer stopped by the studio and sheepishly showed work he was doing "on the job." I flashed back to the last such job I held, in Baltimore. Specifically, I was thinking about a project I should never have been working on in the first place, an annual report cover, that degenerated into a situation wherein the client, a middle manager at Blue Cross Blue Shield of Maryland, was standing behind me making me move type around, "Move this over here . . . try this in blue," etc. I insisted that we put a sunset in there while we were at it.

I told this designer to quit immediately and figure out how to pay his bills some other way. This is advice I would have found difficult to follow when I was in a similar situation (that is, making a steady paycheck). I had to be fired before I finally made the decision to work for myself. I always wished I'd quit that last job, which is probably why I remember this cover twenty years later.

VOICE DEFENSE

I once worked on a logo for a ridiculous product called Voice Defense. It was a small, handheld alarm (like a car alarm only portable), but this one didn't beep. It yelled:

"HELP ME, SOMEONE HELP ME!"

This poster was created very early on for Fells Point Corner Theatre, and it's so bad that I have kept it hidden away in a flat file over the years. I have included it here because it serves as a bookend to my internship experience in Cleveland. At the time, I justified the poster by calling it an "homage," and that it "parodied" artist Barbara Kruger's work.

Stealing, even when it's for a specific reason, is rarely a good idea. Parody is weak. It's ALWAYS better to try to make something new, even with the probability that you will fail in the process. Joe Orton's uncomfortable, funny, and original play deserved better.

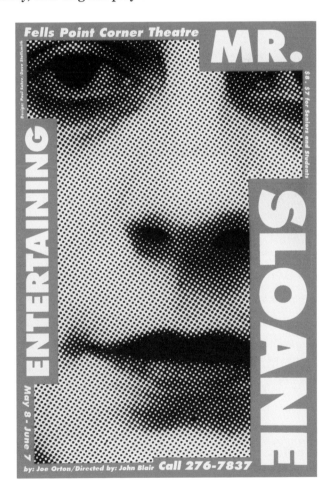

I don't know where I got this or who designed it, but it's the business card equivalent of a royal yacht: the engraved, embossed, foil-stamped, 9-PMS-color, pearlescent business card of Rama IX, the king of Thailand.

HOW I CHANGED A HISTORY OF WESTERN PHILOSOPHY

Since typography should be a core area of competence, I'm not 100 percent sure why most graphic designers are such terrible spellers and proofreaders. Even in the era of spell-check, this remains the case. My theory is that we are so focused on the form of the type that we often miss the typo. Case in point: Please note the ridiculous error on this cover, which, in effect, retitles one of the most important books of the twentieth century. I noticed this years after my redesigned cover was in just about every philosophy classroom in the English-speaking world. The correct title is *A History of Western Philosophy*, not *The*.

I wonder if Bertrand Russell would have been "philosophical" about this? "Mr. Russell, the graphic designer thinks the title works better on the cover this way: 'A' would hurt the rag. 'The' works much better."

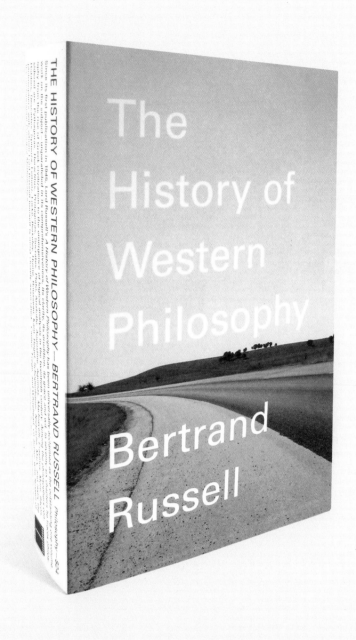

CAN WE HAVE A REAL BEAR, PLEASE?

I have done hundreds, if not thousands, of editorial illustrations over the years, and I am still occasionally surprised by a client objection.

What you see here is (or what I thought was) the final illustration for a *Time* magazine piece about Obama getting chummy with Wall Street and the auto industry. But this wasn't the final illustration.

They asked for a real bear.

To summarize: They were OK with the person-in-GM-logo suit but had an issue with the person-in-bear suit.

FUR EXTRA-ROUNDED

My one and only typeface design started with a poster for Fells Point Corner Theatre. The poster (designed with my friend David Plunkert) was for a play called *A Lie of the Mind* by Sam Shepard (regret #1: we misspelled his name, see page 159). We manipulated the typeface Futura on a stat camera by throwing the lens out of focus. This resulted in letterforms being rounded to varying degrees. I set about designing a typeface with the experiments we did for the poster as a starting point. I was interested in the idea that you could take a well-known typeface like Futura and develop a new set of variations (rounded, extra-rounded, extra-extra-rounded) to augment the existing typestyles (bold, light, extended, italic, etc.). I had large plans, but when I got down to the actual task of drawing and refining each character,

I realized I didn't have the gene necessary for that sort of attention to detail—that and someone alerted me to the fact that Neville Brody had already designed a typeface called Blur that was the same thing, except he started with Helvetica. I ended up combining many of the studies I had done up to that point into a single typeface.

The quick brown fox jumped over the lazy moon.

I got a great piece of advice when I was trying to settle on a name. "It's your first typeface, right? Then whatever you name it, don't name it after yourself; you will probably end up regretting it if you do."

~~Sahre Extra-Rounded~~

Thus, Fur Extra-Rounded was born. I sold it to T-26 Digital Type Foundry and every year I get a royalty check for a few hundred bucks. I have also watched, in surprise (and horror), as others employed my typeface on everything from book covers to potato chip bags. For years, Fur Extra-Rounded wandered around the world with no purpose, an experiment, lost.

I can happily report that Fur eventually found its reason for being. It has been used (quite appropriately) in the "Are You Gellin'?" ad campaign for Dr. Scholl's.

Are yOu gellin'?

DYNCORP

I guess this is my Leni Riefenstahl moment. Actually I had a number of these at my first job in Baltimore. Due to the company's proximity to DC we did work for a handful of clients that fell into the category of "military-industrial complex." Whenever I was assigned one of these projects it caused internal debate.*

This was a capabilities brochure for a company that serviced military aircraft. I was troubled enough about working on it that I designed a cross out of the headline on page three. When questioned about it I said I was referencing helicopter blades. This was my silent (if idiotic) protest. I wasn't forced. I didn't ask to be excused from the project because of my beliefs. No one said, "Work on this DynCorp capabilities brochure or you are fired." I guess I just felt that it wasn't my client and this was my job. I was being paid to design things, did it matter who or what I was designing for?

*As an aerospace engineer, my father worked his entire career on military contracts for various governments around the world. He didn't seem to be wracked with guilt about it.

The answer to that, of course, is yes. There is nothing a designer has to do. We choose to do things for different reasons, but it's always a choice. A designer is responsible to, and for, their clients. The job doesn't free any of us from this responsibility.

CONTEXT IS EVERYTHING

I collaborated with Nicholas and Christoph on this poster in January 2002. It was a present for fellow designer James Victore on his fortieth birthday (copies of the poster were handed out at the party).

This poster reminds me how important context is to the work we do as graphic designers. Looking at it now it doesn't make any sense, at least not in terms of the original intent. It's missing the context of the moment in which it was designed. At the time, we were inundated by patriotic messages in the period directly after September 11, 2001: Statues of Liberty, bald eagles, American flags, I (Heart) NY More Than Ever. These types of messages were strange to see on the streets of New York. This was before the United States invaded Afghanistan, before the United States invaded Iraq. The poster relied on the current environment

and was designed to be yet another (but in this case intentionally) lame ultra-patriotic message, which was ironic, since Mr. Victore himself would only employ an American flag as the tongue of a skull or something.

Perhaps this is a subtle observation, but one of the reasons the poster was ironic is now gone. The context has changed. The poster is still ironic, but in a way different than originally intended. And, of course, irony itself was declared dead around the time the poster was designed. For me, a purposefully lame-yet-somehow-good poster in 2002 is now, in 2017, just lame.

Therefore a question occurs to me: How much consideration should a designer give to how his or her work might be understood in the future? Is this even possible? And even if it is possible, is everything we design doomed to be lame and eventually misunderstood?

In *Capital: Volume I* (1867), Karl Marx wrote that "marketing often masks the intrinsic human connection to value." He described this "connection" as "the fantastic form of a relation between things." That anything man-made has a value that comes from all of the human interactions involved in the making of that thing.

So, on one hand, this cover is the result of hundreds of years of injustice that led to the racial murder of four black sharecroppers. This led to the writing (fifty-seven years later), editing, design, printing, distribution, etc., of a book. On the other hand, this cover is a lie.*

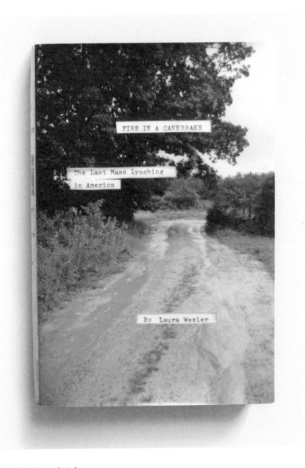

*Marx might have called it a fetish.

While it evokes the sense that something terrible happened here, this is not the spot of the Moore's Ford lynching. It's a beautiful photograph by William Eggleston of a Southern dirt road that is *similar* to the place where the murders happened.

The only image of the actual location available to me was a grainy, black-and-white crime scene photo. We all agreed* that this image would make for a weaker cover.† The marketing of this book, i.e., getting people to buy (market value), outweighed the connection between the event and the cover (intrinsic value).

AN INNOCENT SCAN

I am always reading, and what I am reading is almost always a book I'm designing a cover for. This makes for a somewhat random reading list. Saying yes or no to cover commissions is my only control mechanism.

Enter the book *Parallel Universes: The Search for Other Worlds*, by Fred Alan Wolf. It deals with quantum mechanics, black holes, and relativity. As I am not that familiar with these subjects, much of the book was over my head, but when the author turned to imaginary time and what it might be like if the present interacted with the future and the past, I could totally relate. This book was also my introduction to the many-worlds interpretation, which states that there exists an infinite number of universes and everything that might have happened in our past, did happen in some other universe. This means that every time you come to a stop sign and

*Editor, creative director (John Fulbrook), marketing department, and me.
†And would hurt sales.

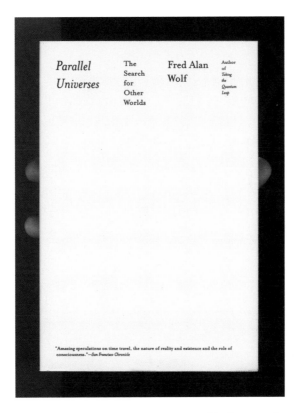

Parallel Universes: The Search for Other Worlds by Fred Alan Wolf, Author of *Taking the Quantum Leap*

"Amazing speculations on time travel, the nature of reality and existence and the role of consciousness."—*San Francisco Chronicle*

turn right, there is a universe where you turned left. To a designer, the implications of this theory are staggering. After all, designing is a process of making decisions. The different possibilities involved (and parallel universes created) in the design of this cover alone boggle the mind.

But it wasn't until I scanned the cover that I became concerned. When I opened the scan in Photoshop, I was surprised to see that the graphic of the portal—a mirrored, rainbow-foil stamp centered on the cover—had somehow *disappeared*.

Could scanners act as doorways to other universes? I mean, if Wolf can suppose that schizophrenia patients are in touch with alternate worlds, then why not? I wish I had known this earlier, as I am now imagining all the things I have ever scanned showing up in some other universe.

That, and I just noticed there is too much leading between "parallel" and "universes."

The little fuck-ups can be the most troubling.

I was asked to design the materials for the Type Directors Club's competition and exhibition. This is one of my favorite design annuals. I was looking forward to designing the book and the call-for-entries poster, but the certificate of excellence was another matter. I generally loathe these things. I mean, it's nice to have your work recognized, but, outside of third grade, the certificate seems kind of desperate and sad to me. So when it came time for me to design such a certificate, my approach was: "What does this need to be to make me want to hang it on my wall were I to receive one?"

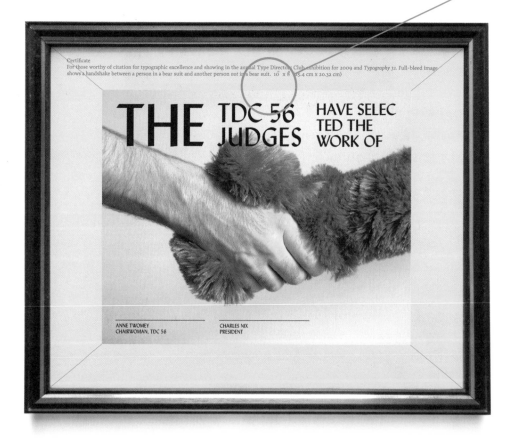

Certificate
For those worthy of citation for typographic excellence and showing in the annual Type Directors Club exhibition for 2009 and *Typography 31*. Full-bleed image shows a handshake between a person in a bear suit and another person *not* in a bear suit. 10″ x 8″ (25.4 cm x 20.32 cm)

THE TDC 56 JUDGES HAVE SELEC TED THE WORK OF

ANNE TWOMEY
CHAIRWOMAN, TDC 56

CHARLES NIX
PRESIDENT

Like many people, I live in a world (the one outside my office) that couldn't give a shit about many of the things I care about. This includes typography. From the subtitles in *Avatar* to the latest Red Roof Inn logo, bad typography is everywhere.

The double prime (inch marks) in place of quotation marks is an especially irritating example of this. In the studio, this problem is akin to a bug infestation. One proof at a time, we are ever vigilant, lest one or more of these slip through onto the printed page, or, worse, a tweet. While it is a small but egregious type crime to use a double prime in place of the quotation mark, let's face it, the double prime is an ugly thing even when it is used correctly (to indicate a unit of measure). In general, graphic designers suffer silently about typography.

The problem in this instance had nothing to do with the marks we used, but that they had somehow shifted. We received and approved a proof, but didn't notice this until after the certificates were printed.

To anyone who received one of these: Congratulations. Nice work. Please don't let this discourage you from framing and displaying in a prominent location. No one really looks at them anyway.

A DECISION REGARDING PRIMITIVE MAN

I draw on surfboards. This one, of a male bipedal hominid called *Paran-thropus*, expended at least a dozen #2 pencils. When I started the drawing (modeled after an illustration by nature artist Jay Matternes), I hadn't considered what I would do when I arrived at *Paranthropus* man's genitals. Please consider that I chose to draw on the top of the board, where the surfer—who would more than likely be me—sits. The drawing stalled for a few weeks as I considered my next move: Genitals or no genitals?

I like to think that I simply decided to "abstract" this area of the drawing by putting it in shadow. However, a number of people have since referred to *Paranthropus* man as "she."

Sorry, *Paranthropus* man.

FATHER OF THE MAN

A dispirited, deranged bus driver from Binghamton, N.Y., hijacks his vehicle and demands to see his son, a Vietnam vet who has been MIA for a dozen years, in return for the release of the seven passengers on board. The novel starts off with a series of WWII flashbacks that establish the patriotism of Dutch Potter, who struggles to find rewarding work after the war and ends up as a bus driver whose unhappy marriage offers little solace. —*Publishers Weekly*

Not only was this book set in my hometown, but it also took place (fictionally) in 1982, when I would have been there. That was the year I graduated from high school. So I called my dad and asked him to go out with his camera and shoot around town.

This project got out of hand, with at least a dozen, if not more, different cover directions being presented. There are many poor souls in the bowels of the big New York publishing houses who are hard at work right

now designing many, many more options for whatever title they are currently working on, trying to satisfy the editor, creative director, marketing department, author, author's agent, author's husband, author's pets, IT guy, etc. This isn't the norm for me. After three or four are rejected, I usually pull the plug. This one was different, because it involved HOME. So I kept at it until I was told that they "went in another direction."

It would have been nice to see my father get a photography credit.

CANCER SURVIVORS

Even for a loner, design is a collaborative process. There is often compromise, yet there are times when I get so focused on something I think is essential, that I have a hard time letting go. Overall, I consider this a strength, but there are situations when my stubbornness and the stubbornness of someone I am working with/for (even with the best intentions) has resulted in failure.

In the late 2000s, I served as art director at large for *New York* magazine, designing covers for stories ranging from the construction of the High Line to Rudy Giuliani's run for the presidency. The cover story for one issue was "The Survivor Monologues," a series of first-person accounts on living with cancer. The magazine put out a call for survivors to meet on a Saturday morning in Central Park for a huge group photograph; about two hundred people showed up. We rented a crane, and photographer Jason Schmidt shot the gathering from above. The idea was to stage the photo in such a way as to fit everyone into a perfect rectangle, in the same proportion of the magazine.

When it came time to design the cover, I was working with a headline: "Everyone on this cover is living with cancer." It perfectly captured the spirit of the gathering. It was a powerful declaration: We have cancer. WE ARE HERE.

The collaborative process was working beautifully up to this point—including, but not limited to, the photographer, all of the people

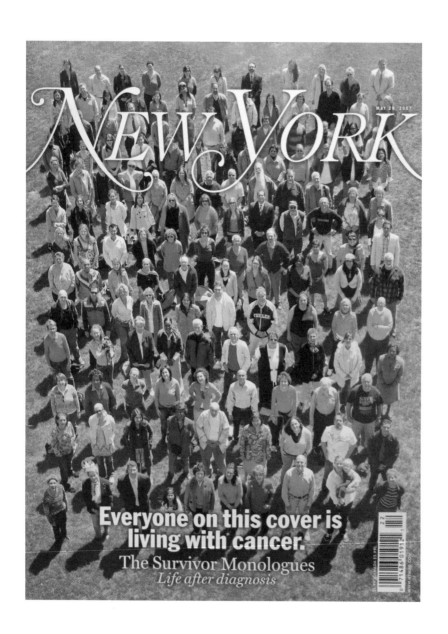

Everyone on this cover is living with cancer.
The Survivor Monologues
Life after diagnosis

who coordinated the shoot, and the people in the photograph. Even the weather cooperated. Then a writer wrote a headline.

All I had to do was select the best photograph and put some type on it. This is where the collaboration part broke down. Editor-in-chief Adam Moss—always heavily involved in the covers, like everything else in his magazine—thought the photograph should be cropped. I didn't. His reasoning was that the image would be more powerful if it felt like an infinite number of people, which would have been the effect if the image bled. My feeling was that we had to present the photograph as is, that the survivors who gathered came together to do an unusual thing: pose for a photograph in a perfect rectangle. I thought it made for a much more interesting cover *with rectangle*. That was it. That was what we went back and forth with for two days.

When *with rectangle* was finally approved (because of all of the debate, and my unwillingness to give in), I didn't have time to do some retouching to the image that I thought was essential. The nameplate of the magazine obliterated the faces of ten or more of the people in the photograph. It would have been easy to move each of these people up, down, left or right, but that would take time I didn't have. In this case, "an interesting cover" was way, way, way less important than WE ARE HERE.

▲

There are many more regrets to come.

Meanwhile, down in my mom's basement, my brother Greg never stopped making things. To this day, he sleeps in the same room he's been sleeping in since 1973, which is fitting because, though he is pushing sixty, he will always be twelve years old.

He has made all sorts of stuff down there. He's invented board games and crossword puzzles and collages, executed complicated Spirograph drawings, made buttons, and built model rockets from scratch out of spent toilet-paper rolls. He's planned and executed elaborate chalk drawings on the driveway and designed and built slot car tracks with entire HO-scale communities, complete with handmade billboards advertising some of his favorite things, things you'd never see on an actual billboard like Charleston Chew or Mike and Ike.

He made all of this underground (literally, the basement). He has never been that concerned with getting his work onto the fridge or on the walls of the living room or out into the world, but he is almost always making something with someone else in mind. He will often give things he has made as a gift and quite often these gifts are personalized.

He also got into plastic canvas needlepoint, so much so that it has become his go-to medium. It's like the needlepoint Mom does, only Greg's designs are stitched into plastic canvas. The canvas can be made into all kinds of 3-D shapes. As I write this, he is in the process of making a headliner for his 1969 Dodge Dart, but his main focus is tissue box cozies.

His subject matter is sort of all over the place: He does sports teams, Warner Bros. characters, or something ASL-related (American Sign Language). He once gave me a purely typographic box with my name repeated over and over. I keep this tissue box in my studio. Visitors ask me if he'll make one for them, but he won't. Turns out he doesn't take requests. He's stubborn. Good for him, although it has occurred to me that if he would just concentrate on doing these, he might create an entirely new typographic movement the likes of which haven't been seen since Ed Fella circa 1995.

When I'm visiting, Greg will motion for me to come downstairs, hand-signing to me out of reflex. Once down there he'll ask me to explain some piece of mail he doesn't quite understand and show me something he's working on. His hoarding has spread over the years to engulf not only

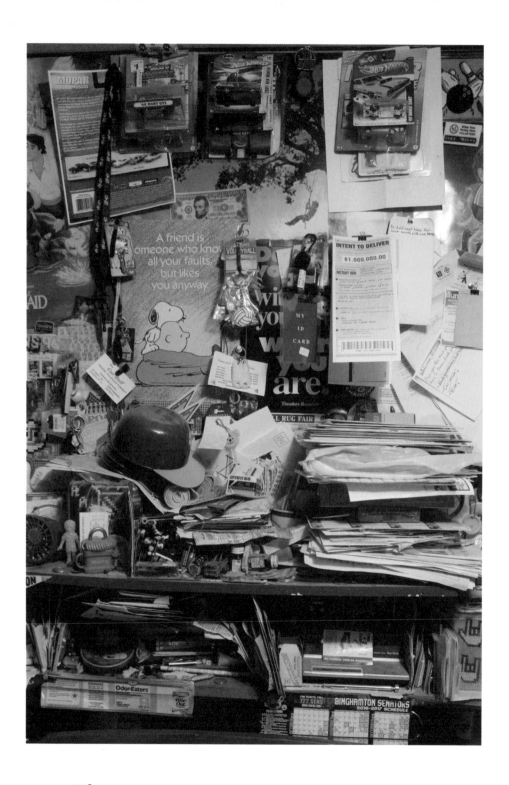

his bedroom, but the entire rec room as well. My mom doggedly holds on to the laundry and sewing room (the room formerly known as my bedroom). I don't know if this is the case with other hoarders, but Greg knows where everything is, he doesn't just put something in a pile and forget about it. Greg is like Wall-E. One of his jobs is collecting and putting out the garbage and recyclables, so he throws a lot away, just nothing that might have any possible future use. If the rest of us decided to get on a huge spaceship and leave, Greg would remain in that basement making his needlepoint.

Every once in a while he will design something original and this is when it gets interesting for me. With one tissue box in particular, he took the familiar sign for "I Love You" and created a unique symbol. It had a rainbow inside the hand and a redundant red heart in the upper left corner between the forefinger and the thumb.

My first thought was that it looked like a symbol for a gay, deaf cult. This was clearly not his intent. He was trying to make something 100 percent positive. Either way, there was no denying that this object was powerful.

Back in my studio, I couldn't stop thinking about Greg's tissue box and my reaction to it. There was such a huge disconnect between what he meant to convey and how it actually communicated.

Intent is an interesting thing as it relates to design. Greg wasn't designing a stop sign, for instance, something where the designer's intent and the way a design is understood have to be identical. There is no room for subjectivity. Still, with anything visual—even a stop sign—there is always some interpretation. So much of the cause and effect between intent and understanding is learned.

You'll recall my ice machine example from earlier in this book. For years after grad school I conducted an unscientific experiment in my classes where we would do image association. I deconstructed visual elements and then projected them on the wall for a few seconds. The students would write down the first word or idea that popped into their heads. For instance: We forget about it, but a stop sign is designed. If we deconstruct it, what we have visually is a shape, color, and a word that takes a certain form (typeface).

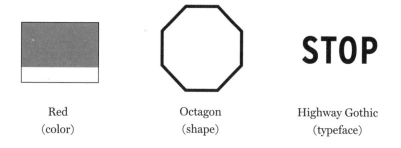

| Red | Octagon | Highway Gothic |
| (color) | (shape) | (typeface) |

Here are a few of the most frequent responses for each design element:

Blood	Stop	Go
Passion	Nothing	Light
Love	Bumper pool	Red
Stop	Janggi	Car
Hell	Umbrella	Sign
Lipstick	Shape	Halt

This is a simple example, but a designer must have an understanding of the complexity of meaning that exists with the most basic visual forms—if we can hope to have any degree of control once we start combining them for specific effect, like getting a motorist to stop at an intersection.

Of course, that we can understand anything from a color (or shape) is learned and is often culturally specific. Since there are a lot of Korean students attending SVA, the word "Janggi" appeared multiple times when I projected the slide of the octagon. Janggi is a kind of Korean chess, where the pieces are octagons.

Because of where I live and work, between the neighborhoods of Chelsea and Greenwich Village, there are rainbows everywhere. Not so much in Binghamton where Greg is. The rainbow has a totally different meaning in a country like South Africa for instance, where "rainbow nation" is a term that Desmond Tutu used to describe his country post-apartheid. At the risk of comparing my older brother with the archbishop, his rainbow was employed for the same basic reason: to communicate something inclusive and positive.

The hand symbol could be interpreted in a number of different ways. If one is not familiar with the ASL sign for "I love you," it may be taken as a cult-like or satanic gesture. Again, this is a learned understanding that is the result of repetition and consistency. There was an already understood meaning associated with a rainbow that was co-opted, and if it's done consistently and repeated, a new meaning and association are created.

Greg lives in upstate New York and not Joburg, but still, the more I thought about it, the more I appreciated Greg's heartfelt, if naive, sentiment. The fact remained that he created something powerful. So, without asking him, I worked on refining his original to see if I could create a more abstract, universal version of it. I wanted to see if I could keep the essential aspects of what he was doing—that it could be customized and spread goodwill—but extend his reach. Up to this point in my career as a graphic designer, I designed mostly theater posters and book covers, but I've always

wondered what it would be like to design something like the smiley face. Something ubiquitous, something EVERYBODY knows.

Love it or hate it, you know the smiley. But do you know its origin? Contrary to what you might think, it wasn't designed with global domination in mind. It was created by a graphic artist named Harvey Ball in 1963 after he had been hired by an insurance company to create an image that could be used to increase morale at the company. The design took all of ten minutes and he was paid $45 for his services. The symbol would go on to appear on millions of buttons, T-shirts, and other merchandise, and has long since crossed over to electronic messages and emojis. None of this was according to a plan, it just happened, mainly because of commerce and the fact that Ball never copyrighted or trademarked the smiley.

What if Greg had unknowingly created a new smiley face? I had to find out. I would use graphic design to see if I could spread his message globally.

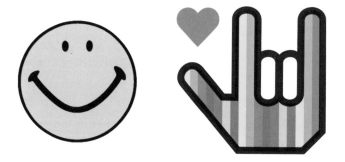

So I branded the shit out of it.

I named it *Spreadin' the Luv*. It was 2004. I designed a website and piggybacked it on social media (specifically MySpace and Flickr) and developed a simple participatory campaign that involved the dissemination of the symbol, which, in turn, encouraged the spreadin' of good vibes all over the place. Oh, and I did this without any outside funding. I wanted to see if it would spread without the money part of the equation. I sent

dolphin oracle
friendswithyou
littleoddforest
sleepy pete
modi

squirrelly
jes
die doppelgangerin
illwaukee
sykoradio
2 in the pinky...

lindsay
ultra geek
snaggs
vars
karlssonwilker
sataray

ghost vs. everything
el.e.°
LP666
theresa
the mum sisters
owl movement

odd duck
ellis
brooklyn bunny
jennifer
st. patrick
d'etoile

monorex
vaseline
grimace
seim22
zach
(b) (a) (b)

snowboots
vinny idol
sweet n' toxic
joonest
jordan
pink ranger

candy cane
g²
yeoman rand
diamond
she woke up
mike essl

281

thousands of free stickers, buttons, and patches around the world to all who requested them, and, in turn, people photographed the symbol in the wild. Customization was encouraged. An editable PDF of the artwork was provided on the website and hundreds of people contributed to its growing image database.

When I showed my brother what I was up to, he was ambivalent. I don't think he quite understood what I was doing. I loaded him up with buttons and stickers and we never spoke about it again until the following Christmas, when he presented me with a new tissue box . . . complete with *my* reinterpretation of *his* original symbol.

I was obsessed with this project for a time. It was spreading, but it was becoming clear that the only way that it would continue to spread was if I kept pushing it uphill. It never quite took on a life of its own. After a few intense years of activity and thousands of dollars of my own money, I moved on to other things.

Unlike the post-9/11 primordial ooze that gave it life, optimism is now chic. *Spreadin' the Luv* lies dormant, biding its time, ready to pounce with hearts and rainbows when cynicism is again in vogue, whether the world wants it or not.

Interacting with clients is one of the most challenging—and often the most fascinating—aspects of working as an applied designer. On a good day, a client request can make something you are designing better; on a bad day, it can totally fuck things up. Presenting work is an art, and it takes practice.

It has been interesting to see how these interactions have evolved over time. I started off presenting my work almost exclusively face-to-face. Then it moved to over the phone. Now I present most of my work via email and often follow up with a Skype meeting. Each time, there has been a learning curve on how to manage the situations and problems that attend each method of communication. The means by which a designer interacts with clients is also dictated to a large degree by the type of work that designer does. If I was working at a digital agency, I assume I would be doing more face-to-face presenting and traveling a lot more than I do now. Then again, I don't really know that to be true, because I don't work at a digital agency.

At the beginning of my career, I spent most of my time arguing and resenting bosses, clients, coworkers—basically anyone who I felt was getting in the way of my work. I burned a lot of bridges. I just felt like the work came first, and I didn't understand why no one else seemed to feel the same way. Never mind that (a) I was just out of school and (b) I was working at companies in Baltimore that didn't care about doing good work anyway.

I soon realized that being able to "sell your work" (meaning getting someone to approve what I am proposing) was the main difference between myself and the designers I admired. I have gotten better at it, through

trial and error (mostly error), and by seeing others do it.

This brings me back to a designer's relationship to the word "no." Early on I would say no in ways that would elicit a defensive response, arguments, and sometimes yelling (see *Getting Fucked by Steely Dan*, page 195). I've learned (the hard way) to respond to adversity with much more tact. As my reputation has grown, this is less of an issue. I am still pretty uncompromising in terms of the work, but I think I'm much easier to get along with, mainly because I can identify trouble further off. I also get away with things now that the younger version of me never could. I still make mistakes, but I have found that, with experience, comes trust.

What follows is the story of one project, from beginning to end. I am sharing this paticular project because most of the client interaction was through email. Sappi Paper hired VSA Partners in Chicago, they had an idea and, in turn, hired me and five other designers. All of my interaction was through an art director who worked for VSA. I first needed to convince my art director, then he had to convince his creative director (in this case, Dana Arnett), then they had to convince their client.

Most emails that pass between designer and art director/client are quick questions or comments about format or some other minor detail. I have left some of these out, but typos and other grammatical errors have been left alone.

From: Jason McKean <jmckean@vsapartners.com>
Subject: VSA Map Assignment
Date: October 23, 2007 10:40:49 PM EDT
To: paul@officeofps.com

Hi Paul,

We've asked six designers/illustrators to render a portion of the United
States. Ideally, when all six of these posters are put together, they'll form
a map of the United States. Your region, the Northeast, can be illustrated
in any medium you choose. I understand Dana has expressed some
interest in seeing your illustration take shape with geometry and classic
typography.

The final product will be 21" x 17.5". I've attached an Illustrator eps
with a skeleton map of the states you'll be illustrating. Given Dana's direc-
tion, it's up to you to represent this however you see fit. Obviously, keeping
our corporate client in mind, we'd like to avoid profanity or political slant.

Our drop dead delivery date is in mid-November. We'd like to look in on
your progress a couple times, too—first with a sketch on October 31 and a
check-in on November 9. The complete summary is below. If you have any
questions, please call or send a note.

TIMING
Sketch: Wednesday, October 31
Check-in: Friday, November 9
Final delivery: Thursday, November 15
Budget: $5,000

Thanks,

Jason

From: Paul Sahre <paul@officeofps.com>
Subject: Re: VSA Map Assignment check-in
Date: November 1, 2007 2:34:08 PM EDT
To: Jason McKean <jmckean@vsapartners.com>

jason,

sorry for the delay in getting back to you.
yes, i received the email. count me in. i have started on the map. i should
have something for you to look at early next week. i hope
that works.

a quick question: can i conceptually play with the map (like rename places
or mix them up or something like that), or is it meant to be more of a literal
stylistic re-imagining of a working map?

-PS

From: Jason McKean <jmckean@vsapartners.com>
Subject: Re: VSA Map Assignment check-in
Date: November 1, 2007 3:04:09 PM EDT
To: Paul Sahre <paul@officeofps.com>

The map is open to conceptual play—rename places, mix things up, have
fun with it. It doesn't need to be terribly literal, but it should look—at least
in some way—representative of the states in your region. That way, when
it's grouped with the other five posters, we will have some semblance of
the U.S.A.

Make sense?

Jason

From: Paul Sahre <paul@officeofps.com>
Subject: Re: VSA Map Assignment check-in
Date: November 1, 2007 3:06:50 PM EDT
To: Jason McKean <jmckean@vsapartners.com>

great, makes sense, thanks jason. i'm on it.

-PS

From: Paul Sahre <paul@officeofps.com>
Subject: Re: Map sketch?
Date: November 7, 2007 5:58:49 PM EDT
To: Jason McKean <jmckean@vsapartners.com>

jason,
here are my 2 proposals/ideas for our map:

1. UFO
Sightings, flight patterns, etc. see attached.

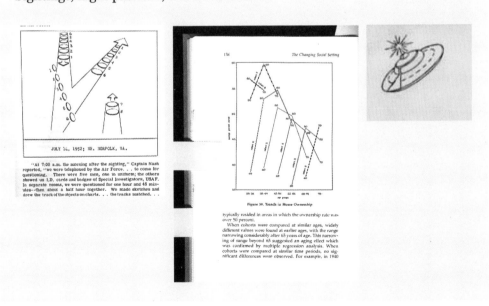

2. FUTURE MAP

what could the northeast look like in, say, 10,000 years? possibly a series of islands vaguely named after things familiar to us?

the northeast might be a series of islands by then. perhaps the map would have similarities to the early explorer maps? see attached.

either of these ideas could work. 1. is more practical, 2. is scary, a lot of stuff to make up. but both are doable. let me know what you think.

-PS

From: Jason McKean <jmckean@vsapartners.com>
Subject: Re: Map sketch?
Date: November 8, 2007 10:54:35 AM EDT
To: Paul Sahre <paul@officeofps.com>

Paul,

These both sound like fun ideas. FUTURE MAP has us most intrigued—
let's go that way. Looking forward to seeing how it all turns out!

Jason

From: Paul Sahre <paul@officeofps.com>
Subject: Fwd: Future map PDF
Date: November 8, 2007 1:11:22 PM EDT
To: Jason McKean <jmckean@vsapartners.com>

Sounds good. Here is another reference image I forgot to send.
Something like this . . .

-PS

From: Paul Sahre <paul@officeofps.com>
Subject: Fwd: Future map PDF
Date: November 21, 2007 10:26:37 AM EDT
To: Jason McKean <jmckean@vsapartners.com>

jason, attached find our map in its present state. we are trying desperately to
finish this up today. mainly we are still adding and altering stuff. review and
let me know what you think. There are a number of different ways we can go
with color and it might be good to have some direction on this. everything is
meant to be read (most of it is gibberish, but of course could be understood
by someone in the future). we are also doing some straight up Chinese trans-
lations that also read.

-PS

From: Jason McKean <jmckean@vsapartners.com>
Subject: Re: Future map PDF
Date: November 21, 2007 12:29:26 PM EDT
To: Paul Sahre <paul@officeofps.com>

This is really, really cool. I might suggest a limited spot use of color. Our other posters are really pretty saturated. This would stand in nice contrast. I'd avoid RED—DJ Stout's poster uses some giant red letters.

One other thing: Your height dimension is short by an inch. The poster needs to be 21" x 17.5"
I need this by 5 p.m. at the latest. Achievable?

Jason

From: Paul Sahre <paul@officeofps.com>
Subject: Re: Dimension correction . . .
Date: November 21, 2007 1:31:47 PM EDT
To: Jason McKean <jmckean@vsapartners.com>

got it. will be 21" x 17.5"
i'll try for 5 but i think its going to be later . . . and we will need every last second. send my your FTP info.

-PS

Date: November 21, 2007 10:01:23 PM EST
The Final Map was sent to VSA via FTP.

From: Paul Sahre <paul@officeofps.com>
Subject: Re: Dimension correction . . .
Date: November 21, 2007 10:07:57 PM EDT
To: Jason McKean <jmckean@vsapartners.com>

jason,

still there? i uploaeded this beast to your FTP. sorry for the delay, but i think it was worth it. i could have kept working on this for another 6 months with a smile on my face. thank dana again for me.

-PS

Two weeks later

From: Jason McKean <jmckean@vsapartners.com>
Subject: Re: YO.S.A. Poster
Date: December 3, 2007 12:47:52 PM EDT
To: Paul Sahre <paul@officeofps.com>

Hey Paul,

Hope you're well . . . We're getting very close to seeing your vision put to paper. It's been well-received around the office.

Our client at Sappi, of course, has a few questions. She's not sure she gets your jokes. I roll my eyes as I ask this, but: Is there any further light you can shed on the following things:

- YO! S.A.
- Forbidden Zone
- Chinese characters (Do you know the translation of everything you've said on the map? Can you help us?)

- Year of our Elvis
- Wawa references
- East of North

We've been telling her over and over to stop trying to read too much into your poster. Maybe you should be flattered, but she won't stop trying to glean meaning and understanding. Because she's paying the bills, we need this information from you as soon as humanly possible.

Thanks,
Jason

From: Paul Sahre <paul@officeofps.com>
Subject: YOU ASKED FOR IT
Date: December 4, 2007 12:47:52 PM EDT
To: Jason McKean <jmckean@vsapartners.com>

All of these "future differences" fall under the heading of "things that might be different in the future" while still keeping things familiar enough to us now that we can understand each on some level. if the specific reason for a change isn't understood, i think that's ok. when looking at maps that are more than 300 years old, a contemporary person would not understand quite a bit of the information. i don't necessarily think it's that important that everyone understands the references or the reasoning. but here goes . . .

Yo! S.A:
by 2413, the pervasiveness of hip hop culture (plus other undefined events) eventually leads to a change from U.S.A. To Yo! S.A.

FORBIDDEN ZONE:
a specific reference to the future (in film)

The Forbidden Zone in the Planet of the Apes movie series is the barren, lifeless area declared off-limits to all apes. while the specific reasons the area is forbidden are unknown, they know it as a wasteland fit only for humans, outlaws, and fools.

i have also included APE CITY (which is near the forbidden zone) for this reason.

CHINESE CHARACTERS:
due to China's increasing global influence, Chinese culture and language will be increasingly prevalent in years to come.

i can give you translations if need be, but there are no hidden offensive or even questionable things being communicated. i wouldn't do that to you or your client. understandable that they would like to know what everything means.

A FEW EXAMPLES OF THE TRANSLATIONS:
(it is assumed that all of this will make sense to someone from the future)

from the text below the half-life equation in the lower left:
it was possibly displayed, exponential decay, ĐĐ ĐĐ from this relations:

the sun symbol to the left of this area translates as:
HALF
LIFE

The text titled WAWA in the lower right translates as:

The water now is everywhere. We must face for a higher land transportation. (Elvis) God blesses the people and the water.

The text in the lower right translates as:
In north east side is the prosperous area. This bob action is the
typical movement for this area people.

The text under SMELL translates as:
When the bag popularly sends the odor fully to hope the aviation

The text under DATING EMITTERS translates as
The hill vividly is described truly is not the hill basis. Perhaps they help the
forward person to understand the symbolic constructs.

The text in the frame to the left of Yo! S.A. reads:
Mapping

if you would like the rest of the translations, let me know.

YEAR OF OUR ELVIS
in the future Elvis is considered a deity. play on "year of our lord"

WAWA
in the future, "wawa" is used in place of river, lake, ocean, etc.

EAST OF NORTH
just a "its the future so language is a bit different" way to say northeast.

let me know if there are any objections.

-PS

They printed the map as is.

●

RECAP

This was a terrific project. This was a case where the solution stemmed from personal interests as well as stuff I had lying around the office. My dad long ago had me hooked on old radio shows, in particular a '50s show called *X-Minus One*. We incorporated a bunch of stuff from that. We also referenced a number of books I have in my library.

While it might seem to have been a completely open-ended brief, if you read closely, it wasn't. There was a very well-defined set of wants from the art director that were articulated clearly, from the beginning, that really helped us focus a lot of energy in a relatively short amount of time. If I could do anything I wanted, I might still be working on it.

The only hitch was at the very end and that was totally understandable, given that the client is responsible for any "hidden messages" contained in the map. There are often multiple interested parties that have to be satisfied before something is approved.

Explanation of my thought process is usually offered only in small doses. In this case, I chose to include ALL of my thinking, but only after specific questions were raised. I didn't want them to have objections about anything, and by dumping so much detail, I think they understood that while there *were* hidden messages in the map, those messages couldn't be understood by anyone but me. Resistance was futile. The last thing anyone wanted was more emails from the designer.

Lesson: Sometimes it's good to overwhelm with rationale.

Once you get above grandparents on the Sahre family tree, there is virtually nothing. No photographs, no end tables, no military uniforms, no scrapbooks, no love letters, no personal items, no stories. No trace. The fact that there are boatloads of the aforementioned from the outermost limbs (in my parents' attic), makes me wonder what happened to all of it. Was there one totally unsentimental nineteenth-century ascetic uncle who disposed of it all? Or was there a darker explanation?

Shortly after my father retired, he became interested in genealogy. This made sense. My dad felt his lack of family information keenly, having only fuzzy memories of his father. As filmmaker Errol Morris put it, "My father died when I was two years old . . . this is someone I should know, but instead there is a mystery. Who is this man who is central to my life in so many ways?"

My father also had a proclivity toward information and statistics and used both on the job every day to help him understand complex problems and situations. Numbers and data were tangible. He worked for a company that designed flight simulators. As this work involved military contracts for various governments, his work was often top secret. His company had a contract with the Swedish Air Force and he would travel overseas without his family knowing his exact whereabouts. I had never even been to his office. The closest I got was the back door at the big plant in Kirkwood when my mom would drive out to pick him up after work. I would sit there in the passenger seat and stare at that back door, waiting for him to emerge, the warm light of the end of the day glinting off his white short-sleeve dress shirt and clip-on tie.

One summer while I was home from college, he got me a job in the mailroom, so I was able to visit his office for the first time. The walls were covered with the light green pin-fed computer printouts of the early '80s. It was all numbers. Geek wallpaper. He sat me down and attempted to explain the project he was working on. It was a navigation system for a C-130 Hercules aircraft. The numbers covering his office walls constituted his "work." These equations allowed him to visualize a *simulated* navigation system for a *simulated* aircraft! There was nothing tangible: no airplane, no air speed, no altitude, no destination. It was all a mathematical construct. I realized then that this was how he saw the world, through the underlying math of everything.

So his interest in genealogy seemed natural, but when he started his research, I have to think (deep down at least) that he knew he would find something bad back there, somewhere. Maybe he suspected something. He never said as much to me, but I mean, it's obvious, right? He wasn't going to find anything really *good*. If there was something amazing at the limbs and trunk of the tree, he would have already known about it. He'd know that his great-great-grandmother was the hero of the battlefield or that his great-second cousin was the inventor of the light bulb. These are things relatives love to perpetuate because it makes everyone in the family—even that weird aunt—look good by association.

Something my nana said may have raised a red flag with my dad. When he told his mom he was researching the family history, she discouraged him. "What would you want to go and do that for?" she asked, adding, "That seems like a waste of time to me."

Undaunted, he dug through old records and online databases, followed leads, made phone calls, and traveled to city halls, public libraries, and microfiche rooms. He followed wherever a lead took him. He started by verifying things already known. His great-grandmother on his mother's side was indeed the daughter of a Shinnecock Indian chief, but because of the lack of Native American recordkeeping, the trail ended there. The rumored Civil War veteran, also on his mother's side, was a private in the

4th New York Volunteer Infantry Regiment and was named either Isaac Hulse or Hultz or Hults depending on which official document you believed. His grandfather, Charles Sahre, immigrated to the United States from Germany in 1877. He had an uncle, Robert Sahre, who was hit by an automobile and died in 1931.

My dad would call me every once in a while when he found something—a name, a date, a fact—but there wasn't much. He did this on and off, but on the whole the results of his efforts didn't yield anything surprising. Until, one day in a microfilm room in White Plains, New York . . .

He was looking for his father's death certificate. He wasn't even sure why he was doing it. He already knew how his father died: He was an alcoholic who was "drying out" in Grasslands Hospital in Westchester. A call came informing his mother (my nana) that she could come and pick him up. When she got there, they told her he was dead. Cause of death: Heart attack. Only, according to the death certificate he was looking at forty years later, that was *not* how his father died.

CERTIFICATE OF DEATH

Name: Edward Humphrey Sahre
Date/Time of Death: June 18, 1948, 5:15 AM
Occupation: Letter carrier, World War II veteran
Cause of Death: Carbon Monoxide Poisoning
Location: Garage
Cause of injury: Auto exhaust
Due to: Temporarily mentally disturbed

Damn.

My father was a numbers guy. I'm not, but even I can create a narrative from these facts: His father suffered from depression (or some other mental disorder), or maybe it was the booze, or both. Either way, he commits suicide in his garage while his wife and two kids are asleep

upstairs. His mother doesn't tell them that their father took his own life. Over the next forty years, she lets sleeping dogs lie.

But the thing is, my father left it there, despite the suddenly deeper mystery about who his father was. The microfilm (and his mother's lie) had told him all he needed to know. He shared this information with his brother and his family but he never told Nana that he knew, nor asked her why, even though she lived a few more years after.

Errol Morris couldn't have done that. Neither could I.

When I started designing for one of my all-time favorite bands in 2011, a few years after the Marvel book, I approached it in a more professional manner, yelling, "NO FUCKING WAY!!!" while reading the email. John Flansburgh, one of the two "Johns" (the other, John Linnell) who founded They Might Be Giants back in the early '80s, had emailed me after seeing my work for the *New York Times*.

What started as a job designing some digital art for their upcoming release *Join Us* turned into the design for all the band's collateral, including the CD and LP design, digital art for iTunes, digital booklets, posters, T-shirts, ads, and over a dozen illustrations.

The album cover was a response to the album's "death theme" and featured a monster truck hearse crushing some tastefully aligned Helvetica. Flansburgh's initial reaction was positive, "Let's make it Day-Glo pink!" but he had an issue with the typeface, saying, "We aren't a Helvetica band." When I explained that a ridiculous pink monster hearse crushing

Helvetica was the ultimate *anti*-modernist statement, he immediately came around.

At that point our work was done.

Except that I didn't want it to end there. The iTunes digital booklet seemed like it might be an opportunity to do something interesting that we hadn't considered. These things are basically just PDFs with liner notes, so we used the PDF format to create instructions for making a tabletop model of the monster hearse that fans could build with paper, scissors, and glue. The design of the tabletop model and the PDF instructions alone took forever. The bulk of those hours were logged by Santiago, my intern at the time. I'm sure he still has nightmares about it.

At the last minute I changed the title to "Now you can build your very own official They Might Be Giants *Life-Size* Paper Monster Hearse." We had no illusions that anyone would actually attempt to build it life-size; it just seemed funnier that way, especially because the only change we made to the actual instructions was "STEP ONE: Print out this PDF at 3,400%."

Now we were done.

But, of course, we weren't, because the more I thought about it, the more I convinced myself to actually build it. I called A2A Solutions, the output place I usually work with, to get an idea if this was even possible. Far from telling me it was impossible and/or stupid, Adam said, "We can do it," only it turned out that the large-scale printing alone would take seventy hours and cost at least $1,000 for paper and ink. I went back to the band and asked for the green light.

The green light was given.

I had the vague idea that we would film the construction and create some sort of video, but it really started as an open-ended challenge. I wanted to see if I could do it. After all, I am Two-Dimensional Man, everything I design is flat. I had no business building what amounted to a monumental three-dimensional sculpture.

Once we had the printing figured out, we needed a large space. My studio certainly wasn't big enough, so Adam, the man crazy enough to print this thing at cost, went all in by offering A2A's driveway for however long it would take to build it. My guess was two weeks.

It took six months.

A handful of interns, employees, and students constituted our assembly team. There was a lot of improvising. After we spent two solid days trying, unsuccessfully, to build a single tire, we realized that we had no internal structure figured out that would support the weight of the outer skin. Construction stopped for about a week while we devised a cardboard skeleton that could support the weight but also be held together with hot glue. The tabletop version didn't need it; the life-size model did. An intern, a Belgian designer named Elias, was tasked with figuring this out. I'm not sure why I tapped him to do it. It may have been that he had operated a hot-glue gun before. A few days later he came back to me with a tiny mockup of designs for the skeleton, the wheel, the undercarriage, and the hearse that he had based on the tabletop version. "Do you think it will work?" I asked him. He shrugged, "In theory we should be able to enlarge these at the same proportion. It should work."

I started to think I might have gotten in over my head. This certainly was not going to take two weeks. Like most monumental human tragedies—from the Titanic to the Donner Party—if we knew what we were getting into, we probably wouldn't have started out, but now there was no turning back.

Construction resumed and the hearse assembly fell into a predictable routine. First, I checked if the weather in Stamford (an hour train or car ride away) was good. We had to see if we could drop what we were

doing at the studio for the day. If yes, then we all met at the Jay Street train stop in DUMBO, where I picked up whomever could go with me. We would work all day and sometimes into the night, then, exhausted, we would return to the city. Repeat. Former student Joe Hollier was filming everything and, by the end, had logged hundreds of hours of footage.

It wasn't clear until we were at the very end what we would do with all of the footage we had or whether what we were building would actually hold together long enough to be documented. I added to the difficulty by insisting that the monster truck had to move, which meant that axles of some kind had to be devised. Nerves were fraying. There were numerous hot-glue burns, minor cuts, bruises, and periods we couldn't work because of the weather or projects at the studio. Adam was getting antsy because pieces of the monster completely filled his garage and part of the first floor.

On a particularly tense day, with little time to spare, I had ventured out to McDonald's to get Erik and Santiago a Big Mac and fries. Traffic was so bad that it took me two hours to go there and back, burning a large chunk of the day. When I delivered their lunch, we realized they had forgotten to put the Big Macs in the bag. So they drank their Cokes and ate their fries and got back to work. They were stranded on a desert island. They were looking at me all afternoon as if *I* were a Big Mac.

Eventually, inevitably, at 11:34 AM on November 8, 2011, we pushed the monster out into the street for the first (and only) time. With Joe filming, we did a test take that became the only take because the tires started to give way under all of that weight. We made it exactly 120 feet, the same distance the Wright brothers traveled at Kitty Hawk.

We deconstructed the monster and took it by U-Haul (in three trips) to a storage place in Stamford. The manager told us that They Might Be Giants were now the second famous musical band storing stuff at that facility. The other was Average White Band.

While the monster sat in storage, Joe did a rough edit. I had been holding off sharing anything but a few still images and vague promises that "things were progressing" whenever Flans asked, so this was the first time he had seen anything move. After seeing what we had, he gave us the best song on the album—"When Will You Die?," a song about wanting someone dead—and asked for a music video. The footage we had was amazing, only we didn't have an ending.